Columbia University Press regrets that the following color reproductions in *Robert Motherwell: What Art Holds* have been cropped at the top during printing: *Elegy to the Spanish Republic No. 172 (With Blood); Summer Seaside Doorway; Study in Automatism; Greek Door; Garden Window* (formerly *Open No. 110*); *Untitled (Blue Open); Mallarmé's Swan; Gift;* and *N.R.F. Collage No. 2.* The color reproduction of *Untitled (Blue Open)* has also been printed upside down.

The frontispiece photograph of Robert Motherwell and the photographs appearing on pages x, xiv, xxi, xxii, xxiii, xxiv, xxvi, 17, 23, 43, 54, 168, 171, 175, 177, 178, 180, 183, 186, and 198 are by Renate Ponsold Motherwell.

R O B E R T M O T H E R W E L L

Interpretations in Art

Robert Motherwell.

R O B E R T M O T H E R W E L L

█HAT ART HOLDS

Mary Ann Caws

C O L U M B I A U N I V E R S I T Y P R E S S ■ N E W Y O R K

 Columbia University Press
New York Chichester, West Sussex
Copyright © 1996 Mary Ann Caws
All rights reserved

Published with the assistance of the Getty Grant Program.

Cover illustration: *Mallarmé's Swan*, 1944. © The Cleveland Museum
of Art, Contemporary Collection of The Cleveland Museum of Art,
61.229. © 1994 Dedalus Foundation, Inc.

Quotations from the writings of Robert Motherwell courtesy the
Dedalus Foundation. © 1996 Dedalus Foundation, Inc.

Library of Congress Cataloging-in-Publication Data
Caws, Mary Ann.
 Robert Motherwell : what art holds / Mary Ann Caws.
 p. cm. — (Interpretations in art)
 Includes bibliographical references and index.
 ISBN 0–231–09644–5 (cl : alk. paper)
 1. Motherwell, Robert—Criticism and interpretation.
 2. Surrealism—United States. I. Motherwell, Robert.
 II. Title. III. Series.
 N6537.M67C42 1996
 759.13—dc20 95–20819
 CIP

Printed in the United States of America
c 10 9 8 7 6 5 4 3 2 1

Man is his own invention: every artist's

problem is to invent himself.

Robert Motherwell, preface to *The Rise of Cubism* (1966)

CONTENTS

> How to keep—is there any, is there none such, nowhere known
> some, bow or brooch or braid or brace, lace, latch or catch or
> key to keep
> Back beauty, keep it, beauty, beauty, beauty, . . . from vanishing
> away?
> Gerard Manley Hopkins, *"The Leaden Echo"*

Robert Motherwell knew what art holds, in both senses of the word: what art contains and what kind of art is most lasting. To endure a work of art must be deep in itself and have the capacity to render its many possible interpretations as profound as the thought behind its making and expression. The following study is based on my interpretation of Motherwell's knowing, his art, and its way of holding, again in that double sense. I do not mean this to be a compendium of the facts found in the many publications already devoted to the painter, but something far more personal.

A few years ago, while speaking of the "Painter's Objects," Motherwell alleged of the art world and our reading of it that we had all of us been so occupied with the small that we had made ourselves unable to create anything more meaningful:

> With what our epoch meant to replace the wonderful things of the past—
> the late afternoon encounters, the leisurely repasts, the discriminations of
> taste, the graces of manners, and the gratuitous cultivation of minds—what

Motherwell mailbox, Greenwich, Connecticut.
Photograph courtesy of Renate Ponsold Motherwell

we might have invented, perhaps we shall never know. We have been made too busy with tasks.[1]

Yet as I see it Motherwell himself was somehow enabled to discover a few crucially important things for himself and for us. In 1985 he claimed, and rightly so, that his pictures were joined to each other: "In a sense, all of my pictures are slices cut out of a continuum whose duration is my whole life, and hopefully will continue until the day I die."[2] That they did, and more. All those pictures were part of a discovery he wanted to share. The following text is a personal essay on what I find most meaningful in his creation, on the ways it responds to what lies outside it in literature, art, and life, and on its ways of holding.

My grateful thanks to:

Robert Motherwell and Renate Ponsold Motherwell for their enthusiasm, affection, and warmth;

Joan Banach, curator of the Dedalus Foundation, for her invaluable help from the beginning and over the years; the Dedalus Foundation; Dore Ashton, Jack Flam, and David Rosand, for their friendship, counsel, and much-appreciated support; Mel Paskell and Cynthia Siu, for their help;

all the friends and colleagues in all sorts of places with whom I discussed this project in its very long unfolding; Boyce Bennett, for his critical and sustaining judgment;

Ann Miller, Sara Cahill, Kerri Cox, and Linda Secondari of Columbia University Press, for their patient, creative, and intelligent approach to this project;

the Getty Center for the History of Art and the Humanities, for its offer of a Getty Scholarship in 1989–1990; for its hospitality during my stay there, enabling me to undertake this project; and in particular for its crucial support of this study and all the artwork included here through its generosity.

PERSONAL CRITICISM AND THE ESSAY FORM

I want to start by putting my cards on the table. This is a book about someone I knew, loved, and admired, who encouraged this project from its inception, and through its changing conception, until his death. This is a partisan book.

I knew Robert Motherwell as a colleague at Hunter College, and as a teacher and writer. He graciously served as the art adviser for a small journal I coedit called *Dada/Surrealism*. So I knew him first as an intelligence and subsequently as a person willing to share it. Then one day in Paris I happened upon an exhibition of Robert Motherwell the artist. Surrealist that I was, I thought it just right to have found this when I was not seeking it out. I stood in front of an *Elegy*, my heart rushed to my throat, and I was rooted to the spot. Ah, I thought, *why did I not stay in art history, where I started at Bryn Mawr, so that I could write about this artist?* Only later did it occur to me that I could, perhaps even should, write about him in relation to the literary side of things, to which I had gravitated in the meantime. Literature was important for him, it was important for me—this was the field I had chosen. This was what I would do, eventually, when I had time, I decided, but only if he agreed.

Things did not change in my view of his art and its meanings. I reread his writings, admiring what I read. I continued to look at his work wherever I could. I spent a year at the Getty Center for the History of Art and the Humanities, to ponder how I would combine a study of his art and his writing, conferring with him about this project. He was encouraging, in all his letters, telegrams, phone conversations, and interviews.[1]

Robert Motherwell reading Caws manuscript.
Photograph courtesy of Renate Ponsold Motherwell

I count among my greatest fortunes that of having been able to write on this artist and thinker in whom I saw so many different elements, so little of that sameness that would have discouraged me in the long process of writing, seeing, rewriting, and thinking things over. I could bring all I had to what I was doing. His encouragement was constant and never ceased to be a driving force.

On many occasions during the last years of Robert Motherwell's life we discussed the kind of book this was to be. Never intended as a classic life-and-work study, it was always to partake of the more open spirit of the personal essay. Some of our conversations on this topic and others are included here in the final chapter. However, much of our conversation, not recorded in these interviews, was about literature: as a literary critic, I take a point of view different from that of the art

historian. These two factors, the personal and the literary, explain, I think, the appeal for him of the sort of work I was doing and am now presenting. He claimed that I did my best writing about art, as he did his best art about writing: perhaps so.

The responsibilities of the personal essay and of personal criticism as I see them are no fewer in number, although of a different sort, than those of the standard study of a person and work. I have spoken of them elsewhere, at length, but have not yet tired of confronting them.[2] Briefly, they concern warmth of intonation and conviction, personal involvement in expression and interpretation, and above all the moral certainty of celebrating only the works, the topics, and the artists you believe in and care about. Of course, the autobiographical may enter, but it is not the point of the writing or its focus. This writing is turned toward the other, not toward the self, although the self is intimately sensed as present.

Personal criticism is, as I see it, diametrically and unembarrassedly opposed to any distant, scientific or theoretically cold approach and the rigidly roped-off sectionalism of some traditional criticism. It is more about *conversation* with the work and the others looking at it, about a kind of collective creation, rather than any authoritarian declaration.[3] It builds on, instead of attacking, what has gone before, merges with what it loves, expresses openly its admirations and distrusts; it is fluid before it is neat. Personal criticism follows a Virginia Woolf line, say, rather than a Matthew Arnold one. Personal is not professorial, which does not at all mean that personal critics do not teach or even that they do not know—but it does mean that they are not reluctant to take issue for what they care about, undistancing themselves. They care about directness even in their indirections.

This sort of criticism is far from working for all art. It is my contention that it does work for such artists as Robert Motherwell. If while reading this you were to say, *ah! this is about personal statement and about warmth of response, the artist's and the critic's,* you would not be so wrong.

JANUARY 24, 1915

Birth of Robert Burns Motherwell III in Aberdeen, Washington, of Scottish and Irish parents.

1932–1937

Moves with his family to San Francisco. Attends the Otis Art Institute in Los Angeles, a San Francisco high school, and Moran Preparatory School, where he discovers the illustrations of modern art in the *Encyclopedia Britannica*. Briefly studies painting at the California School of Fine Arts. Attends Stanford, from which he receives his A.B. in 1937. Travels around Europe with his father and sister. Encounters the work of James Joyce, a lifelong hero for him: his *A Rose for James Joyce* is testimony to this, as is his sketch of *Molly as Tower* in the *Dedalus Notebook*.

1937–1940

Enters the Philosophy Department at Harvard, planning to translate and write on Delacroix's *Journals* for his degree. His studies with David Wright Prall are of particular importance for his future ideas on aesthetics.[1] Travels in Europe in 1938–1939, studies for a time at the Académie Julian in Paris, translates Signac's *D'Eugène Delacroix au néo-impressionnisme,* and returns to teach in Eugene, Oregon. In Paris his friend Arthur Berger, a composer and teacher, suggests he go to work with Meyer Schapiro at Columbia University, which he does in 1940.

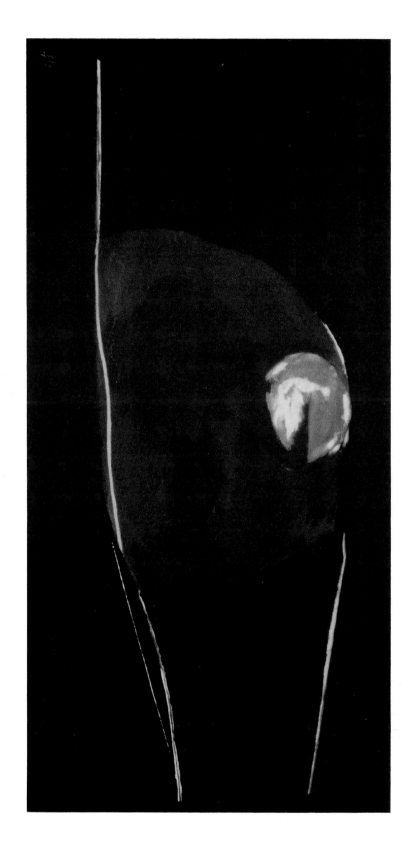

A Rose for James Joyce, 1988.
Acrylic on canvas, 78 in. × 38 in. (198.12 cm × 96.52 cm).

Private collection of George Dalsheimer, Baltimore, Maryland. Photo credit:
Ken Cohen. © 1994 Dedalus Foundation, Inc.

1940–1942

After moving to New York, studies with Meyer Schapiro in the Art History Department at Columbia and, at Schapiro's instigation, goes to study with Kurt Seligmann. Meets through Seligmann the surrealists present in New York, to whom he will remain close for a time, particularly Matta Echaurren. Travels with Matta to Mexico, and on the ship meets the Mexican actress María Emilia Ferreira y Moyers. Works with Matta in Taxco, and then paints for four months in Mexico City, absorbing the colors of Mexican folk art, which will recur in his own painting, as will the extreme contiguities of white and black, festival and mourning. Works in Mexico with Wolfgang Paalen, one of whose essays he translates for the first issue of Paalen's journal *DYN*. Returns to New York to paint. Marries María in Provincetown in 1942.

1942–1948

Works with André Breton and Max Ernst on the journal *VVV*. Takes up automatic writing and drawing, under the inspiration of the surrealists. Meets Joseph Cornell and William Baziotes, to whom he will be especially close. Included in the surrealist exhibition at the Whitelaw-Reid mansion in 1942. Rents an inexpensive house with solar heating in the Hamptons from the architect Pierre Chareau; will return to this area frequently until 1950. In 1944 becomes editor of the Documents of American Art series. Signs a contract in 1945 with Samuel Kootz Gallery in New York, where he will exhibit for the next ten years. Meets Mark Rothko, Barnett Newman, and then Harold Rosenberg. Teaches at Black Mountain College in the summer, where he will also teach in 1951, and remains, as he will for several years, on Long Island in the winter. Produces in 1947 the single issue of the journal *possibilities*, with Harold Rosenberg, John Cage, and Pierre Chareau.

1948–1953

Moves to New York City because María had felt isolated on Long Island. Makes the sketch for a Rosenberg verse that inspires the *Elegy* paintings; will develop these the following year, making another *Elegy* entitled *At Five in the Afternoon*, after García Lorca's "Llanto por Ignazio Sánchez Mejías," the bullfighter. Founds the school he will call "Subjects of the Artist" with Baziotes, David Hare, Rothko, and Newman. Writes for *Tiger's Eye*. Divorced from María in 1949; meets Betty Little in Reno and will marry her in 1950. Meets the sculptor

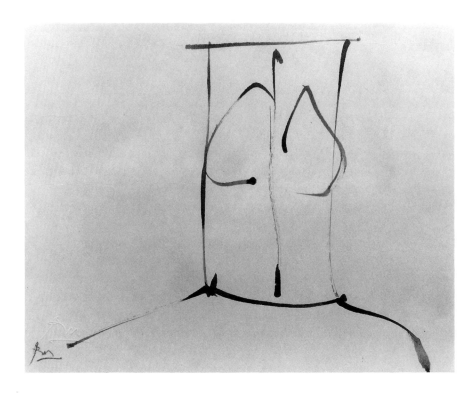

Dedalus Sketchbook: Molly as Tower, 1983.
*Sienna ink on Strathmore drawing paper, 6 in. × 7.75 in.
(15.24 cm × 19.69 cm).*

Private collection. Photo credit: Eric Pollitzer. © 1994 Dedalus Foundation, Inc.

David Smith in 1950—Smith will be a close family friend until his own death. Dismissed on "astrological" grounds by George Wittenborn, who says to him, "You are about to have seven unhappy years." Begins teaching in 1951 at Hunter College, where he will teach until 1959 and then later, from 1971 to 1972, as Distinguished Professor. [Will continue giving seminars, art classes, and serving as visiting critic and counselor at various universities and centers: in 1952, at Oberlin College; in 1954, at Colorado Springs Fine Arts Center; in 1962, at the University of Pennsylvania; at Columbia University from 1964 to 1965; in 1966–1967, at Carpenter Center, Harvard, and Yale University Summer School; subsequently at Bennington College, Bard College, Purchase College of the State University of New York in 1974, among many others.]

1953–1958

Daughter Jeannie born. Purchases a brownstone on East Ninety-fourth Street in Manhattan, where he will live for the next seventeen years. Daughter Lise born in 1955. Included in the Museum of Modern Art exhibition "Modern Art in the United States," which tours Europe. Spends summer of 1956 in Provincetown, where he will spend most summers for the rest of his life and where he will do much of his painting. Divorced from Betty Little in 1957; meets the painter Helen Frankenthaler. Sidney Janis Gallery becomes his dealer, remaining so un-

Robert Motherwell with Jeannie Motherwell.
Photograph courtesy of Renate Ponsold Motherwell

Robert Motherwell with Lise Motherwell and
Sidney Simon.
Photograph courtesy of Renate Ponsold Motherwell

til 1962. Marries Frankenthaler in 1958, travels with her and the children, and
paints in Spain and in Saint-Jean-de-Luz in France. Included in the Museum of
Modern Art's "The New American Painting," which tours Europe.

1959–1965

His first retrospective exhibition is held at Bennington College. [Many others
will follow: Sao Paulo, 1961; Pasadena, 1962; the Museum of Modern Art, 1965;
Mexico City, 1968; the University of Connecticut, 1979; and Barcelona and Mad-
rid, 1980. An exhibition of his prints is held at the Museum of Modern Art in
1980; a retrospective opening at the Albright-Knox Art Gallery in 1983 then trav-
els throughout the United States, ending at the Guggenheim Museum in 1984.
A Mexico-related exhibition originates at Knoedler, continues in Mexico City,

Provincetown Bay.

Photograph courtesy of Renate Ponsold Motherwell

and ends in Fort Worth in 1991, opening shortly after his death.] Throughout his life, Motherwell will travel widely, in the United States and Europe, remaining involved in events abroad as well as at home, and will take much of his inspiration from European literature, themes, and artists. Paints during the summer of 1960 in Alassio, Italy. Signs the statement "In Support of French Intellectuals" in 1961, reacting to the Algerian war. Becomes in 1963 the art consultant for *Partisan Review*, with whose board of editors he will remain friendly.

1965–1971

Makes the *Lyric Suite* drawings inspired by Alban Berg's music, which are interrupted by his intense sorrow over the death of his close friend, the sculptor David Smith, in a driving accident. Signs several protests against the Vietnam War. Appointed a director of the College Art Association, bringing into that group

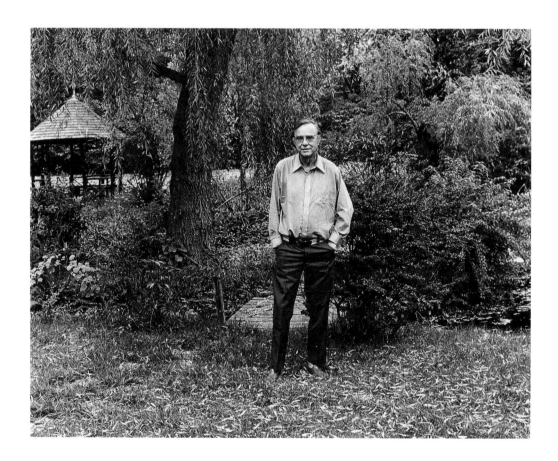

Robert Motherwell in garden, Greenwich, Connecticut.
Photograph courtesy of Renate Ponsold Motherwell

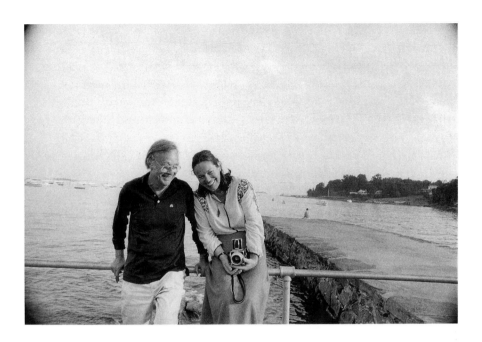

Robert Motherwell and Renate Ponsold Motherwell.
Photograph by Terri Wehn Damisch

Dore Ashton, Frank Stella, Robert Hughes, Richard Diebenkorn, and Donald Judd. Made an education adviser for the Guggenheim Foundation, a post he will occupy for twenty-four years. He and Frankenthaler are represented in the Venice Biennale of 1966. Made an advisory editor of the *American Scholar* in 1968, and founds the Documents of 20th-Century Art series, of which he remains, until his death, the general editor, inviting Arthur Cohen as managing editor.[2] Named adviser to the Bliss International Study Center at the Museum of Modern Art; made special adviser to the National Council on the Arts in 1969; is a trustee of the American Academy in Rome from 1979 to 1980; will continue advising various institutions until his death. Acquires a carriage house in 1970 in Greenwich, Connecticut, where he will move permanently in 1971, when also he is divorced from Frankenthaler.

1971–1973

In the fall meets the photographer Renate Ponsold. Appointed counselor to the Smithsonian Institution. In 1972, when he is no longer tied to Marlborough, his dealer for a number of years, many galleries and museums request material for Motherwell exhibitions; Knoedler Contemporary Art becomes his exclusive painting dealer, an arrangement that will last to the end of his life. Donates works to Spanish Refugee Aid. Marries Renate Ponsold in 1972 in Wellfleet,

Massachusetts. Installs an etching press in his Greenwich studio in 1973; will do his lithographs with Ken Tyler of Tyler Graphics.

1974–1981

Undergoes major surgery for his heart; in the next few years he will be hospitalized for surgery a number of times. Contributes to the Chile Emergency Exhibition. Videotaped in 1975 for the Albright-Knox Gallery in Buffalo and conducts a filmed interview with Robert Hughes for the BBC in 1976. Is the subject in 1977–1978 of a documentary for French National Television called "L'Atelier de Robert Motherwell," which was filmed during his retrospective in Paris and ends in his studio in Greenwich. Another documentary is commissioned for public television in 1979, in conjunction with the installation of his mural in the East Building of the National Gallery of Art, Washington, D.C. A documentary is made for CBS on his retrospective exhibition in Madrid in 1980; during this exhibition the poet Rafael Alberti recites his poem celebrating Motherwell's use of black, "El negro motherwell."

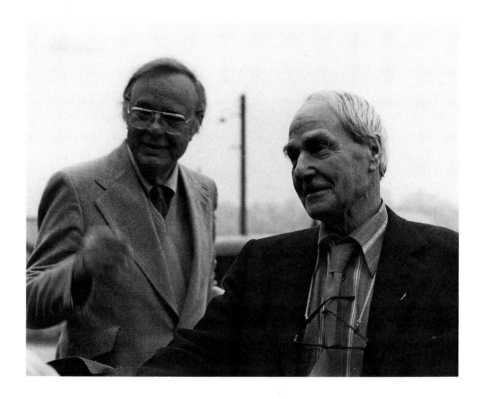

Robert Motherwell and Henry Moore.
Photograph courtesy of Renate Ponsold Motherwell

1982–1990

The Bavarian State Museum of Modern Art inaugurates a room devoted to major Motherwell works. He is interviewed for Canadian radio by Robert Enright, whose second interview for his journal *Border Crossings* is undertaken five years later in Provincetown. Renate Ponsold presents him in 1985 with a collection of writings for his seventieth birthday, with contributions by forty of his friends in the world of art and letters. Already a member of the American Academy of Arts and Sciences, he is inducted into the American Academy of Arts and Letters in 1987 and is the recipient of a Presidential Award in 1989. [Among his other awards: the Guggenheim International Award in 1964; the Spirit of Achievement from Yeshiva University in 1970; La Grande Médaille de Vermeil de la Ville de Paris in 1977; the Pennsylvania Academy of Fine Arts Gold Medal of Honor in 1979; the New York National Arts Club Gold Medal of Honor in 1983; the Great Artist Series Award from New York University and the Guggenheim Museum in 1985; the Medalla d'Oro de Bellas Artes in Spain in 1986; the National Medal of Arts in 1990.] In 1990 he is briefly hospitalized in Greenwich Hospital for a week after a mild stroke, but recovers and paints until the end of his life. In 1991 the documentary of American Masters "Robert Motherwell and His Contemporaries" is completed; a film prepared since 1987 with Catherine Tatge appears on public television.

JULY 16, 1991

Motherwell dies in Provincetown. A memorial service is held on the beach in front of his studio, and later, in November, another is held at the Metropolitan Museum of Art.

ROBERT MOTHERWELL

Thoughts and Themes

Don't try to be anyone else.
Henry James, *The Ambassadors*

He who has never failed somewhere, that man cannot be great.
Failure is the true test of greatness. . . . And if it be said, that
continual success is a proof that a man wisely knows his powers,—
it is only to be added, that, in that case, he knows them to be small.
Let us believe it, then, once for all, that there is no hope for us in
these smooth pleasing writers that know their powers.
Herman Melville, *Moby Dick*

America from Here

The work of Robert Motherwell contains, first of all, in spite of its clear connections with European culture, something very American. Americanness often seems to be the conscious preservation of a sturdy personal and stylistic eccentricity. In joyful opposition to the smooth and the pleasing, the American spirit maintains a willingness to try things out, maybe to get them wrong, and then to start over. Originality, says Melville, is to be fostered at all costs and in whatever unbeautiful guise, "crabbed and ugly as our own pine knots." Unlike the expected, whether glorious or inglorious, it exalts the forces of life and art against the flattening impulse of any imitation. In both life and art, the smooth is seldom the forceful.

American style is personal, says Alfred Kazin in *An American Procession.* American criticism, like the superbly unimitative and inimitable writing of Marianne Moore or William Carlos Williams, has the courage to prefer the irregular to the smoothly ironed out. It is just this unevenness that Moore salutes in Williams's works, giving as an example his poem "To Wish Courage to Myself." She admires his hardiness in invoking his *own* spirit through such a text. This courage is part of

the pioneering spirit that, she says, we all "wish" to ourselves. She insists on the Americanness of Henry James, whose motto she quotes (from Gloriani, in *The Ambassadors*[1]) and who defines the American as "'intrinsically and actively ample . . . reaching westward, southward, anywhere, everywhere,' with a mind 'incapable of the shut door in any direction.'"[2]

Courage and bravado are part of the American temperament at its most open-spirited. The American philosopher Stanley Cavell quotes Emerson about our being responsible "for finding the journey's end in every step of the road," in our own gait. Painting was always for Motherwell, who certainly had his own gait, at once a way of knowing himself and the world outside.[3] It is, finally, with Emerson's "becoming of the soul" that the epic gestures of art are bound to deal.[4] Cavell talks of the author and the reader as "congeners" bringing each other into existence. However ungraceful the term is, the notion has power to it, "to place this search (for the world I think) as something like a moral constraint."

Motherwell's work as process and presence, as journey, becoming, and amplitude, implies a constant eagerness to start over. Writing this study, with its deliberate windings back to the beginning, its spiraling around a few central images, I have borne all this in mind, hoping that its own impassioned form will be taken as the kind of tribute that Motherwell's radically nonlinear work calls for. It is in any case the sort that his thinking responded to.

Repetitions, Series, and Risks

Repeating then is in every one, in every one their being and their feeling and their way of realizing everything and every one comes out of them in repeating. . . . Slowly every one in continuous repeating, to their minutest variation, comes to be clearer to some one.

Gertrude Stein, *The Gradual Making of the Making of Americans*

What is to be done about space and time as Stein sees them is something strictly American: "To conceive a space that is filled with moving, a space of time that is filled always filled with moving and my first real effort to express this thing which is an American thing began in writing *The Making of Americans*."[5]

I would like to claim, for Robert Motherwell, that what informs his deeply American art partakes of precisely the kind of motion Stein describes. His works in series—his return to the notion and the practice of the *Elegy* and the *Opens*, to the *Lyric Suite* and the related works of *Beside the Sea*, to the emotionally charged *A la pintura*, *Black Rumble*, and *Night Music* titles—is as essentially concerned with the repetitions of living as with the dying that is necessarily part of the cycle. Already the *Elegies* speak of his "private insistence that a terrible thing happened that should not be forgot," where the stress on *forgot*, instead of the more obvious *forgotten*, gives the expression a feeling of great and historic seriousness, as in the

biblical "Lest we forget." That it should have been the dark *Elegies* whose initial creation preceded the largely bright-colored *Opens* is remarkable; then the *Night Music* series, which follows the *Opens,* returns to the dark. Needless to say, the works overlap each other. Later, the *Opens,* with their continual rebeginning, form the other pole within the series structure. These two opposites, of *Elegy* and *Open,* are reflections on the nature of the series itself, always living and becoming, yet always already about to end.

Consistently, in conversations and writings—as in his visual work—Motherwell concentrated on the risk entailed by the kind of ethical choice that had to be made. "All our choices express us," he once said.[6] He meant it. Painting is a cognitive act. Through the gesture of art and "through the act of painting I'm going to find out exactly how I feel," he says.[7] An artist's art "is nothing other than his conscience, slowly and painfully formed, through the numerous errors committed along the way."[8] To choose means, among other things, to preserve as well as art can the epiphanic moments of everyday living—witness, for example, the *Je t'aime* series—along with those majestic and mourning-filled moments. "Stay," Virginia Woolf repeats after Goethe, to the moment, "You are so fair." The moment will not, the artist cannot, nor can we. But the work of art remains, consecrating the choice it memorializes.

Motherwell often meditates on the risks of serial repetition. His meditation is inspired in part by Kierkegaard's *Repetition,* a remarkable and magnificently complicated work on the subject of obsession and self-repeating from the man who was perhaps Motherwell's greatest philosophical hero, to whom he will pay homage with his brooding and massive painting *Either/Or.* Perfectly aware of the dangers of serial self-repetition, which entail the lessening of possible public or private interest and effect, Motherwell still believed in the extraordinary values of accumulation and insistence. All his series demonstrate this, from the *Elegies* to the *Beside the Sea* works, from the experiment of the *Lyric Suite* on to the *Opens.*

We have only to look at the force of one of the *Opens,* entitled *The August Sun and Shadow* (1972), to feel the complexity of observation the painter requires of himself and the viewer. Done between the dates of August 10 and August 28, this painting uses the colors of the cave—that basic and immemorial dramatic mixture of ochre, white, and black, already calling on a vast temporal and imaginative span from ancient to modern; we recognize these shifts of sun and shade or, then, life and the central dark rectangle of death bordered in white on the background of ochre. Mediating between the black expanse and the white surround is a thin black border, ending almost at the top of the left side, stopping two-thirds of the way up the right side, like a lifeline cut short. The feeling is powerful: the eye, seized by the difference in length, is troubled. The painting arrests the viewer with its own arrest. In its forced irregularity you feel it is taking, and asking you to take, some sort of risk.

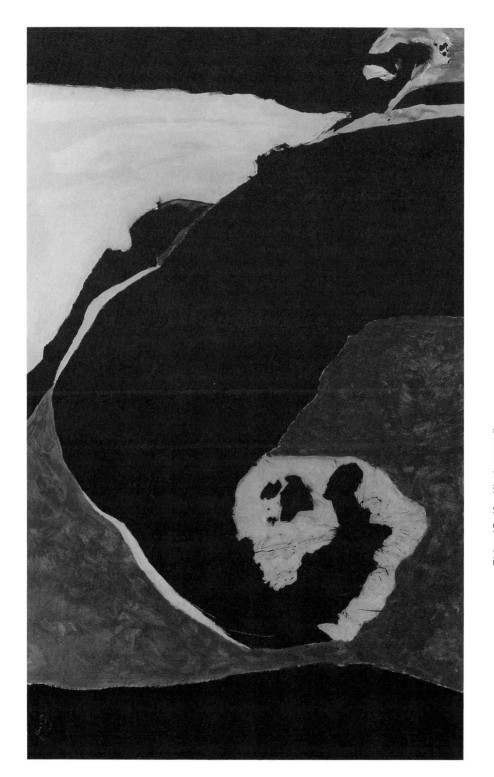

Either/Or (for Kierkegaard), 1990–1991.
Acrylic on canvas, 60 in. × 96 in.
Courtesy Knoedler and Company, New York

Motherwell continues to insist: "The art risks are psychological and spiritual,"[9] and we have to take them, if art is to convince. From the open idea of collage and the impermanent made permanent, he will extend himself to the repetitive idea of series, whether the closed *Elegies* of regret or the explorative works that begin in 1947, as in the one-issue journal *possibilities* he associated himself with in the forties. The idea of series is itself both closed (the same subject or/and form) and open (it can continue). Like his favorite image of the *porte-fenêtre*, or door-window, it opens on a world both limited and sacral, out to a certain moment of space-time and inside to a mental creation. Motherwell's more gigantic paintings have as their ground, like the *Opens*, a wall; at the same time they are always closed and yet contain the possibility of opening onto something else.

Motherwell would generally think of his close-ups in human terms, as opposed to his distant shots: "My personal abstraction is, in terms of the senses, relatively imbued with warmth."[10] Like love, painting is an active enterprise, a continual creation, and not a talent simply bestowed by some deity. Motherwell's relation to his work was intimate, like his relation to whatever author he was reading. He used to say he would always prefer to read forty books by one author rather than forty works by forty authors, being a "person-to-person reader." His painting is intended to strike to the heart, one to one. When he spoke with you or looked at paintings with you, he would remark how the current was passing "from heart to heart with no interruptions."

Such "precision of feeling"—to use Marianne Moore's expression—is exact, repeatable, vitally measured and measurable.

> For obviously part of what painting is universally, to the degree that it is art, the condensing of quantity, into quality. Nothing else is precise enough to weigh this process of the human sensibility, so far more subtle is the accuracy of human feeling.[11]

Successive works in a series show an intense consciousness of concern; it all goes back to those words *conscience* and *consciousness*, about which Motherwell and Breton had their celebrated argument so very long ago, Breton claiming their distinction not to be a great one, and Motherwell speaking for the vast difference.[12] To demonstrate his own belief that art is nothing other than the conscience of the artist, Motherwell quotes Picasso, for whom what we love and admire in the work of someone is not his talent but rather his anxiety:

> It is not what the artist *does* that counts, but what he *is:* Cézanne never would have interested me a bit if he had lived and thought [like an academic painter], even if the apple that he painted had been ten times as beautiful. What forces our interest is Cézanne's anxiety—that's Cézanne's lesson. The torments of Van Gogh—that is the actual drama of the man.[13]

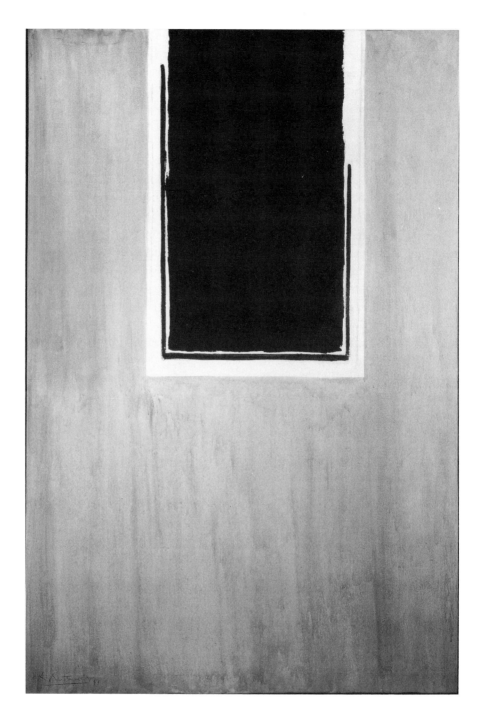

The August Sun and Shadow, 1972.
Acrylic on canvas, 71.75 in. × 47.75 in.

Courtesy Knoedler and Company, New York

Work in series is anxious, choosing to repeat over and over, with slight differences, what it wants to say and show and relive—at once nostalgic, tragic, elegiac, and vital. It does not narrate toward the end of something, in a teleological determination, but rather toward the recycling and re-making possible of something once living and always relivable in its working out.

Ernst Cassirer's theory of and writing on *Symbolic Form* had a great effect on Motherwell's thinking. This was the way one could combine implicit reference and partial abstraction, relation and freedom from the too-specific, metonymy and meaning. Without the symbolists and postsymbolists of the nineteenth and twentieth centuries, Robert Motherwell's work would be in no way what it is. I believe that a large part of the intense emotional strength of his best canvasses and collages is related to his wide experience, reading, and sensing of the symbolist aesthetic. Here most truly is the source of that "joy and radiance" he misses in realism and social realism (he adduces Wyeth and Shahn as examples).[14]

This is in no way to deny the anguish that gave its most profound meaning to much of his work: say, the Kierkegaard canvas *Either/Or,* or the brooding effort of *Africa,* the Iberian black and yellows, or the *Elegies,* with their depth drawing on both Gerard Manley Hopkins's despairing Sonnets of Desolation and the "Llanto por Ignazio Sánchez Mejías" of García Lorca. It *is* to say, and at the outset of this study, which aims at putting together the literary and visual sensitivity that so mattered for him, how massively important Motherwell's knowledge of literary movements was to his entire being and creation.

I shall be speaking of many poets and writers from a number of lands, to all of whom Motherwell felt himself explicitly or implicitly connected: Baudelaire, Mallarmé, and Hopkins; Kierkegaard, Joyce, and Beckett; Lorca, Stevens, Frost, Eliot, and Alberti. His reading was wide-ranging, as our response must be.

Mallarmé and His Swan, 1944

Le vierge, le vivace et le bel aujourd'hui.
[The virginal, lively and lovely today.] Stéphane Mallarmé

A great deal still remains unspoken and only suggested in this essential early work, *Mallarmé's Swan,* as in the work of its namesake, the symbolist poet Stéphane Mallarmé. Emblematic of initial constraint and final freedom, in its central images of imprisonment, imprinting, and setting sail, it combines many techniques. First, the automatic beginning in the lower center of the collage, where paint was poured on the surface and allowed to run on a vertical piece of pink paper. Then the reaction of forms to accidents: the yellow stripes responding to the yellow spatters of paint in the center, and the oval shape on the upper left in echo to the paint spills

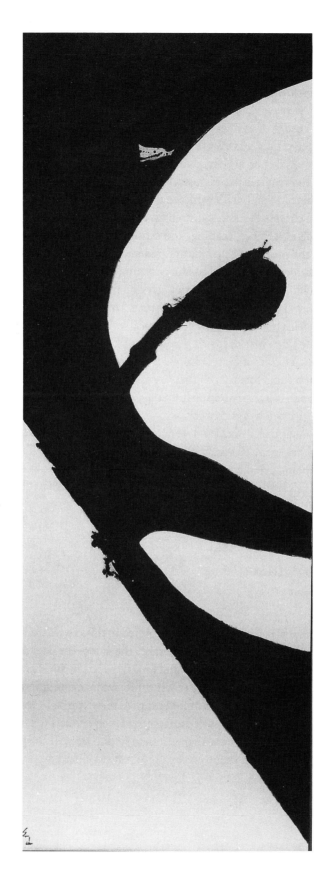

Africa, 1965.

Acrylic on Belgian linen, 81 in. × 222.5 in. (206 cm × 565.4 cm.).

The Baltimore Museum of Art: Gift of the Artist. BMA 1965.12

below. Also the bending of one shape against another: the beige stripe responding to the pressure of the oval pushing against it, as the oval shapes in the *Elegies* will press against each other in the mind and on the canvas.[15] These techniques, left visible here, are essential to the process of painting as Motherwell conceives it at this time. The response of forms to each other, the automatic doodling or gesture that begins the work, the passage of pressure from one element to another—all these will continue, stronger still in his later work.

At the bottom of the great space of vertical stripes, Motherwell's *Mallarmé's Swan* is black and reflected red, is red and reflected black, combining in its body and in its backdrop the implicit white and the explicit red and black that are the great baroque colors, set beneath the sail shape at the top of the canvas. This particular painting exercises a strange power. The sail sets free both artist and observer, and yet retains them by that blot symmetric and haunting, by the pink, black, and yellow colors in their singular relation, and above all, by the stripes remembered from *The Little Spanish Prison*. The stripes in turn remember Mondrian,[16] the short red horizontal stripe struggling against the "pale, bar-like vertical field of yellow and white."[17] The very containment of Mallarmé's poem, and Motherwell's work based on it, can become by reverse reading a vow toward motion. That sail might fill for a victorious departure someday, gathering wind from all the strength of the flights as yet unflown.[18]

Emblematic of symbolism and celebrating its chief poet, *Mallarmé's Swan* is no less representative of Motherwell's own poetic credo. What sets sail here is a lifetime of work impassioned and haunted, of reading symbols and symbolists equally haunted, from Baudelaire to Stevens, Eliot, Lorca, and Alberti. These will form the background for the first part of this study, as they did for much of Motherwell's conscious concern. Motherwell says of this collage:

> This work was first titled *Mallarmé's Dream*. Joseph Cornell, with whom I shared in those days a lonely preoccupation among American painters with French Symbolism, misremembered the title as *Mallarmé's Swan*, which along with white or blankness was the symbol for Mallarmé of purity. I preferred Cornell's misremembrance, and the picture has been so named ever since.[19]

Here Motherwell displays a generosity typical of his own openness. He lets others name: his dreams, his swans, and those of the poets to whom he is close. I find this act of collaborative renaming particularly moving. Unlike the dream, the swan has nothing to do behind, or with, closed doors. The lake of ice, the prison of the page or the canvas against which the great poet's bird can always be seen to struggle, is tipped on end here, nevertheless resounding in possibilities. The silent sail included in this statement composes the prelude for the later canvas of *The*

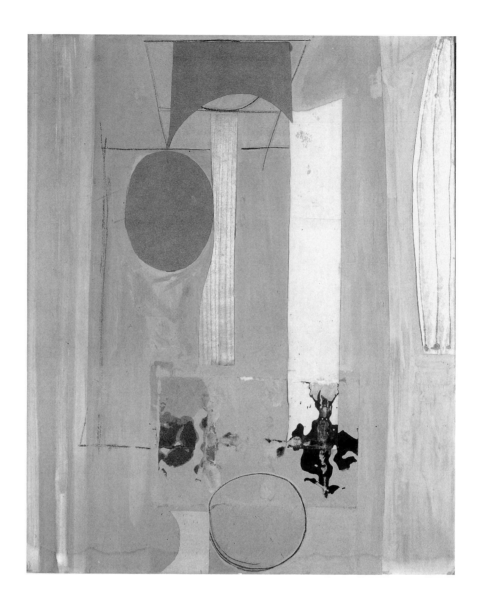

Mallarmé's Swan, 1944.

Gouache, crayon, and paper on cardboard, 110.5 cm × 90.2 cm.

The Little Spanish Prison, 1941–1944.

Oil on canvas, 27.25 in. × 17.125 in.

© 1995 The Museum of Modern Art, New York. Gift of Renate Ponsold Motherwell
{see color plate}

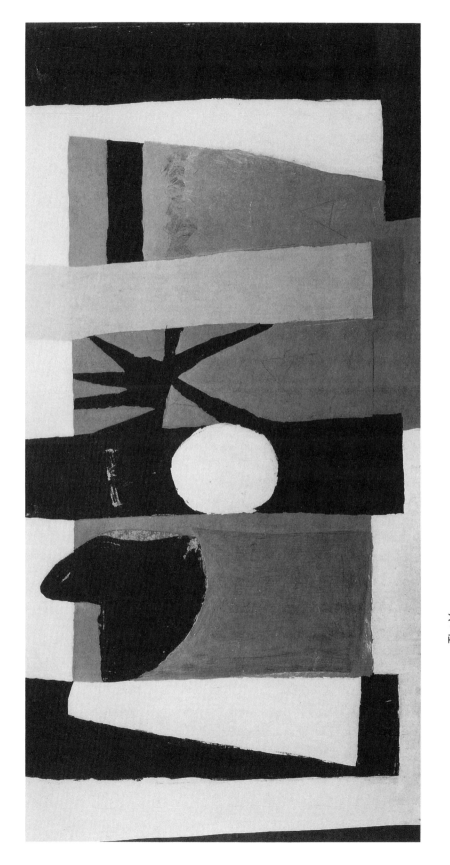

The Voyage. 1949.
Oil and tempera on paper mounted on composition board,
48 in. × 7 ft. 10 in.

© 1995 The Museum of Modern Art, New York. Gift of Mrs. John D. Rockefeller III

Voyage, which relates both to Baudelaire's celebrated poem "Le Voyage" and to this implicit Mallarmean journey.

But the most essential point is that this work is the conceptual ancestor of the upended rectangle of the continuously *Open* series, where it is the expression of potential possibility, moral as it is physical. The swan will be taking off any time now.

As early as January 1944 Motherwell was insisting on the nonmimetic, calling the way in which many painters reject the external world an "extraordinary phenomenon."[20] He ascribes to Piet Mondrian's *Compositions* a particular power of making the observer aware of how the objects of that world are not present—it is clear how Mallarmé's project hangs over these statements, how his "flower absent from all bouquets" gives its peculiar fragrance to Motherwell's reading of the Dutch painter. "The problem," he says in the same essay, "is more nearly how not to lessen the original virginal loveliness of the canvas." How could we not hear under this writing the celebrated lines he loved to quote, about Mallarmé's swan trapped in the ice, like the artist about to break the vast expanse of whiteness or the hesitation of the symbolist writer before the "sheet that whiteness defends"?

Like Mondrian, Motherwell was, as he liked to say, essentially concerned with *relations.* These haunting themes stand in poetic relation to two poems by the great American Wallace Stevens: first, the celebrated "The Snow Man," and second, a poem Motherwell himself quotes, "The Poems of Our Climate." Stevens was a poet with whom the French artists who had come over to the United States could identify. The first issue of *View,* in September 1940, carried some of Stevens's maxims; like the French, he believed in the natural closeness of art and poetry. Both of these disciplines determine the meaning, value, and implication of the expanse of white, large or small, that the artist or poet must begin by contemplating, as if it were the canvas or the page.

"The Snow Man" is concerned with the senses as they confront the wintry landscape glittering in the wind and, more crucially still, with the nothingness it implies, contains, and reflects back to the human consciousness. This existential anguish under a snowy sky, with its intensity quickened by the bareness of the place, is the exact counterpart, even if at the other pole of color and season (white to black, winter to fall), of the poem "Domination of Black." "The Snow Man" depicts the central nothingness as something positive, absence as something remarkably present, a whole state of mind as at once satisfactorily and disturbingly complex:

> One must have a mind of winter
> To regard the frost and the boughs
> Of the pine-trees crusted with snow;

And have been cold a long time
To behold the junipers shagged with ice,
The spruces rough in the distant glitter

Of the January sun; and not to think
Of any misery in the sound of the wind,
In the sound of a few leaves,

Which is the sound of the land
Full of the same wind
That is blowing in the same bare place

For the listener, who listens in the snow,
And, nothing himself, beholds
Nothing that is not there and the nothing that is.[21]

To enable one to grasp the feeling of some of Motherwell's works, this poem is particularly important in its stress on the ideas of gaze and looking ("regard," "behold . . . beholds") as compared to hearing ("sound, sound, sound, sound," "listens"). It is as sensual as it is metaphysical, a full poem about nothing and absence, but also about existence.

The second poem of concern to us is "The Poems of Our Climate,"[22] where whiteness is identified with impersonal simplicity, against the complex selfhood and too-muchness of the intensely alive being. In this poem the senses are invoked with the same intense dynamic as in "The Snow Man," although the outer winter landscape has been transferred to the interior. The structure of in and out will mark much of Motherwell's meditation on the *porte-fenêtre,* or door-window, like Matisse's *Porte-Fenêtre à Collioure:* this is the major architectural element of the *Open* series. Often in Stevens's poetry, what is outside, like the trees, is brought into a domestic consciousness, to be absorbed in the peace of the still life, illusory or not. Such a long single sentence, initiated by the command to speech "Say," places the poem "The Poems of Our Climate" in the realm of outright discourse, with the problematics of simple and complex laid out with formal clarity:

Say even that this complete simplicity
Stripped one of all one's torments, concealed
The evilly compounded, vital I
And made it fresh in a world of white,
A world of clear water, brilliant-edged,
Still one would want more, one would need more,
More than a world of white and snowy scents.

Robert Motherwell managed to live in a world as complex as that of the great symbolists. He had the imagination for it, the talent for accommodating himself

and his works to it, and the ambition to share both the imagination and the world it was responding to with the audience reading his words and those of the authors and artists he was publishing—for Motherwell was always aware of multiple possibilities. In his Statement and Introduction to the Illustrations of the First Series in *Modern Artists in America,* he quotes Stevens on the subject of what is new around us:

> It is one of the peculiarities of the imagination that it is always at the end of an era. What happens is that it is always attaching itself to a new reality, and adhering to it. It is not that there is a new imagination but that there is a new reality.[23]

Yes, but this new reality was in fact already sensed by the nineteenth-century symbolists, to whom Stevens, as Motherwell reads him, is strongly attached.

In a lecture for the College Art Association in October 1950 entitled "The New York School," Motherwell makes it very clear that this group, as well as other modernists, has "as its background of thought those fragments of theory, which, taken as a whole, we call the symbolist aesthetic in French poetry."[24] Stevens is certainly one of the greatest modern-day symbolists; the atmosphere of this poetry as well as its essential conviction permeates much of Motherwell's work. One of the "Don't Forget" signs posted on his studio wall reminded him always of the supreme French thinker Valéry, that quintessential predecessor of Stevens and admirer of Leonardo, both of whom Motherwell admired greatly. He was never to forget Valéry as the author of the vastly complicated "Method of Leonardo." Motherwell liked methods of intelligent complication, particularly when he could connect them to the emotions. Any dry-as-dust intelligence was the opposite of his own.

So he emphasizes, even in connection with Valéry, how "intensely emotional," rather than intellectual, the New York School is and then adds what turns out to be an extremely useful definition of this painting's tendency to use bodily gesture for the sharpening of consciousness.[25] This is a typical Motherwell move. He is associating emotion and intensity with consciousness, positing the latter as the highest good, in the way Valéry never ceased doing. That the New York School of painting pushed its activity in this direction is beyond doubt—what is more interesting here is the way that Motherwell uses his wide reading to explain what was perhaps more of an intuitive act for the other painters.

In any case, Stevens and Valéry form the backdrop against which Motherwell's Mallarmé work must be read, as an act of symbolist homage. Valéry speaks, in his greatest creation, "The Graveyard by the Sea," of something akin to Stevens's "evilly compounded, vital I," which the universe had somehow to swallow as a default in its simple purity ("I am the secret fault of your diamond," says the human to

the world of which we are so small a part). The fault is, like the grain of the sand in the pearl, quintessentially what makes us, and art.

The symbolist clings to the fault, as to the idea. Symbolism is not sublimism. As is clear in Motherwell's essay "A Tour of the Sublime" (1948) (originally entitled "Against the Sublime"), the value he attaches to the personal, to the irregularities of human emotion against the noble overarching impersonal Idea, is what will carry him beyond movements with capital letters; all of us, he says, in this article and elsewhere, must reject the idea of the Sublime in its social or institutional authority. Reflecting on that idea, he starts, characteristically, with a "perhaps"— the very mode of "perhaps" is what would save his project from sublimity.

> Perhaps—I say perhaps because I do not know how to reflect, except by opening my mind like a glass-bottomed boat so that I can watch what is swimming below—painting becomes Sublime when the artist transcends his personal anguish, when he projects in the midst of a shrieking world an expression of living and its end that is silent and ordered. That is opposed to expressionism.[26]

With the acuity characteristic of his literary perception, he reviews Homeric tradition in the light of the early Sublime. Here, as elsewhere in his literary discussions, the elegance of the style is noteworthy—in Motherwell's writing, unlike his canvasses, there are not the irregularities, the drips and splashes that mark the process as ongoing. Yet the feeling is of a thought in progress:

> When living Ulysses meets in Hades the shade of Ajax, from whom he had won the armor and set on the course that led to Ajax's death, Ulysses expresses his regret; but Ajax "did not answer, but went his way on into Erebus with the other wraiths of those dead and gone." One has not the right from one's anguish to bring to the surface another's anguish. This must be the meaning of the first century A.D. treatise on the Sublime when it says: "The silence of Ajax in *The Wraiths* is inexpressibly great." Otherwise it can only mean how terrible is being dead.[27]

There will predominate in the artist's discussions the moral concern visible here—not to arouse another's anguish by your own. We can read through this to his own pain over the increasing strain with María, his Mexican wife, and yet the discretion inherent in his treatment of Ajax, and of his own troubles, prevents our dwelling on it. The point would be to go beyond and yet keep your pain, claiming and ordering your individual anguish, without either transcending it completely for the impersonal Sublime or sinking into it. The latter would be equivalent to expressionism without the abstract part that finally becomes essential to Mother-

Robert Motherwell reading in a café.

Photograph courtesy of Renate Ponsold Motherwell

well's attitude. One solution is to vector the emotions and their expression toward a loosely conceived symbolism. Motherwell said repeatedly of himself that he was a symbolist; judging from the writers who so strongly influenced him, and from his reaction to them, especially to Mallarmé, the greatest symbolist of them all, what he said was both explicitly and implicitly true.

In a letter of November 1956, Motherwell makes very clear his attachment to things French: "I have a relentless prejudice," he says, "that modern European artists of the first line have been fed on modern French poetry as Spirit, and the Mediterranean as the Medium. . . . All ancient and prehistoric art is 'Mediterranean.'"[28] Even when we have made the link, for our own understanding, between

Motherwell the Francophile and Motherwell the strongly American artist and thinker, we may have in our minds a second question about symbolism and romanticism. Here I am stressing his closeness to the French symbolists, as he always did in his conversations with me. If we were discussing Joseph Cornell, for example, he would make very clear that whereas Cornell was a romantic, he, Motherwell, was a symbolist. Yet the question remains. If Motherwell was finally so close to the symbolists, he was certainly once a romantic: as he says of the thirties, "We were all romantics then."

In a sense, of course, he moved from a romantic hope of action in relation to society, held just at the outset of his relation to surrealism, to a more symbolist framework and attitude. But in any case, he retained both tendencies, just as he did with his impulses toward both America and France, toward Western and Eastern modes of thinking. He was European in nature and in culture, with a European sensibility. He was American in his belief in openness and possibilities. Why limit oneself? The spiritually responsible artist will always push against simplistic categories.

There is not only a precedent for this, but exactly the precedent Motherwell would have clung to, and in fact did. The surrealists, whom he knew for a time so well, about whom he spoke so eloquently, were themselves part romantic and part symbolist.[29] Surrealism claimed itself, in the voice of Breton, as "the tail of romanticism, but how prehensile!" And surrealism underlies this developed art of the spontaneous beginning stroke, on which subject Motherwell waxes so eloquent and never wanes. He had originally wanted to call what became abstract expressionism "abstract surrealism," giving credit to that spontaneity he cared about, as the only path to what David Smith had called "a certain primitive directness in art."[30]

Je t'aime. Robert Motherwell paints the French words on his canvas, and says, in 1956:

> For the last two years I have been making a series of paintings with *"je t'aime"* written across them in calligraphy of the painting, sometimes tenderly, sometimes in a shriek.—I never thought much about it, but I am sure in part it is some kind of emphasis or *existing in* what is thought.[31]

In some of the series the statement reads in Spanish instead of French—Mexico having had an impact on his painting and life in a different but equal way with France—so that, scrawled across the top of the painting or at the side, we see *te quiero.* Now it would never have occurred to Motherwell, says the philosopher and art critic Arthur Danto, to write there "I love you." His values were European, and his language. This made him a perfect translator of the European surrealists to America; since they were not that interested in having America translated to them, the weight given to each side did not have to be negotiated.

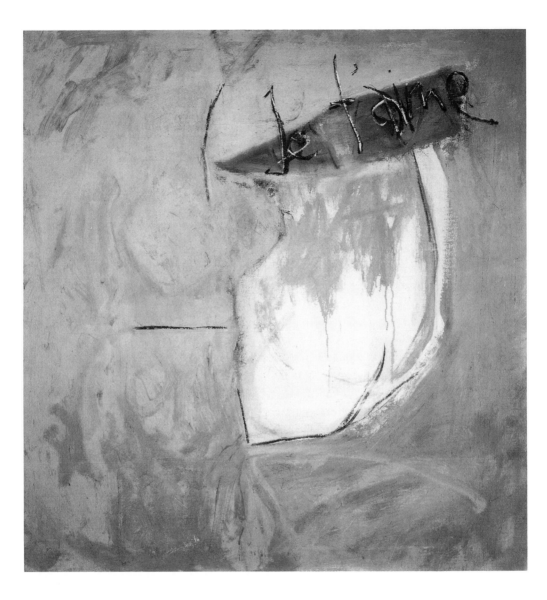

Je t'aime VIII (Mallarmé's Swan: Homage), 1957.
Oil on canvas, 42 in. × 40 in. (107 cm × 102 cm).

Private collection. Photo credit: Steven Sloman. © 1994 Dedalus Foundation, Inc.
{see color plate}

I don't paint things. I paint the relations between things.

Henri Matisse

The internal relations of the medium lead to so many possibilities that it is hard to see how anyone intelligent and persistent enough can fail to find his own style.

Robert Motherwell

What I want to deal with here is first of all how Motherwell spoke of the surrealists and surrealism in my long interviews with him on the subject, some of which are transcribed at the end of this study. His own relation to the telling of that tale fascinates me for the following reason. When Motherwell spoke or wrote of Mondrian, for example, and of the objective nature of his working out of color relations or his demonstration of "what lies in a certain direction," he would call it scientific. But then he never failed to point out in what sense Mondrian's demonstration seemed to him a failure, offering a *clinical* art when people were longing for the human, for felt expression. Mondrian failed, said Motherwell, with his "restricted means, to express enough of the felt quality to deeply interest us . . . to determine a complete mental-feeling state in the observer." Now Motherwell's discussion of his own relation to surrealism is exactly the opposite of clinical, objective, and unfelt. It is one among several experiences that deeply marked him, by forcing him to differentiate himself from something he cared about, realizing exactly what it was within the movement that mattered to him personally, as well as to the public. *That* he wanted to keep—the rest he could leave.

I have also wanted both to take account of the fact that a few years have gone by now since the times of our long talks in Greenwich and Provincetown and to gain some distance from his spoken words. I want to compare them with what he said of surrealism in his writings and in speaking with others, reflecting on the importance of this relation between two great entities: French surrealism and its New York experience on one hand, and on the other the work of the abstract expressionists, in particular his own. Motherwell acted often as a translator of the surrealists to America, of America to them: sometimes on such burning questions as what you drink with hamburgers and where to get good olive oil, but sometimes on more major points, such as those concerning language itself. This experience of translation turned out to be crucial, even to have a case of conscience connected with it, whose importance I will try to explain.

As for the experience of the surrealists in New York, we have multiple witnesses, some reliable.[32] Two points are of interest to me here, and they both concern language. As one of Breton's translators, I am especially impassioned by such problems as those I heard of and read of repeatedly. The first is general: Breton and

the others made no effort to learn English, and in fact took and kept their distance from the Anglophones. I knew this, but it made absolutely no impression on me until Charles Henri Ford, who had been the editor of *View* and had worked with Breton—and whom I was interviewing because of his connection with Joseph Cornell[33]—said it point-blank. They didn't know English, they didn't care to learn English, and this kept the surrealists definitely separate. Thus originated some of the problems with *VVV*, even over its title. I quote Motherwell, who was very droll on this and many subjects:

> They wanted a new letter, a triple VVV, and I kept explaining that in French it makes perfect sense: "double-V" [the sound of W in French as well as its look, like 2 V's], "triple-V," but in English you can say, "double-U," you can't say, "triple-U."

In 1947 Motherwell made a vibrant collage called *Viva* (Long Live!), where the word is painted in very large letters running up the right side in deep green against red and white lettering in the background. On the left side, there are 3 W's (WWW) atop each other, or 6 V's, in two adjacent piles—making both the V of *Viva* and the journal *VVV*. The W shapes stand out in light green, red, and darker green against a black background. These are like mountains upended, for read upside down, the WWW gives the dramatic verticality of the M for Motherwell in three versions; Motherwell often called on the dramatic and mountainous effect of the M in his own signature. Thus, the artist signed himself and the journal at once. The memory of the surrealist collaboration is not lost but rather subsumed under the double sign of both the V and the W that Motherwell had wanted to use in the first place. He arranged to have it all and mark it as his own.

His adventure with the surrealists in New York is best savored in his recounting. Let me quote him at this point, in a first conversation with me in 1990 about surrealism:

> It was an extraordinary experience, but it was not a big help for me in some ways, because I had negative feeling about a lot of it. I guess I thought they weren't painterly enough. The painters were definitely secondary to the writers. The unexpressed opinion was the writers were good, and the painters existed primarily to illustrate the writers' ideas. Of course that was partly the problem with surrealism in America, because surrealism was identified partly with Dali and several others, and because all the writing was in French, so that . . .

Now he didn't fill in the rest, but I got the picture, and you get it too. He went on, after pausing:

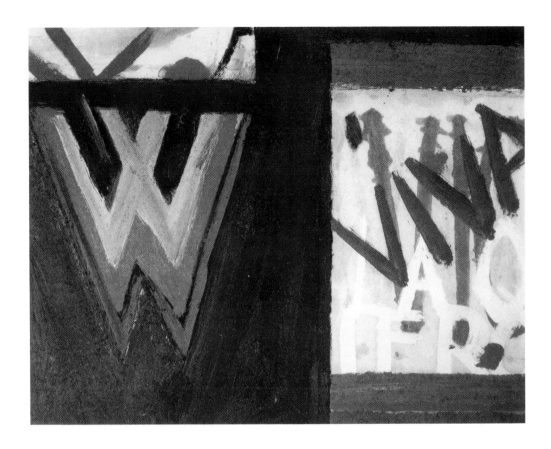

Viva, 1947.
Collage of oil, gouache, sand, and paper on board, 15 in. × 20 in.
(38.10 cm × 50.80 cm).

Private collection, Germany. Photo credit: Steven Sloman. © 1994 Dedalus Foundation, Inc. {see color plate}

I remember one of the crises. They were worried about being exiles, and all the rest of it. Breton was offered a position to be regularly on the Voice of America, to broadcast to Europe in French, and was this giving in to capitalism and imperialism, and so on. That kind of issue, and there were a couple of months of—I am sure on his part—tormented decisions, and so on. Whereas painters are much more peasants, one thing at a time. You know, what is the practical solution.

MMM. Robert Motherwell at table.

Photograph courtesy of Renate Ponsold Motherwell

Now we get to the particulars: Breton needed Motherwell to translate an article of his into English, and the sticking point was one word, quite a word at that.

> He wanted a column in a magazine, called "The Conscience of Surrealism," and I asked if he meant *consciousness* or *conscience,* and he couldn't get the distinction with *conscience.* He made it all quite ambiguous.

So much for language: it got everyone into trouble. This is the point that David Hare brings up in his tales of Motherwell and the surrealists, and the point that is generally alleged to have signaled the end of Breton's and Motherwell's relationship. But understandably Motherwell had always felt more of an affinity with the painters in the group, and Matta in particular, pointing out in another 1990 interview with me that he "was brilliant in his way, and generous, and my age. The surrealists in general were a generation older."

It was Matta who had influenced him with the torn shapes of his drawings, where the morphological forms are more clearly defined than in his paintings, and Matta who had suggested he continue with the medium of collage. In a world torn asunder, with no central certainty to relate to, the chaos of the collage with its ambiguous title *La Joie de vivre,* which can be read ironically or not, makes a recall of Matisse's *Le Bonheur de vivre,* at once tribute, for the bright chaos of the whole, and irony, for the black shapes on the ceiling speak loudly of a sort of disaster. Repeatedly he would mention his lifelong obsession with death. When he was making his *Pancho Villa, Dead and Alive,*[34] with its division down the middle and its blood splatters, while the stick figures in Picasso's *Studio* were one of the sources, another was Matisse's *Bathers by a Stream,* hanging in the Pierre Matisse Gallery at that time.

From Matta he took the idea that forms could be torn, like wounds in the picture—again like the moral statements art could make, must make. Most important of all, it was from Matta that he learned about the automatic beginning of the painting gesture, what became the Motherwell "doodle" or spontaneous scribble at the origin of many of his works. It is what starts you into your spontaneous creation; it is at the source of enthusiasm. It is far from trivial.

Motherwell explains, in 1960, the advantage of making a mark on the too-clean canvas, anguishing to the point of aesthetic paralysis, like the white page that Mallarmé dwelled on, feared, and made a symbol of cosmic panic for the artist:

> In my case, I find a blank canvas so beautiful that to work immediately, in relation to how beautiful the canvas is as such, is inhibiting and, for me, demands *too much too quickly;* so that my tendency is to get the canvas "dirty," so to speak, in one way or another, and then, so to speak, "work in reverse," and try to bring it back to an equivalent of the original clarity and perfection of the canvas that one began on.[35]

La Joie de vivre, 1943.

Mixed media, collage on cardboard, 1105 mm × 84 mm.

The Baltimore Museum of Art, Baltimore, Maryland: Bequest of Saidie A. May, BMA 1951.344 {see color plate}

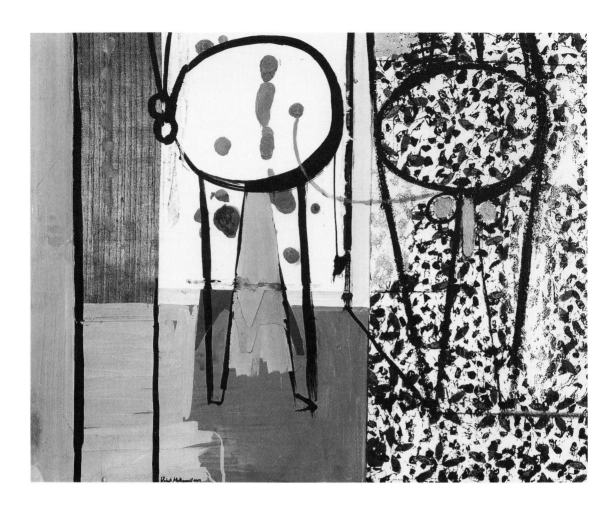

Pancho Villa, Dead and Alive, 1943.
Gouache and oil with cut-and-pasted paper on cardboard,
28 in. × 35.875 in.

So the doodle mediates between nothingness on the empty page and the mind eager to express itself. The term *improvisation,* as in a 1991 work of that name, prepares exactly the aesthetic ground on which the witness to spontaneity occurred. American as improvisations may sound, Motherwell's doing them was tinged with the Oriental, because at the moment you let your "hand take over," it is as if you are painting with someone else's hand.[36] You have to give up the major emphasis on yourself.

James Johnson Sweeney says of Motherwell's painting (in a catalogue for an exhibition at Peggy Guggenheim's gallery): "With him a picture grows, not in the head but on the easel."[37] Painting as process was entirely the point. Later, in 1959, Motherwell would say: "I have never had a thought about painting while painting."[38] Like the Dada and surrealist statements about "thought being made in the mouth" (as Tristan Tzara would say) or "in the brush" (as Picabia would say), here the thinking is in the doing, in the painting, in the enthusiastic way you open yourself up, give yourself over, to the spontaneous start.

Indeed, it is toward surrealism that we most often turn in relation to Motherwell, where he turned most often to explain, to defend, to advocate his method—taken from Matta and the other surrealists—of the sublime scribble. Motherwell called it "doodling," and this humble word conveyed a great deal for him and others. "Doodling," Steinberg had said, "is the brooding of the hand."[39] The word, like some uses of the term *scribble* for writers, has just enough irony to save it; now we know, and Robert Motherwell reminds us, that the irony on which we live, so as not to die from anguish, should not enter into painting. Perhaps not, but it enters into his writing, right along with metaphysical anguish, violence, sorrow, ecstasy.

The initial contact with the canvas, say, this line or stroke thrown down, just like that, can lead where we may want to go. One of Breton's definitions of surrealism speaks to this process, even after he had given up on automatic writing (that "catastrophe," as he was to call it later). What he continued to believe, so convincingly that we end up doing so with him, was that there might be, in the world of objective chance—like the title of Robert Motherwell's one-issue journal, *possibilities*—an answer we might come across in the exterior world to a question we didn't know we had.

A personal parenthesis here: once when I was working at the Museum of Modern Art, I found in a set of unpublished drawings by Robert Desnos *The Night of Loveless Nights*—he is the French surrealist renowned for his automatic drawings and speaking in his sleep, who was deported and died of typhoid fever in the concentration camp at Terezina. In several of these, you could clearly see how Desnos began his sketches with a random series of strokes across the page, using, before Matta, the automatic scribble or doodle. He would make a fevered hatching or scratching with pencil on the paper preparatory to making his sketch, so that both the black lead lines and then the blue ink of the drawing are still visible.[40] The

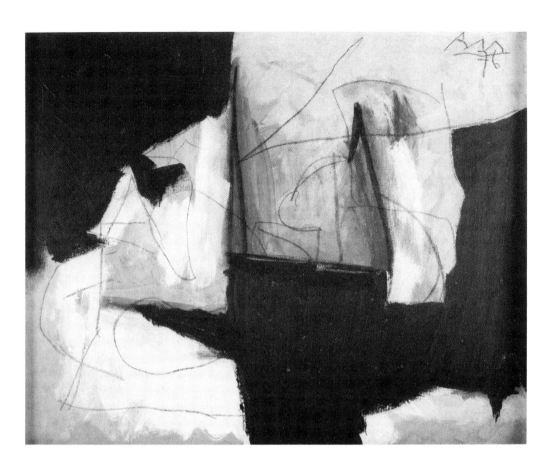

Study in Automatism, 1977.

Acrylic on canvas, 16 in. × 20 in. (40.64 cm × 50.80 cm).

Collection The Ulrich Museum of Art, Wichita State University, Wichita, Kansas
(Museum Purchase and Gift of the Dedalus Foundation). Photo credit:
Zindman/Fremont. © 1994 Dedalus Foundation, Inc. {see color plate}

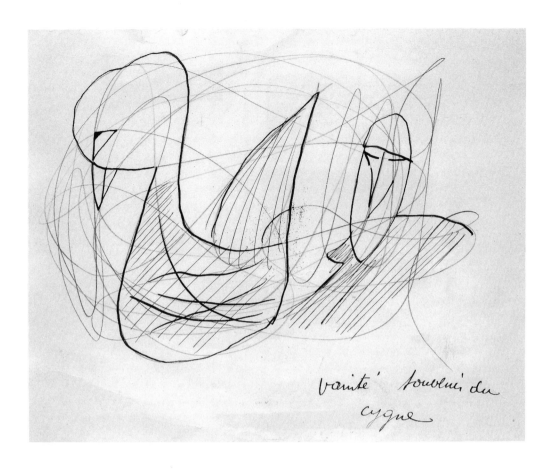

Four of six sketches by Robert Desnos from 1925, found
in the original manuscript of *The Night of Loveless
Nights*. Original illustrations by Robert Desnos.

*Anvers, published privately (?), 1930. Pencil and ink on paper, sheet:
8.3125 in. × 11.125 in.*

The Museum of Modern Art Library, New York

most interesting of all these, reproduced here along with three others, is entitled
Vanity Memory of the Swan. Together with Joseph Cornell's own box, *Homage to
the Romantic Ballet*, with his own swan encased and surrounded by feathers, and
the memory of Cornell's brilliant misremembering of Motherwell's *Mallarmé's
Swan*, these make a constellation to be remembered, as well as a starting place for
the consideration of this technique of automatic drawing and its initiation.

From his reading of Anton Ehrenzweig's *The Psycho-Analysis of Artistic Vision
and Hearing: An Introduction to a Theory of Unconscious Perception*,[41] Motherwell
took ammunition for his views about automatic scribbling or doodling as indica-
tive of something below the normal and expected surface. Ehrenzweig emphasizes

au milieu des
pouces et os doigts
indicateurs

the way in which the human psychology, longing for a smooth understandable gestalt, is likely to "cover up and smooth out symbolic forms" in order to restore an articulate structure and what seems a rational entity, ruling out any psychology of depth. But "to a great extent, the creative process remains on an unconscious inarticulate level where unconscious perceptions communicate themselves directly to the artist's 'automatically' writing hand." So the task of the artist is to "disintegrate the articulate and rational surface perception and to call up secondary processes in the public," calling on the secret life of the emotions, those techniques of scribbling that have their direct outcome in emotional power. The musical equivalent of this is the accidental glissando and vibrato, those unintended inflections that express something more profound than the smooth surface.[42] In order to open up these possibilities, Ehrenzweig shows how the techniques of the modern "automatic" painter manages to retain the "initial stage of fluid gestalt-free perception by suppressing all definite formative ideas" (p. 36).

It was this technique that interested Motherwell. As for the general and particular tensions between the verbal and the visual, they became radically personalized

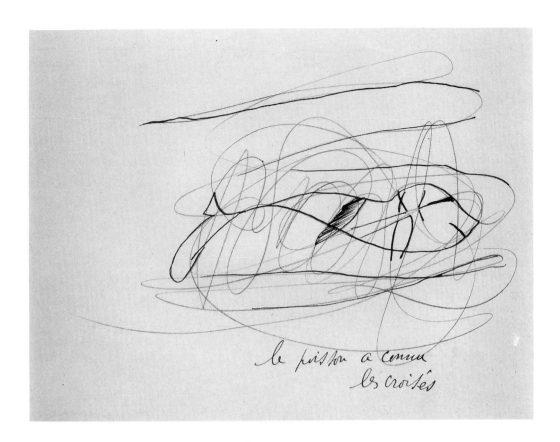

le piston a connu
les croisés

in surrealism. Breton's personality was not such as to smooth things over. Mother-well tells a wonderful tale here:

> Another thing that struck me was they would get into violent arguments, and there were once in particular Max Ernst and Breton having a furious argument and standing face to face shouting in each other's face, and it had something to do with their wives, and Breton was saying at a certain mo-ment, "If it weren't for me, your painting wouldn't exist." What struck me was the Frenchness of it. At that point of emotion, Americans would have hit each other, but there was never any question of that.

Besides the technique of automatism, which you can see clearly working in many of his paintings and collages, what Motherwell most admired in the surrealists was their ability to form a community. This aspect of their relation had, I think, as much potential importance for his subsequent work and life as the doodle; as long as I knew him, his belief in and longing for an artistic community was one of the

L'ange ou
bizarre

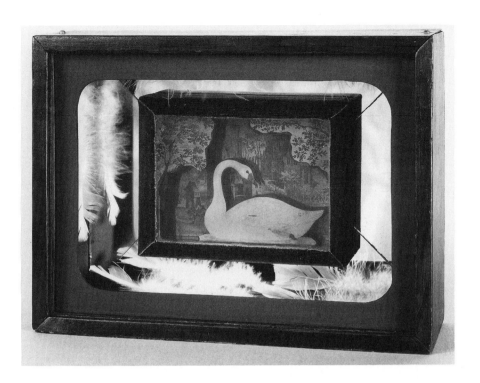

Joseph Cornell, *A Swan Lake for Tamara Toumanova (Homage to the Romantic Ballet)*, 1946.

Box construction—painted wood, glass pane, photostats on wood, blue glass, mirrors, painted paperboard, feathers, velvet, rhinestone, 9.5 in. × 13 in. × 4 in.

The Menil Collection, Houston, Texas. Photo credit: Hickey-Robertson

major things that mattered. Motherwell's warmth as a person needed surrounding reassurance and response. Here he is on the topic of fraternity and his relation to theirs:

> But basically I stayed on the sidelines, because what did interest me was the fraternity. All the American painters were basically essentially rivals, and the collaborativeness of the surrealists was something really amazing. . . . just the idea of poets sticking together. There was a real fraternity, with very high stakes, in the sense that if somebody was thrown out, it was almost like a family disinheriting a cousin or a son. And Matta was always a little sensitive to that, because he came from a wealthy background with which he had broken, and was Spanish-speaking and a young genius. The last young genius they had had who was Spanish-speaking was Dali, who was absolutely a traitor, and Matta instigated a palace revolt. He wanted to do abstract expression by creating a palace and getting Baziotes to go around and explain automatism to some other American artists, like Gorky, Hans Hofmann, De Kooning, and a more minor artist called Peter Busa. And the Americans were all not very interested, maybe because I was just a beginning painter and didn't have any prestige, but mostly essentially every man was on his own, and out for himself.

This is exactly the feeling I wanted to emphasize. That Motherwell's tenacity about the importance of what is ongoing and continuing, both vertical (what we inherit) and horizontal (our relation to our friends and artistic community), gave to his work a sense of unusual connectedness. "Every intelligent painter," he said, "carries the whole culture of modern painting in his head. It is his real subject, of which everything he paints is both an homage and a *critique,* and everything he says a gloss."[43]

He did of course believe, as he stated most eloquently, that "everyone's life has to be spent in transcending his initial inheritances," that "Man is his own invention: every artist's problem is to reinvent himself,"[44] but it was also true for him that "reality consists of relations." His relation to the surrealist group, which he never tired of describing, was crucial in his formation, perhaps more than he sometimes stated, emphasizing just the doodle; that sense of community was to go far. The adventure he wanted to set out on was of an internationalist variety:

> Really I suppose most of us felt that our passionate allegiance was not to American art or in that sense to any national art, but that there was such a thing as modern art: that it was essentially international in character, that it was the greatest painting adventure of our time, that we wished to participate in it, that we wished to plant it here, that it would blossom in its own

way here as it had elsewhere, because beyond national differences there are human similarities that are more consequential.[45]

He had wanted to translate surrealism into America and had hoped that William Carlos Williams would join him in this endeavor. At this point, Motherwell was defining surrealism as follows:

> a. stimulation of the imagination—in the sense of enriching sensuous life by insisting on ignored aspects of reality, the invention of new objects of perception within reality, etc.; b. the preservation of the dignity and value of personal feelings—a response to the felt need (in a world increasingly able to deal with physical nature, and potentially, with social relations) of insisting that the only possible end of science and of a good society, the *felt-content* of the organism's experiencing, must not be annihilated or be held in contempt because it is not scientifically or sociologically useful. Hence the importance of the artist, etc.; revolutionism—not so much in the sense of dwelling on the material difficulties and means (though this is implied), but revolution in the sense of increased *consciousness*, of consciousness of the *possibilities* inherent in *experiencing*. Emphasis therefore is on novelty, invention, the disturbing, the strange—the power of feeling to move the organism; d. the dialectic—not so much in the Hegelian sense as constituting the metaphysical nature of reality, or in the Marxist sense as the economic nature of society, but in the sense of a weapon for interpreting and synthesizing reality, as when Breton asks for a union between normal consciousness and the unconscious.[46]

So for Motherwell it was essentially that primordial relation between day and night, reality and dream—in short, the *Communicating Vessels* experiment made by André Breton—and this belief in possibilities that mattered. This was, along with automatism, the founding credo of surrealism and was to be crucial in his own working out of his artistic consciousness. And this is why, I think, the translation of Breton's term *conscience* as a social conscience or a more wide-ranging "consciousness" had been of such import.

It was this misunderstanding that was to lead to the end of their cooperation, a point stressed by both David Hare and Motherwell, from opposite sides of the boxing ring. The French term *conscience* that covers both politics and interior morality means that the public and the private are made, in this case, to be word-fellows, often quite as important as bedfellows, and not just for the French. As Breton says: "Les mots ne jouent plus. Ils font l'amour" ("Words are no longer playing, they are making love"). Well, not always these two senses of the word *conscience*. Motherwell's double passion for freedom and for precision would not

Portrait of André Breton, 1979.
Monotype and oil on paper, 32 in. × 29 in. (81 cm × 74 cm).

Private collection. Photo credit: Ken Cohen. © 1994 Dedalus Foundation, Inc.

permit him simply to gloss over what was different and separate in the English language, different in his mind and certain in his intellect. His attitude was based on feeling, and that included his passion for language. He believed that you have to care about words, and about letters too. That the title *VVV* doesn't say what it was meant to say is, when you look at it conscientiously, ironic, crucial, and certainly a *cas de conscience.*

So Motherwell's relation of his relations to Breton, Matta, and the other surrealists is never deprived of its conscience, never far from his consciousness.

Dark Elegies

We are the hollow men.
T. S. Eliot, *"The Hollow Men" (1925)*

Elegies for All of Us

Motherwell was looking for a way to express human tragedy. After his mixture of dark and vivid shapes in *La Joie de vivre* of 1943, with its complicated reference to Matisse's *Le Bonheur de vivre* and its feeling of a world gone insane, he needed a new form. In 1948 he found it—in a sketch based on a small poem written by Harold Rosenberg for the journal *possibilities*. This motif became the foundation of his most celebrated works, those massive statements called the *Spanish Elegies.*

In these weighty oval shapes of the *Elegies,* side by side, full and frontal, Motherwell's blacks find the properly monumental response to the tragic event they mourn—the death of the Spanish Republic—not just through his emotions and romantic imagination but in all his literary sensitivity. The dramatic horizontality of the gesture, the heaping on of grief in its loud and public form, bespeaks an underlying depth best and most succinctly expressed by one of his favorite poets, Gerard Manley Hopkins. His Terrible Sonnets or Sonnets of Desolation summon with a terrible power the panic of being choked under great piles of anguish, thick-coated with the dark pain of it, as in his "Carrion Comfort":

> No worst, there is none. Pitched past pitch of grief,
> More pangs will, schooled at forepangs, wilder wring.
> Comforter, where, where is your comforting?
> Mary, mother of us, where is your relief?

Elegy to the Spanish Republic No. 1, 1948.
India ink on rag paper, 10.75 in. × 8.5 in.

My cries heave, herds-long; huddle in a main, a chief
Woe, wórld-sorrow; on an áge-old anvil wince and
 sing—
Then lull, then leave off. Fury had shrieked "No ling-
ering! Let me be fell: force I must be brief."

O the mind, mind has mountains; cliffs of fall
Frightful, sheer, no-man-fathomed. Hold them cheap
May who ne'er hung there. Nor does long our small
Durance deal with that steep or deep. Here! creep,
Wretch, under a comfort serves in a whirlwind: all
Life death does end and each day dies with sleep.[1]

Nowhere have I read a more accurate description of the massive obsessional weight of Motherwell's blackest blacks, turning around upon themselves in ever thickening textures like so many in-spiraling blasts, than in this line from the same poem:

O in turns of tempest, me heaped there; me frantic to
 avoid thee
and flee

We feel this weight in *Iberia,* in the immense meditation on *Kierkegaard,* in the *Samurai* series, in *Threatening Presence,* in *Face of the Night (For Octavio Paz), Monster (for Charles Ives),* and elsewhere. It was all-important to Motherwell that an artist capture in a work "one's own inner sense of weight." "If something gets too airy," says the artist, "it doesn't feel like my 'I.'"[2] And in these repeated shapes, whose size and importance were to grow in Motherwell's imagination as in that of the viewing public, the idea of repetition is especially crucial. Each *Elegy* bears in its own form the idea of the series, of the haunting shapes side by side. This giant gesture in its repeated confrontation of general evils speaks to us intimately, open-ly, terribly.

I expect all of us have the same reactions to certain haunting rhythms: for exam-ple, to T. S. Eliot's great poem "Ash Wednesday" and its deploring of the absence of hope, in the return of despair:

Because I do not hope
Because I do not hope
to turn again

The same spell is cast by the epic *Spanish Elegy,* in honor of the great Spanish poet García Lorca, murdered by the Guardia Civil, whose repeated lament in his epic "Llanto por Ignazio Sánchez Mejías" is the source of the painted *Elegies* in their

Face of the Night (for Octavio Paz), 1981.

Acrylic on oil-sized canvas, 72 in. × 180 in.

Collection of the Modern Art Museum of Fort Worth, Gift of the Friends of Art, by exchange

Monster (for Charles Ives), 1959.

Oil on canvas, 78 in. × 118 in. (198.1 cm × 299.7 cm).

National Museum of American Art, Smithsonian Institution, Washington, D.C., Gift
of S. C. Johnson & Son, Inc.

dark repeated thuds: the poem repeating over and over "A las cinco de la tarde"—
"At five in the afternoon." The repetition summons up something of the primitive,
pre-intellectual impulse, incantatory and ritualistic, for when the blacks work
against the ochre, as in *Elegy to the Spanish Republic No. 132,* all the colors of the
earth are summoned.

Moving from the purely personal lament for mortality implied in all elegies, to
Lorca's bullfight elegy as a public event, to a lament for humanity in general, this
repetition echoes in our minds—like a litany, like a dirge, like John Donne's fu-
nereal bell tolling for us all. The repeats hold us. Lorca's lament for the fallen bull-
fighter, stated at the outset of the poem, will form a litany, a prayer, and a wailing:

> A las cinco de la tarde.
> Eran las cinco en punto de la tarde
> [At five in the afternoon.
> It was exactly five in the afternoon.][3]

Two *Elegies* in Robert Motherwell's studio.

Elegy to the Spanish Republic No. 132, 1975–1985.
Acrylic on canvas, 96 in. × 120 in. (243.84 cm × 304.80 cm).

Private collection. Photo credit: Zindman/Fremont. © 1994 Dedalus Foundation, Inc.

The refrain is then picked up, repeated, throughout the long first part of this elegy for a dead bullfighter, placed in italics like the tragic chorus that it is:

a las cinco de la tarde.

This terrible expression recurs now twenty-four times, like the twenty-four hours of the day, each tolling like a bell, coming to a conclusion of stupendous tragedy and collective gesture:

> Las heridas quemaban como soles
> *a las cinco de la tarde,*
> y el gentío rompía las ventanas
> *a las cinco de la tarde.*
> A las cinco de la tarde.
> ¡Ay, qué terribles cinco de la tarde!
> ¡Eran las cinco en todos los relojes!
> ¡Eran las cinco en sombra de la tarde!
> [The wounds were burning like suns
> *at five in the afternoon,*
> and the crowd was breaking the windows
> *at five in the afternoon.*
> At five in the afternoon.
> Ah, that fatal five in the afternoon!
> It was five by all the clocks!
> It was five in the shade of the afternoon!][4]

The movement here is dramatic, from suns in their plural conflagration to the singular shade of the afternoon at five, like Motherwell's sun and shadow, as the crowd makes its gesture of breaking through and breaking out. That fatal "five, five, five" resounds like the repeated shapes of black on the canvas, like a series in a series, wounded suns bleeding black against dazzling white, sometimes tinged with bloodred, sometimes with blue, but always black in its dominant feeling and implicit tone. Even the occasional *Blue Elegy* resounds as black, like the tolling of bells. Motherwell will do his own *Lament for Lorca*, of 1981–1982, echoing Lorca's lament in his own fury at Lorca's murder by Franco's Guardia Civil, bringing the elegiac one step closer still. Nothing I know makes so clear the relation between the myth of the bull to be killed and the death wish, between wounding and desire on the heroic scale as Rafael Alberti's poem about "The Bull of Death": "Black bull, longing for wounds," it starts, and ends: "Run, bull, to the sea, charge. Nothing. / But since you intend to wound, / here is a bullfighter of spume, salt and sand. / Kill him."[5] All the dignity of traditional gesture, all the legends of male confron-

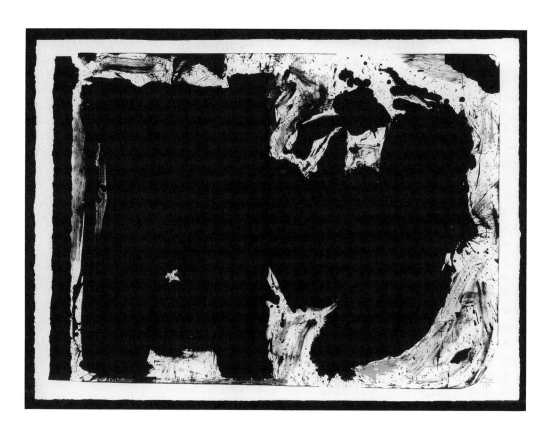

Lament for Lorca, 1981–1982.

Lithograph, 44 in × 61 in.

Printed and published by Tyler Graphics Ltd. Photo credit: Steve Sloman. © 1982
Robert Motherwell/Tyler Graphics Ltd.

tation, animal and awful, is called up by this poem as by the gestures of Lorca and Motherwell, awe-striking in the imagination's arena.

Now the mythology of death and of the heroic gesture, as well as the massive lamentation that accompanies it, is heard and felt far beyond the tragedy of one bullfighter, felt like the whole idea of *Elegy*, beyond bullfights, beyond even the death of the Spanish Republic, to death itself in its colors of earth. The bull has always been the symbol of death in Spain, and this association will invade a whole poetic consciousness in that country and beyond, in the public statement Motherwell intended each *Elegy* and *Lament* to be. The overwhelming black shape of his massive *Iberia* looms in the mind. Spain and Mexico, as Motherwell puts them on the canvas, sometimes protrude fearsomely, as in *Mexican Past* (1991), which raises monstrous suggestions with its claw shape, menacing like his *Monster (for Charles Ives)* with its frightening eye looking straight at the viewer. *The monster is in us;* the political danger is not far from any of us. At other times the *Laments* and *Elegies* for Spain sink into the consciousness, as does a lithograph called *Poor Spain* of 1981–1983, in which the Spanish word for poor, *¡Pobre!,* is printed on red against a grey ground, to the left of a gigantic black mass with just a few traces of white.

Alberti and Motherwell's book entitled *El negro Motherwell* offers seemingly endless variations on black and its idea: *Black Lament, Elegy Black Black, Black Banners, Eternal Black, Black Wall of Spain, Black of the Echo, Airless Black, Black Concentrated, Black with No Way Out, Forever Black, Black Undone by Tears,* and *Black Sun,* among many others. The particular depth of this black and its working out relate to the tragedy of Spain but also to an earlier *Spanish Tragedy* by Kyd and far back in time to the prehistoric caves of Altamira.

Something basic and terrifying confronts the viewer of *Primordial Sketch No. 7* of 1975, where the rough board shows through what overlies it, displaying what civilization has not been able to cover up. The partially hidden monster protrudes in every direction, with a dinosaur neck and claws, in the same lineage as the 1990–1991 painting dedicated to Kierkegaard, no less terrifying, called *Either/Or.* Like his best-known work, the *Primordial Sketch* shows a great black hook curling around small black splotches outlined in white, against a burnt umber background: like the black, white, and ochre of so many of Motherwell's major canvasses, these cave colors address what is indeed primordial in the sensibility, as if it were newly protruding into our consciousness. The view of the massive—take the brooding *Le Massif* of 1991 (like the French mountain range called "Le Massif central")—is most efficiently rendered in this great expanse of black, with a very few ochre inserts, taking up almost the whole canvas. This is a mountain of a painting; Motherwell had a mountain of a mind.

In a discussion of one of Motherwell's important early essays, "The Modern Painter's World," Dore Ashton points out Motherwell's regretful tone as he speaks of the opposition of the artist and modern society, concluding that only the lasting aesthetic or formal values provide any possibility for an escape from the prevailing

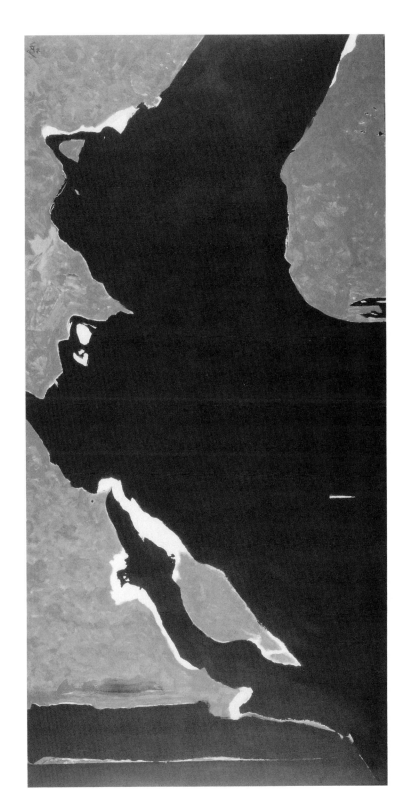

Mexican Past, 1990–1991.

Acrylic on canvas, 72 in. × 144 in. (183 cm × 366 cm).

Collection The Butler Institute of American Art (Museum Purchase and Gift of the
Dedalus Foundation). Photo credit: Zindman/Fremont. © 1994 Dedalus Foundation, Inc.

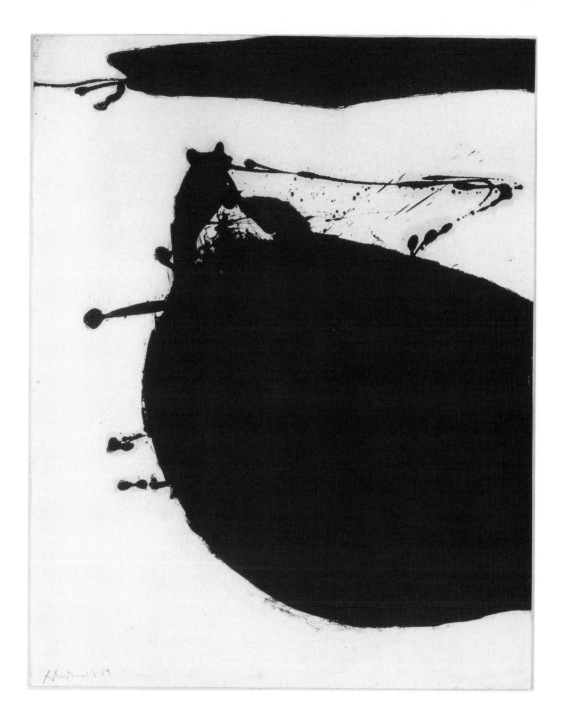

The Black Sun, 1959.

Oil on paper, 30 in. × 23 in. (76 cm × 58 cm).

Private collection. Photo credit: Ken Cohen. © 1994 Dedalus Foundation, Inc.

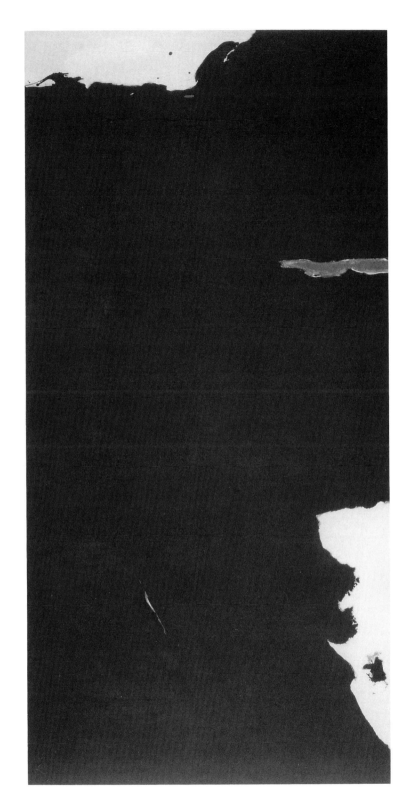

Massive Image, 1991.

Acrylic on canvas, 60 in. × 120 in. (152.40 cm × 304.80 cm).

Private collection. Photo credit: Zindman/Fremont. © 1994 Dedalus Foundation, Inc.

confusion. His earlier attitude toward Marxism and excitement over surrealism "had to give way. . . . Motherwell's regret that the American artist could not paint a *Guernica,* that he could no longer hope to find the symbols that would relate him to his fellows, was, as he later demonstrated in his own series of symbolic paintings on the Spanish Civil War, permanent."[6] Perhaps Picasso's *Guernica* could not be redone. But the lasting effect of such a powerful representation of anguish and anger as that, and as Motherwell's own no less powerful *Elegies,* endures past its specific reference. As in the title of this book, it is an art that holds. The impact of the *Elegies* has not lessened, even though the memory of the Spanish Civil War may have faded from the public mind. It is lasting, more than any other heritage from Motherwell's spirit and hand, like a lamentation that will always be heard. *Lacrimae rerum,* tears over things, a weeping general as well as specific. Like the loss of anything worth loving or living for.

Speaking of the great *Elegies,* Arthur Danto says:

"Spain" denotes a land of suffering and poetic violence and political agony, and "Elegy" carries the literary weight of tragedy and disciplined lamentation. It would be inconsistent for works so titled to reflect back merely upon their own processes, and in truth one cannot see *Spanish Elegy 132* without feeling oneself in the presence of some human revelation as deep as painting allows.[7]

Now a great part of the impact of the *Elegies* is based on the blackness of their blacks: to be sure, there are elegies in blue, and even in green,[8] but to my eye, they are lesser things, and speak with less depth: they only work as referring back to the original black forms. Motherwell's elegiac black is unforgettable and irreplaceable.

Out of the deep, from the lithographs done for the book *El negro,*[9] responding to the poem of Rafael Alberti ("El negro motherwell"), a further meditation on black comes resounding. Motherwell's black, made of carbonized bones and recalling always the whole past of the prehistoric caves, and then of our history, is celebrated as "El negro motherwell" by Rafael Alberti, who stood up at a lecture by Motherwell to recite his poem in its honor. And, in his turn, Motherwell would create an *Alberti Elegy,* in honor of the poet, as he made his *Lament for Lorca,* in the same year, 1981–1982.

> El negro motherwell
> el profundo compacto entrado de la noche
> > [Motherwell's black
> > profound compact entered into with night]
> Negro negro elegía
> negro con sangre negro coagulado

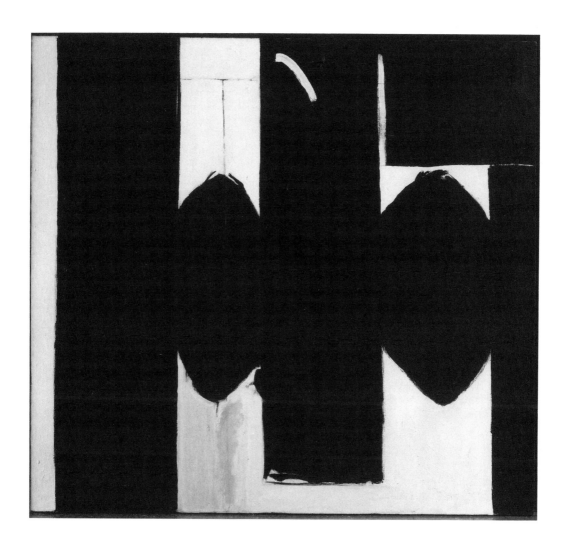

Elegy to the Spanish Republic No. 55, 1955–1960.
Oil on canvas, 178.1 cm × 193.7 cm.

© The Cleveland Museum of Art, Contemporary Collection of The Cleveland
Museum of Art, 63.583. © 1994 Dedalus Foundation, Inc.

con la cal de los huesos recortando las formas
[Black black elegy
black with black blood coagulated
with chalk of bones outlining forms]
Bandas de luto
negros estandartes
[Arm bands of mourning
black flags]
Negros hoyos brocales para el grito
negro del eco que devuelve negro
de aguas paralizadas
[Black holes open for the shriek
black of the echo reflecting black
of rigid waters]
Negro de este país de negro siempre
[Black of this land of eternal black]
¡Oh negro muro de España!
[Oh black wall of Spain!]
Negro esquelas estáticas sin aire
[Still black airless obituaries]
Dolor de negro concentrado angustia
[Pain of black concentrated anguish]
Contrado tirante negro en negro
núcleo negro expandido
negro del revés negro
[Black pulling against black
expanding black waters
black back of black]
En permanencia negro motherwell redoble
[Forever Motherwell's black resounds]
Atravesado negro puñalada invisible
[Pierced black invisible stab]
Llante negro sin fine negro callado
[Endless black lament secret black]
Negro espanta sin fondo
negro lengua cortada sin respuesta
o penetrado negro sin salida posible
[Black bottomless terror
black tongue cut without reply
Oh penetrating trapped black]
Negro de maldición gitana irremediable
[Black of the gypsy's incurable curse]

Yo puedo entrar en ti negro deshecho en lágrimas
 [I can enter you black dissolved in tears]
Por el negro salir purificado
 [Through black emerge purified]
Por el motherwell negro España libre negro
pobre España.
 [Through Motherwell's black free black Spain
 Poor Spain.][10]

Motherwell's black will find a formal working with, and against, white, with their interweaving itself calling on the spirit of exaltation and gloom commingled, that "instinctive joy and instinctive melancholy" Lorca sees as characteristic of the Spanish imagination in general. The Spanish *duende*—that spirit and that power best defined by Lorca, who as we have seen made a great impression on Motherwell—is heard at its highest intensity in the enfevered voice of the flamenco singers and their particular florid wailing during Spain's Semana Santa, the lamentation and triumph of Holy Week. Lorca quotes one flamenco singer as saying: "Whatever has black sounds has *duende*. . . . There is no greater truth."[11] These lamentations enter like black sounds into Motherwell's evocative blacks, from the *Elegies* to the *Black Rumbles*—where the sound is evoked by the massive weight of the form and of the color—to the *Dark Window* of 1990, where black

Robert Motherwell with Rafael Alberti.
Photograph courtesy of Renate Ponsold Motherwell

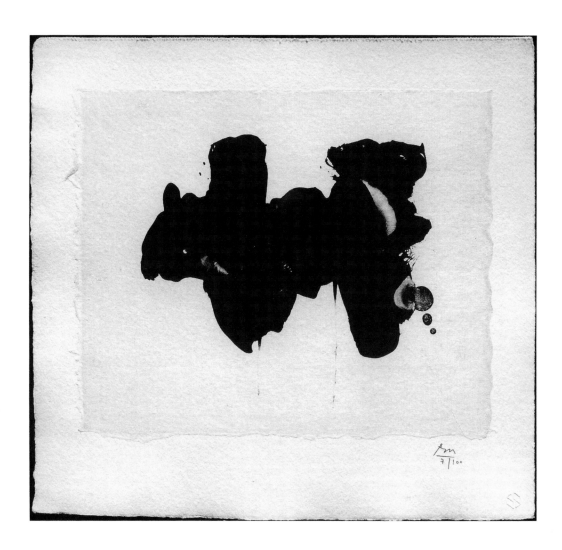

Alberti Elegy, 1981–1982.

Lithograph, chine appliqué, 14 in. × 15 in.

Printed and published by Tyler Graphics Ltd. Photo credit: Steve Sloman. © 1982
Robert Motherwell/Tyler Graphics Ltd.

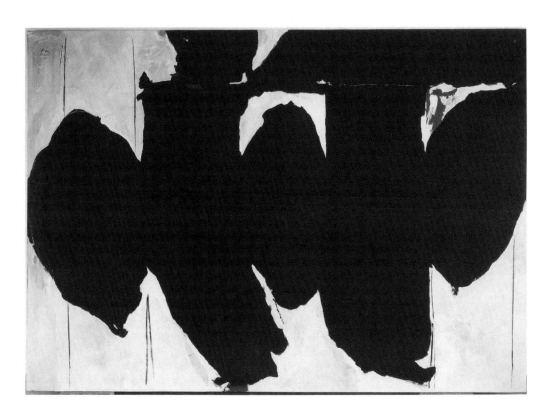

Elegy to the Spanish Republic No. 172 (With Blood),
1989–1990.
Acrylic on canvas, 84 in. × 120 in. (213.36 cm × 304.80 cm).

Collection The Denver Art Museum, Denver, Colorado (Museum Purchase and Gift
of the Dedalus Foundation). Photo credit: Zindman/Fremont. © 1994 Dedalus
Foundation, Inc. {see color plate}

and brown divide up the canvas, except for some light blue streaks that offset the dark colors.

But one of the *Elegies* is more extraordinary still than the rest. *Elegy No. 172 (With Blood)* of 1991 contains its violent battle with itself within a tension agonizing to contemplate. The black masses are bitten into by the white jagged forms, while the brighter and paler red traces mark the vivid struggle in its familiar baroque colors: black, red, and white. Death has occurred and is occurring here; the great expanse of the painting reads like the end of something great, like the end to the *Elegies* themselves.

Reconciliation Elegy: An American Epic

Hung for opening June 1, 1978, East Wing, National Gallery of Art, Washington . . .
white . . . that matter floods pictures with feeling.

Motherwell, *letter to Frank O'Hara (1965)*

"My albino whale"—thus Motherwell describes his immense *Reconciliation Elegy,* which occupies an entire wall of the National Gallery. The history of Motherwell's creation of this canvas, his engagement with the massive *body* of white unprimed, or "raw," canvas that arrived "folded in a package, deeply creased, like an unopened parachute" and would become the backdrop of this colossal work, reads like a contemporary American epic, consciously in echo of Herman Melville's *Moby Dick.*[12] In Motherwell's encomium of Joseph Cornell, he mentions Melville, the white of whose spaces only Cornell had known how to capture before: "His work is filled with the white light of early morning—he and Herman Melville in this country have understood the concept of white the most richly; indeed, he looks like Captain Ahab ashore—irritable, absolute, sensitive, obsessed, but shy."[13]

It is a story of intellectual and emotional involvement complete with struggle and uncertainty, undertaken with a pounding heart and completed only after a delay, for Motherwell is too ill to be present at the painting's installation, and sees it only the evening before the inauguration, viewing it on the vertical for the first time. He has dealt with his monster in the deep, as it stretched out upon his studio floor; he has been walking on it in his socks, seeing always only the enlarged photo of the maquette upon the wall, like someone walking in the dark even on a ground of white. A bit clumsily perhaps, an awkward protagonist.

That white arrived unforgettably in an unprimed state that had to be stretched and tightened every day for a month. Because the canvas factory, asked not to prime it, had not realized it would be used for a painting, this was material in its raw state, and deeply creased. Against slick, against shine, the artist insists on a matte surface not already primed: it reads like a psychoanalytic adventure already, undertaken, as Melanie Klein might read it, against the great breast of mother ocean, against a material untouched and precisely primal, until it is prepared in

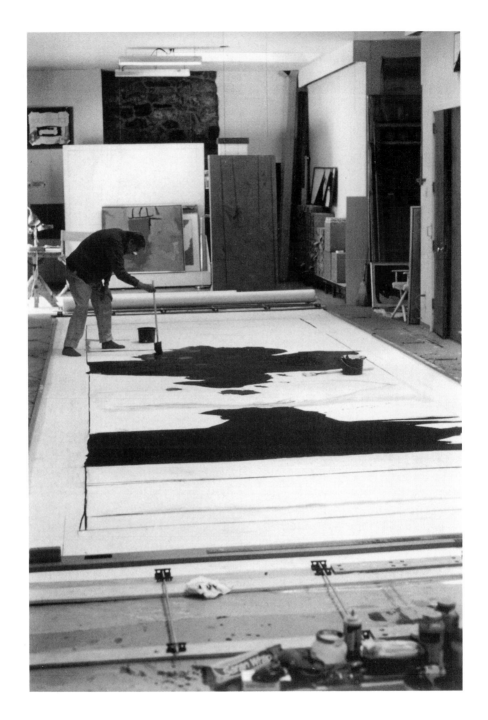

Robert Motherwell painting *Reconciliation Elegy,* 1978, in his Greenwich studio.

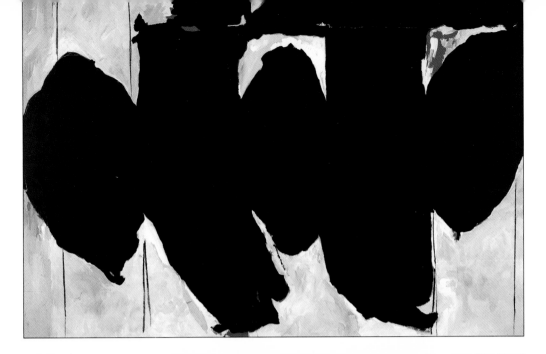

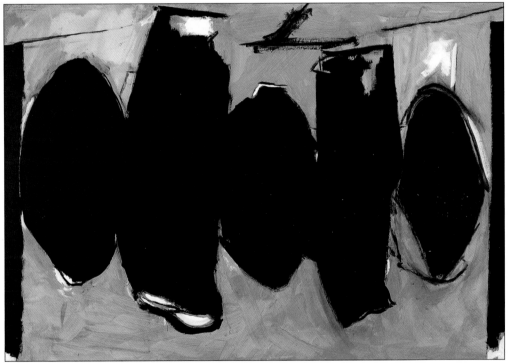

Elegy to the Spanish Republic No. 172 (With Blood),
1989–1990.

Acrylic on canvas, 84 in. × 120 in. (213.36 cm × 304.80 cm).

Collection The Denver Art Museum, Denver, Colorado (Museum Purchase and Gift
of the Dedalus Foundation). Photo credit: Zindman/Fremont. © 1994 Dedalus
Foundation, Inc. {above}

Elegy to the Spanish Republic No. 167 (Spanish Earth
Elegy), 1985.

Acrylic and charcoal on canvas panel, 48 in. × 74 in. (121.9 cm × 187.9 cm).

Private collection. Photo credit: Zindman/Fremont. © 1994 Dedalus Foundation, Inc.
{below}

Open No. 1, 1967.
Acrylic on canvas, 114 in. × 83 in.

Photo credit: Ken Cohen. Courtesy Knoedler and Company, New York

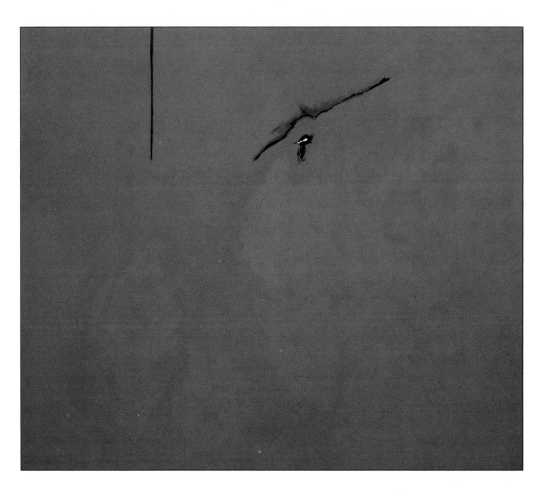

Broken Open, 1981–1987.

Acrylic on canvas, 72 in. × 84 in. (182.88 cm × 213.36 cm).

Private collection, California. Photo credit: Ken Cohen. © 1994 Dedalus Foundation, Inc.

Summer Seaside Doorway, 1971.
Oil on canvas, 60 in. × 40 in.

Frederick Weisman Company, Los Angeles, California

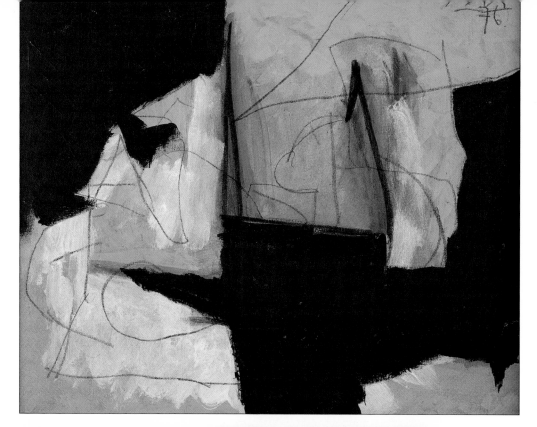

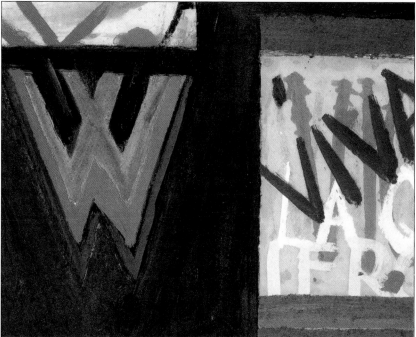

Study in Automatism, 1977.

Acrylic on canvas, 16 in. × 20 in. (40.64 cm × 50.80 cm).

Collection The Ulrich Museum of Art, Wichita State University, Wichita, Kansas
(Museum Purchase and Gift of the Dedalus Foundation). Photo credit:
Zindman/Fremont. © 1994 Dedalus Foundation, Inc. {above}

Viva, 1947.

*Collage of oil, gouache, sand, and paper on board, 15 in. × 20 in.
(38.10 cm × 50.80 cm).*

Private collection, Germany. Photo credit: Steven Sloman. © 1994 Dedalus
Foundation, Inc. {below}

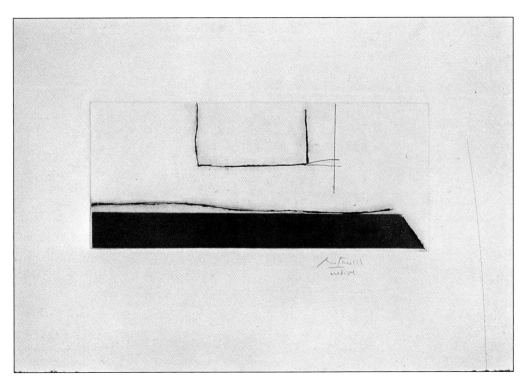

The Green Studio, 1986.
Etching and aquatint from two copper plates printed in green and black,
12 in. × 18 in. (30.48 cm × 35.72 cm).

Photo credit: Ken Cohen. © 1994 Dedalus Foundation, Inc.

Disappearance of Goya's Dog, 1990.
Acrylic on canvas panel, 7.875 in. × 23.875 in. (20 cm × 60.40 cm).

Private collection. Photo credit: Ken Cohen. © 1994 Dedalus Foundation, Inc.

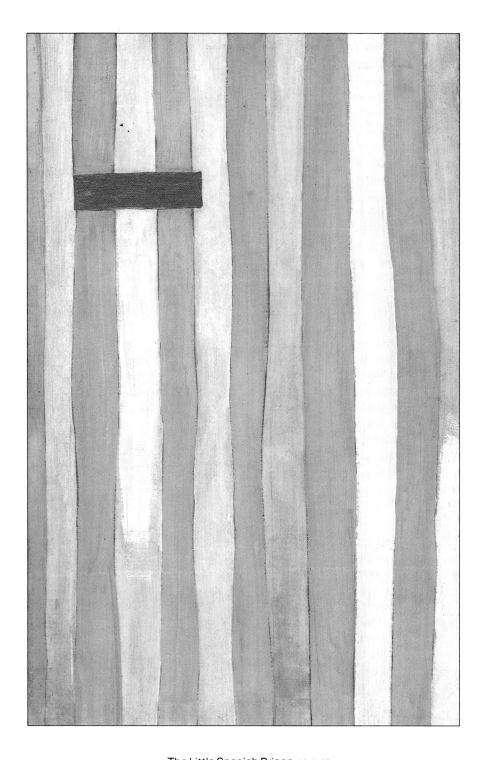

The Little Spanish Prison, 1941–1944.
Oil on canvas, 27.25 in. × 17.125 in.

© 1995 The Museum of Modern Art, New York. Gift of Renate Ponsold Motherwell

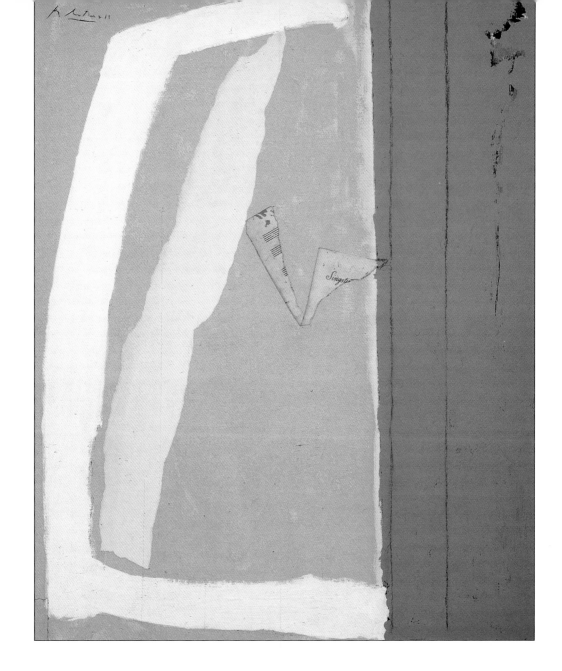

Greek Door, 1980–1981.
Collage and acrylic on canvas panel, 30 in. × 24 in. (76.20 cm × 60.96 cm).

Private collection, Madrid. © 1994 Dedalus Foundation, Inc.

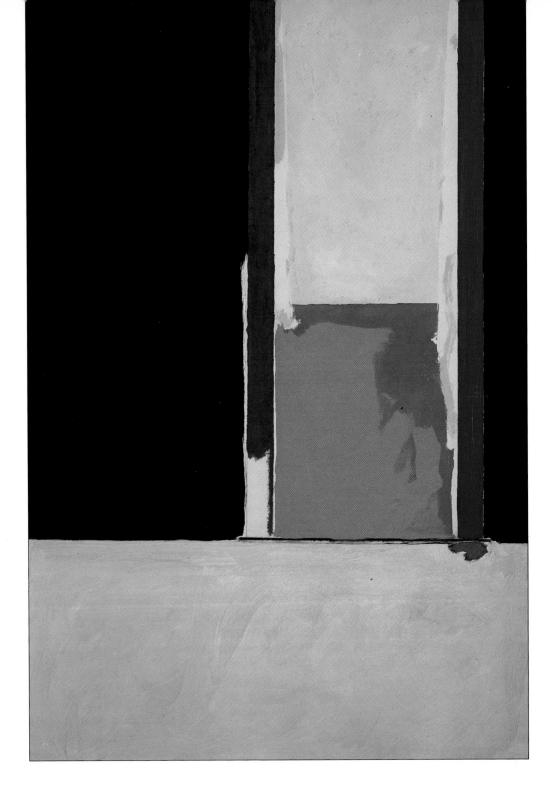

Garden Window (formerly *Open No. 110*), 1969.
Acrylic on canvas, 61 in. × 41 in. (152 cm × 124 cm).

Collection The Modern Art Museum of Fort Worth, Fort Worth, Texas (Gift of the
Friends of Art, by Exchange and Gift of the Dedalus Foundation). Photo credit: Ken
Cohen. © 1994 Dedalus Foundation, Inc.

Summer Open with Mediterranean Blue, 1974.
Acrylic on canvas, 48 in. × 108 in. (121.9 cm × 274.3 cm).

Collection The Modern Art Museum of Fort Worth, Fort Worth, Texas (Gift of the Friends of Art, by Exchange and Gift of the Dedalus Foundation). Photo credit: Ken Cohen. © 1994 Dedalus Foundation, Inc. {above}

Gulfstream, 1980.
Acrylic on canvas, 36 in. × 72 in.

Collection Renate Ponsold Motherwell {below}

Untitled (Blue Open), 1973.
Acrylic and charcoal on canvas, 61 in. × 44 in. (154.91 cm × 111.76 cm).

Private collection. Photo credit: Steven Sloman. © 1994 Dedalus Foundation, Inc.

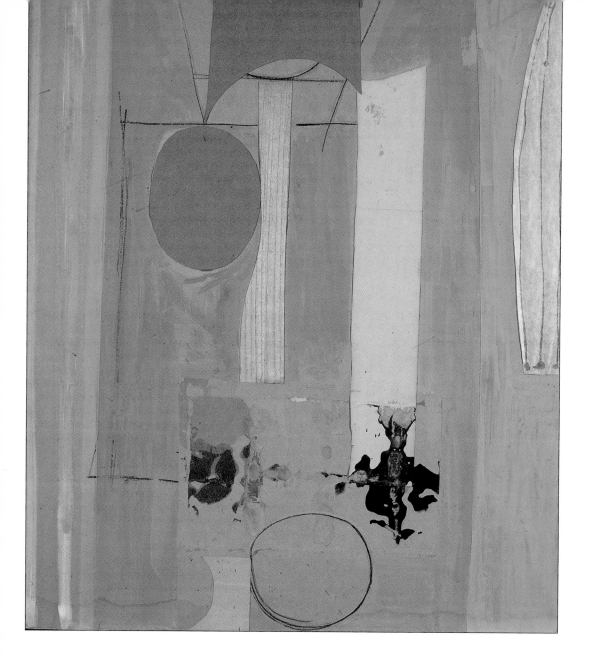

Mallarmé's Swan, 1944.

Gouache, crayon, and paper on cardboard, 110.5 cm × 90.2 cm.

© The Cleveland Museum of Art, Contemporary Collection of The Cleveland
Museum of Art, 61.229. © 1994 Dedalus Foundation, Inc.

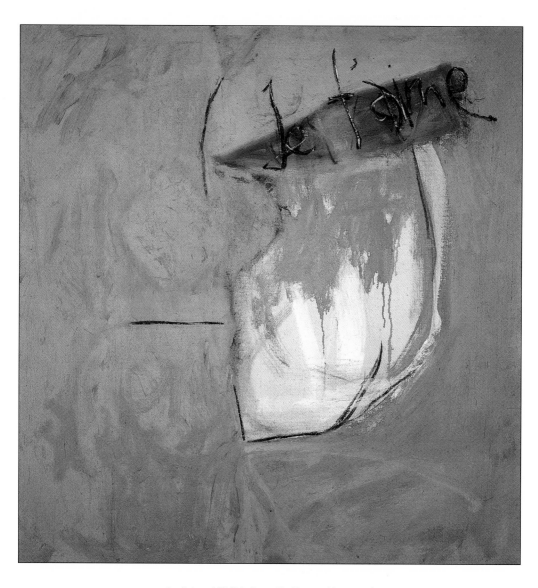

Je t'aime VIII (Mallarmé's Swan: Homage), 1957.
Oil on canvas, 42 in. × 40 in. (107 cm × 102 cm).

Private collection. Photo credit: Steven Sloman. © 1994 Dedalus Foundation, Inc.

Gift, 1973.
Acrylic and paper on Upsom board, 48 in. × 36 in. (121.9 cm × 91.44 cm).

Private collection. Photo credit: Ken Cohen. © 1994 Dedalus Foundation, Inc.

N.R.F. Collage No. 2, 1960.
Oil and collage on paper, 28.125 in. × 21.5 in. (71.4 cm × 54.6 cm.).

Collection of the Whitney Museum of American Art Purchase, with funds from the
Friends of the Whitney Museum of American Art, New York, 61.34 {above, right}

Manchester Guardian, 1977.
Acrylic, charcoal, and collage on canvasboard, 36 in. × 24 in.

Photo: Ken Cohen. © 1994 Dedalus Foundation, Inc. {below, right}

Gauloises with Scarlet, 1972.

Acrylic and collage on canvasboard, 14 in. × 10 in. (36 cm × 25 cm).

Private collection. Photo credit: Zindman/Fremont. © 1994 Dedalus Foundation, Inc.

place for the setting out on the deep. As if, in return, the artist were to be swallowed up by the whale he is stepping on and engulfed in: "I had to paint the ultimate work while *walking on it*, inside its perimeters." It seems wonderful indeed that the material of a great American epic should arrive folded in a package. It is like the envelope holding Motherwell's work called simply *Gift*, like some adventure already *given*, like a parachute, should the venturer fly too high. Ours is not a good age for Icarus.[14] Such conscious, self-conscious involvement in its own willed spontaneity has to be large—in its intentions, in its process, and in its scale: "The supreme gift, after light, is scale."[15]

Once the raw canvas is sized with liquid gesso, Motherwell sees it as the ground for a poetic gesture: "A matte white, white as the houses in Mykonos, as alpine snow . . . intimacy and fear . . . my albino whale, as it lay there on the floor." This mention of Mykonos brings back the memory of the large quest painting called *The Golden Fleece*—allied to *The Voyage*—even as Moby Dick is invoked at the outset of the adventure and will haunt each step of it, monster and beloved object, bequeathing intimacy and fear. At its end, it will have taken nine months from the original sketch—the period of human gestation—but only one day at the outset to imagine.

"Venturesomeness" is the first of the major qualities Motherwell ascribes to the adventure of his colleagues the abstract expressionists. This takes place in brightness, in and under what Edwin Denby called the "steady wide light" of Matisse combined with what Frank O'Hara called Motherwell's own "precise personal light."[16] This is not the general light of twilight or dawn. In this grave American lighting, Motherwell's concern with moral issues is intensified by emotion and the need to transmit it. If the thick lines of the true mathematical ratio of the photo maquette he places on the wall look too powerful from where the artist stands, they must all the same *be like that*, keeping at risk, unforgiving in such a light.

Massive it must be: this work unrepentantly takes up a gigantic space. As Motherwell stands for this combat with the white monster, armed with extralong brushes, seven feet in length, he feels he is painting on the wall of some cave, carrying on the tradition of some atavistic art. Or on those white stucco walls of the Mexico that so impressed him in 1941.[17] "If I'd used a short normal brush, my eye would have been so close to the surface that it would have been impossible to have that swept feeling of *largesse* that I wanted . . . unrhetorical humanism . . . just *there*: A voice listened to or not."[18] Unsentimental, just unapologetically *there*. This art is meant to speak, and even the canvas had to "sing," as he puts it. In case the first one did not, another was prepared.

Even as the former *Elegies* now seem to him more ritualized, and these present figures seem freer, they are nevertheless joined in his imagination to those other *Elegies*, reconciled with them, in some sweeping gesture with a great brush, upon a map he has made: "*My* map, my 'cartoon' that I would energize . . . by painting with emotion, correcting by emotion . . . as the brush swept the canvas . . . or

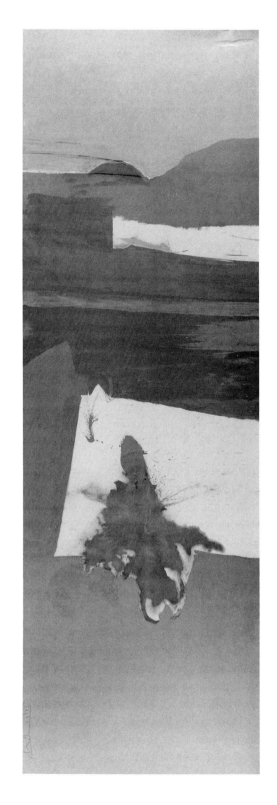

The Golden Fleece, 1961.

Oil on canvas, 69 in. × 204 in.

The Chrysler Museum, Norfolk, Virginia: Gift of Walter P. Chrysler Jr., 86.49

more exactly, through anxiety, through tension." My albino whale, my map: the stance is exact, personal, illuminated by the consciousness of carrying on the mural tradition.

Motherwell had been greatly impressed by the exhibit *The Great Age of Fresco: Giotto to Pontormo* at the Metropolitan Museum of Art, and by the sinopia drawing in charcoal, ochre, and red earth that initiated the final painting on the wall. He and his assistants used the same small tool as was used then to mark out the holes in the paper over the canvas, through which red chalk was forced, like the earth, into the white gesso. When Motherwell included bits of charcoal dust from the burned wooden sticks also into that white, the conjunction was again brought about of red and black and white, restoring an urgency we believed we had lost with the Baroque masters of poetry and art. The art of the cave man, in Lascaux, in Les Eyzies too, was that of incision and marking, of charred wooden sticks and red earth, was monumental in its mystery and urgency, was not meant to be interrupted.

The voice has *"not to hesitate or equivocate,"* and Motherwell could neither see the limits of the canvas nor see the work as it would stand straight up. The process had to be fluid: Robert Bigelow, one of his assistants, describes mixing two parts acrylic Mars-black with one part water: "He likes it so that when he works directly with a brush it flows, it splashes"—the splash makes sound, and the voice takes on the black sounds of battle. For it is a battle plan that has been drawn up and must be carried out: O'Hara claims that Motherwell "from *At Five in the Afternoon* on, is fighting an over-dominant and already clarified symbolic structure from which, through the years, he will wrench with astonishing energy some of the most powerful, self-exacerbating and brutally ominous works of our time."[19]

It was, according to García Lorca, the flamenco dancer Manuel Torres who said, while he listened to De Falla playing his "Nocturno del Generalife," "Whatever has black sounds has *duende.*" Speaking of the very active, nonstatic quality of *duende,* Lorca says that it "is a power and not a construct, is a struggle and not a concept"—like the bullfight itself, this struggle marks all Motherwell's paintings with these black sounds. Lorca's superb "Llanto por Ignazio Sánchez Mejías" discussed earlier in this chapter gives the starting sound and vision of all the *Elegy* series. The solemn discourse is suited to "a country where all that is most important has its final metallic valuation in death."[20] The very density of the metaphoric domain exerts its fascination, before any analytic exercise in interpretation. Lorca speaks of the conjunction of death and the Spanish imagination:

Those heads frozen by the moon that Zurbaran painted, the butter yellows and the lightning yellows of El Greco, the narrative of Father Siguenza, all the work of Goya, the presbytery of the Church of the Escorial, all polychrome sculpture, the crypt of the ducal house of Osuna, the death with the guitar in the chapel of the Benavente in Medina de Río Seco—all equal, on

the plane of cultivated art, the pilgrimages of San Andrés de Teixido where the dead have their place in the procession; they are one with the songs for the dead that the women of Asturias intone with flame-filled lamps in the November night, one with the song and dance of the Sibyl in the cathedrals of Mallorca and Toledo, with the obscure "In Recort" of Tortosa, and the innumerable rites of Good Friday that, with the arcane Fiesta of the Bulls, epitomize the popular triumph of Spanish death.[21]

Without the signs of death being visible, the *duende* will not approach. Lorca describes them as "black sounds, behind which there abide, in tenderest intimacy, the volcanoes, the ants, the zephyrs, and the enormous night, straining . . . against the Milky Way."[22] They are to be read, like the constellations of Mallarmé, like Motherwell's *Elegies*, against the night.

Standing there, with the paint bucket and brush, on that immensity of deck that Melville gave our American imaginations, Motherwell feels the big canvas stirring under him "like an albino whale." He sends his assistants away, maintains a private vigil, so as to "focus," as he puts it.

The white light. In Alberti's *A la pintura*, there is a section entitled, with a wonderful condensation, *BLANCO*. This three-pronged word, meaning at once white, blank, and target, simultaneously spears its object in triple force and form. All these meanings enter into Motherwell's sense of white, when everything is terrifying in its openness.

In her piece of 1944 on "Feeling and Precision,"[23] Marianne Moore warns us against worrying how our work will be received; fear of incorrectness, she maintains, will only lead to rigidity. She first quotes Eliot on Bishop Andrewes's precision when he is "wholly in his subject, unaware of anything else" and next quotes a critic in the *New Sun* saying of Rembrandt's etching "The Three Crosses": "'It was as though Rembrandt was talking to himself, without any expectation that the print would be seen or understood by others. He saw these things and so testified.'" "The same rapt quality," says Moore, "we have in Bach's *Art of the Fugue*—his intensely private soliloquizing continuity that ends, 'Behold I Stand before Thy Throne.'" Seized by the moment and plunged into it, the creator is given over to the creation, and nothing else is called on to bear witness: just the self and what it sees.

Writing to Frank O'Hara, Motherwell exults in the great and grown-up joy of feeling and then turns to the combination of the precise and the personal that Marianne Moore sketched out:

The greater the precision of feeling, the more personal the work will be.
The more anonymous a work, the less universal, because in some paradoxical way, we understand the universal through the personal.[24]

Motherwell loves Gerard Manley Hopkins's emphasis on particularization, what Hopkins called "selving," that absolute individual taste, often bitter as gall, of "that self-taste which nothing in the world can match."

Later it is as if such unspeakable aloneness of experience will have to be shut off from the world entirely. That the resulting painting had to be protected against the air by a light spray varnish—light, because he wants to guard against the glossy and the polished—does nothing to lessen the intensity of feeling. It is like a cave: the elegiac tone we hear resounding now from this great painting recalls the cave of Lascaux, destroyed by human breath. It is now a "voice of silence, even," as Motherwell would have it, and Malraux heard it in his own *Voix du silence,* at the end of which he pictures the human hand trembling as it sketches on the wall of the cave.

There will be nothing but black and white here, in this reminiscence of a cave, linked, as elements in series are linked with others, to the series *In Plato's Cave* about to be discussed, and then to the *Night Music* series. Motherwell's work can be seen as one giant step, elegiac and epic. The personal significance of this entire epic, "the note of the human presence" that is everywhere in it, has to include the tragic sense of both life and death. So it is that Motherwell renounces colors completely in his painting of reconciliation in the National Gallery, deciding to have in his *Reconciliation Elegy* only black and white—always the two major protagonists of his painting, which he considered as colors. He treats this decision as an act of sacrifice, meaningful in itself:

> Twentieth-century modernism began optimistically, *à la* Apollinaire and Léger and Stravinsky, but after eighty years? What about Mandelstam and Kafka and Giacometti and Alban Berg and Black jazz? . . . Authoritarianism, bureaucracy, holocausts, nuclear terror, pollution, waste. . . . Bright color no longer represents social reality but human aspirations . . . as in Gothic stained glass at the time of the Black Death.[25]

Even as the white here, as always for Motherwell, conveys "the radiance of life," the white and black begin to merge, life with death, spontaneity and ecstasy entangled with dying, as in the baroque. Even when the creator was not, could not be allowed breathing time, his own time, even when he could not have a mural, only a separate painting, no matter how large, only *"a separate painting."* That reconciliation between the creator and his art is the final and hardest one. For the voice is regretful, elegiac even for the gesture, and is epic even in its desire: "If I had had the whole wall . . ." Perhaps that dissatisfaction with what is done, the belief that it can be started over, is what marks an American epic.

In Motherwell's studio we take up again our conversation about the *Reconciliation Elegy* in the National Gallery: I remember feeling its power over the beholder the last time I experienced it. Motherwell describes the desperate beating of his own

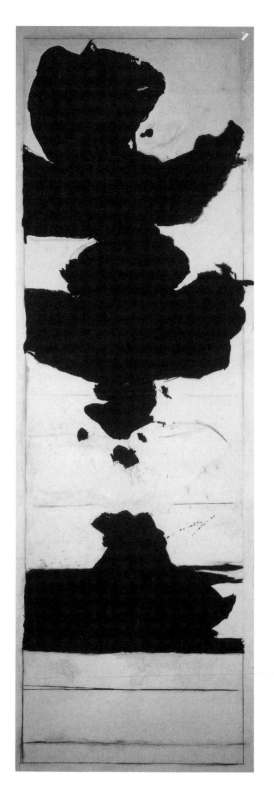

Reconciliation Elegy. 1978.

Acrylic on canvas, 3.048 m x 9.242 m (120 in. × 364 in.).

Gift of the Collector's Committee, © 1994 Board of Trustees, National Gallery of Art, Washington, D.C.

heart when he began at the left of the great canvas, which only calmed down after the left part, a work in itself, was finished. "But I never resolved the space in the left corner," he tells me, showing me a recent resolution of the same problem. I think of the idea of resolve: resolving problems, or resolving some split in consciousness, and the determination, will, and *resolve* such resolutions require.

That breathlessness of the artist, that desperate heartbeat, must somehow be conveyed in the rhythms of the work, its expression precise, not sploshing about in unspecific sentimentality. Robert Motherwell's emotional as well as his moral sense is felt in his language as in his work, and it is *precise,* having to do often with speaking, and speaking rightly, with judging rightly and assigning the right weights to things. A painter's judgments on painting, he believes, are ethical, before they are aesthetic, that his "art" is only "his conscience, slowly and painfully formed throughout the numerous errors committed along the way."[26] The history of his needing to be sure about the translation of the word *conscience* used by Breton into either "consciousness" or "conscience" speaks in the same vein. The argument was indeed about consciousness as well as conscience, and it mattered that it be rightly said, that the proper weight be given to the idea.

Looking at the *Reconciliation Elegy,* I think again of the baroque contraries, of red and black (as in Motherwell's *Le Rouge et le noir,* a title closer to those colors than to Stendhal's novel), and of his recent *Elegy No. 172 (With Blood),* where small red slashes lick about the large black shapes like fire, like blood, leaping vital against the color of death. Your painting is baroque, like poetry, I say to Motherwell, thinking how intensely it strikes against what would be weightless, colorless, lifeless. Yes, he says, that's exactly it.

These reconciliations merge life with death, as in the paintings of 1975 and 1976, with their *Threatening Presence* that emerges from Goya's late picture with the dog howling from the hill, as does his *Spanish Painting with the Face of a Dog.* I think of *Goya's Dog, Les Caves No. 2, Black and White No. 2, Ancestral Presence,* and the *Primordial Study,* where the canvas board shows through, as for the *Primordial Sketch,* whose dark shapes are lit by a sort of halo, but where the strong thrust leftward of the central shape balances the horizontal sweep, with a vague notion of a cross shape. These are all cave paintings, as I see them.

Motherwell says:

As I entered my sixties . . . I found a certain personal atavism, a growing desire for an almost primeval force (that has always been more or less latent in some of my work), becoming stronger. I thought as often of Stonehenge as of Brancusi, of Lascaux and Altamira as well as of *Guernica,* of the Vikings rather than the Parisians or New Yorkers. At any rate, the winter of 1976 was devoted to more barbaric and megalithic images, more so than perhaps at any time since I first stumbled on the *Spanish Elegy* theme.[27]

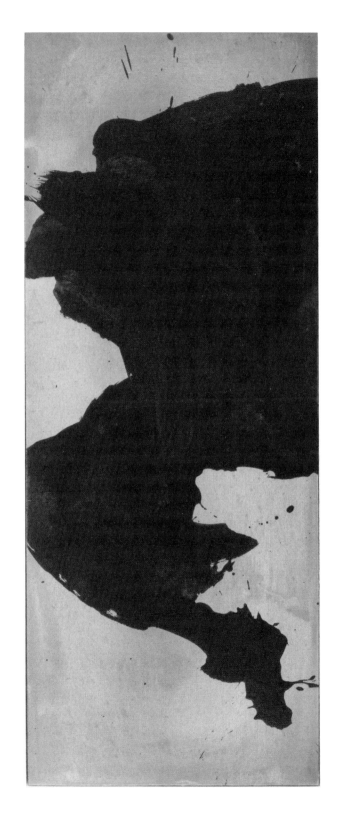

Goya's Dog (Sketch), 1975.

Acrylic on canvasboard, 9.625 in. × 24 in. (24 cm × 61 cm).

Private collection. Photo credit: Zindman/Fremont. © 1994 Dedalus Foundation, Inc.

Disappearance of Goya's Dog, 1990.

Acrylic on canvas panel, 7.875 in. × 23.875 in. (20 cm × 60.40 cm).

Private collection. Photo credit: Ken Cohen. © 1994 Dedalus Foundation, Inc.

{see color plate}

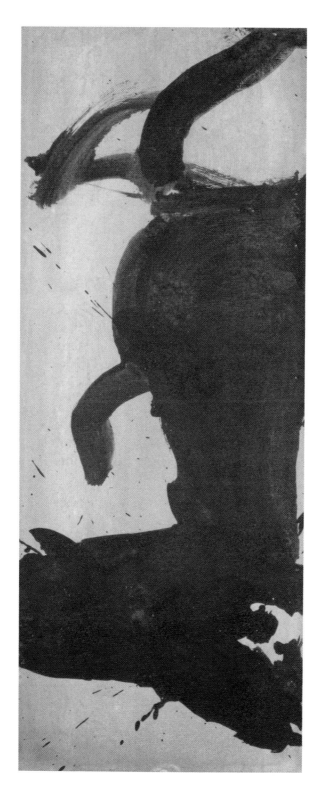

Primordial Sketch No. 7, 1975.

Acrylic on canvasboard, 8 in. × 20 in. (20 cm × 51 cm).

Private collection. Photo credit: Steven Sloman. © 1994 Dedalus Foundation, Inc.

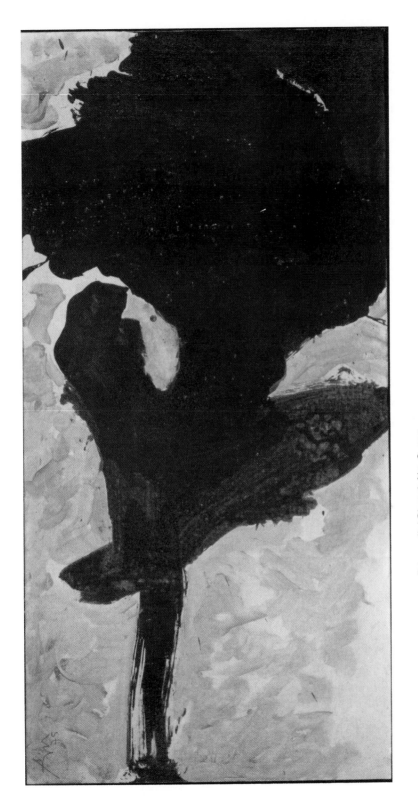

Primordial Sketch No. 9, 1975.

Acrylic on canvasboard, 12 in. × 24 in. (30 cm × 61 cm).

Private collection. Photo credit: Steven Sloman. © 1994 Dedalus Foundation, Inc.

Tell me whom you haunt, says Breton, and I will tell you who you are. Something haunting lingers about the *Reconciliation Elegy*, as if it had been created lonely and "not living with the tribe." Looking back at it, you can sense how the dark sounds of *Night Music* are approaching.

Dark Sounds

That's the one trouble with this country: everything, weather, all, hangs on too long. Like our rivers, our land: opaque, slow, violent; shaping and creating the life of man into its implacable and brooding image.

<div align="center">William Faulkner, As I Lay Dying</div>

Motherwell's paintings brood. Sometimes in color, more often in the drama of black and white. Jack Flam describes the rich associations of black and white in the artist's work, describing how they

> may evoke the abstract idea of death and life, but they also recall Mallarmé's white paper awaiting the excruciating appearance of a word; or the matter-of-factness of any printed words or music; or the extremes of darkness and light; or other kinds of art, from Japanese brush painting to Goya's etchings and Picasso's *Guernica*. As Motherwell uses them, black and white even evoke the stark flat light of certain southern lands: the whitewashed walls and brilliant shadows of Mexican, Greek, or Spanish villages, punctuated by the black garb of priests and perpetually mourning women. And at the same time, there also frequently appear in his pictures—sometimes at the edge, and sometimes at the center of our attention—the colors of sky, blood, and sand, or of bright pink scarves, vivid emblems of the fleeting moments of which eternity itself is composed. Together, these other colors and black and white, all colors and none, evoke the passage of time; but time in the abstract, as it exists beyond events or hours or years. Perhaps it is the tension between these two levels of awareness, between the small measures of time as experienced and the larger rhythm of time as conceived of in the abstract, that accounts for the tragic feeling of loss and regret that emanates from so many of Motherwell's works.[28]

Wallace Stevens's poem "Domination of Black,"[29] referred to above, conveys the heavy rhythms of utter darkness, in spite of never mentioning the black itself except in the title. The poem begins:

> At night, by the fire,
> The colors of the bushes
> And of the fallen leaves,

> Repeating themselves,
> Turned in the room,
> Like the leaves themselves
> Turning in the wind.
> Yes: but the color of the heavy hemlocks
> Came striding.
> And I remembered the cry of the peacocks.

In the center of the poem, the colors of the peacock tails will be linked to the hemlock leaves in their falling, that is, to death. They were already deadly, these "heavy hemlocks." The insistent repetition of the gerundives—"repeating," "striding," and "turning," repeated six times in the poem's heart—sounds out the incessant haunting of the hemlock theme, cried out with the peacocks' dreadful screech:

> I heard them cry—the peacocks.
> Was it a cry against the twilight
> Or against the leaves themselves
> Turning in the wind,
> Turning as the flames
> Turned in the fire

The cry is "Loud as the hemlocks / full of the cry of the peacocks" and then the question arises once more: "Or was it a cry against the hemlocks?" The peacocks crying, uselessly, incessantly, against the death that so permeates the poetry of Stevens, of Eliot, of Mallarmé, of Hopkins—all the poets Motherwell most loved.

In this poem, the narrator, the one who has remembered the cry, seen the colors turning, heard the screech against twilight and hemlocks, now stares out the window, to see "how the planets gathered / Like the leaves themselves / Turning in the wind." The fall of night, after the fall of leaves, striding black, unnamed yet sensed everywhere, dominates the senses entirely, in the poem as in Motherwell's *Elegies:*

> I saw how the night came,
> Came striding like the color of the heavy hemlocks.
> I felt afraid.
> And I remembered the cry of the peacocks.

This is exactly the feeling we have as we look at the great *Elegies* in earth colors (*To the Spanish Republic No. 167 [Spanish Earth Elegy]*), or at *Iberia*, or *Black Sun*, or at the Kierkegaard painting *Either/Or:* this is the dark heart of things, this is what we all remember. In the poem the association has been so worked out, the intertwining of fear and sound and sight so entire, that the two last lines stride into the sensibility all the more absolutely. "I felt afraid." The simplicity of the thing pre-

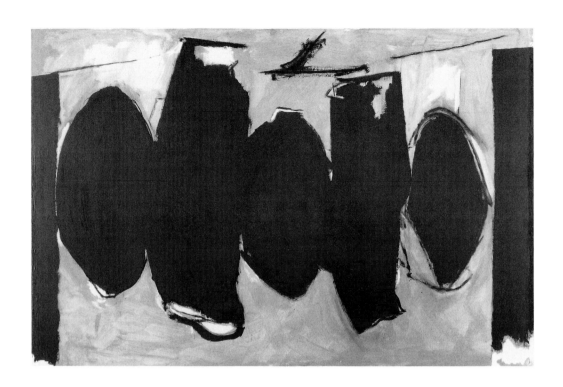

Elegy to the Spanish Republic No. 167 (Spanish Earth
Elegy), 1985.

Acrylic and charcoal on canvas panel, 48 in. × 74 in. (121.9 cm × 187.9 cm).

Private collection. Photo credit: Zindman/Fremont. © 1994 Dedalus Foundation, Inc.
{see color plate}

cedes the resounding "And" that recalls the memory. Of course, the poem had to end with these peacocks and their cry, still echoing in the American imagination. Of course, Stevens is the poet who most links America and France, who epitomizes symbolism for both sides of the Atlantic. Of course, Motherwell loved Stevens, and the way his dark rhythms still dominate, after Melville. Stevens's great poem of white, "The Snow Man" ("One must have a mind like winter . . ."), will link Mallarmé's swan to the American imagination, Motherwell's great white spaces to those in which the American imagination can take sail. . . . But for the moment, we are in blackness.

It is not just Wallace Stevens who is haunted by the sight and sounds of utter darkness, but a whole poetic imagination. Into this specific awareness of a sudden shriek, a peacock's cry, a Motherwell lithograph like *Black Rumble* of 1985 seems to fit. It is an outgrowth of *El Negro,* and itself, printed in blue, grows into a brighter series, *America–La France Variations III.* The transformation is accomplished simply, first with a bit of wrapping paper torn from a shelf, just the label from a package of *paper* (made and sent by the Arjomari-Prioux company), which makes a further intricacy in the layering of the image. Above that a strip of yellow paper is added. So the sheets of paper are sent in paper, labeled in paper that is then used in a collage: the act of using what is sent again bears witness to the occasion, to the *sending-relation* of the event. Like a paper in progress or a work of art on its way.

The outline on three sides of the *Rumble,* two thin red stripes above and to the left, picked up by a black strip below, corresponds to the thick black border all around in *America–La France Variations III,* totally enclosing the image. But the *sounds* of the rumble cannot be contained—this image strikes and remains. The little red dot in the lower right, beneath the black edge at the bottom, echoes the red stripes above, like a vulnerable heart to the whole.

Speaking of Solitude

Only in the ethical is your eternal consciousness: Behold, that is the reward!

Søren Kierkegaard

In his 1954 essay called "The Painter and the Audience," Motherwell tells a self-revealing story. He had received a commission the year before for the design of a tapestry for Congregation Beth-El, Springfield, Massachusetts, which may have provoked his meditation on the medium and the audience. In any case, the tone is singular. Beginning with the exclamation "What a disagreeable subject!," itself passably bizarre, he continues in this vein:

> For the "audience" that a modern painter *could* treat sociably is a ceiling or wall. It is a question of direct social contact. If the painter is commissioned to

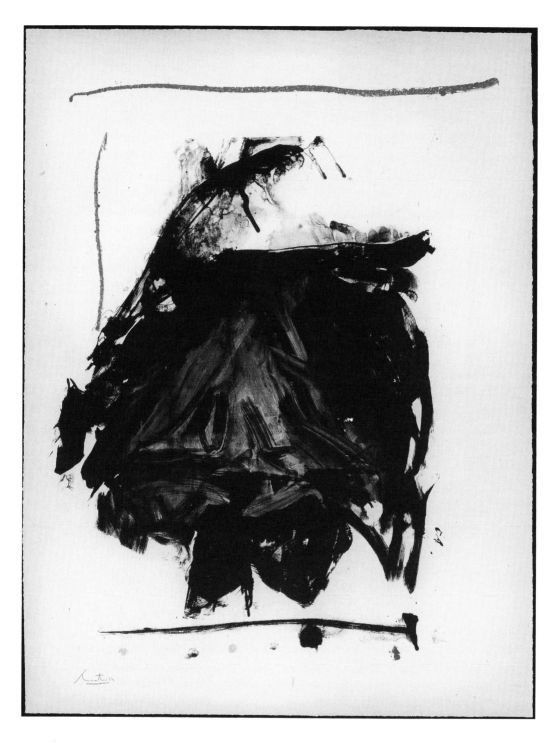

Black Rumble, 1985.
Lithograph, 38 in. × 29.25 in.

Printed and published by Tyler Graphics Ltd. Photo credit: Steve Sloman. © 1985
Robert Motherwell/Tyler Graphics Ltd.

paint a specific wall in a specific place for a specific person, he must take into consideration the wall's needs, as well as his own, and a real marriage could come about, lessening perhaps the distance between the modern artist and the public.[30]

Here he is contemplating the "solitude that has become traditional in modern society," and treating this relation to a wall or ceiling as an effort to reach beyond it. And yet the notion of relating to a wall as audience seems quite the opposite of outreach—the opposite, in fact, of the *porte-fenêtre* he was always so fond of, with its willed uncertainty of being out or in. Surely a wall is one or the other. But of course the desire to lay hands on the wall is, like his desire for painting on the floor, part of his continual attraction to the large, as it is also for Jackson Pollock and Franz Kline. This longing reappears in his handling of the immense *Reconciliation Elegy,* vast not just in size but in its very conception: the long brushes, the struggle with the unprimed canvas, all the imagery of setting out like Captain Ahab after a giant white whale, here floored. As Motherwell paints the *Elegy* on the floor, the horizon vanishes. Here is nothing but the form you can walk around, like the deck of a ship, a second *Pequod.*

Melville never ceases to haunt Motherwell's imagination. This is the Americanness of the *Opens,* the light of the early dawn and the imagery of striking off into the unknown. The epic consciousness, which was always close to Motherwell's own, is linked with "venturesomeness"—a quality which, as Kierkegaard knew, is tied even more closely to solitude as a fact, and to solitariness as an attitude. The path of risk is not lined with easy friendship, calling rather for renunciation. Motherwell quotes Kierkegaard:

> If anything in the world can teach a man to venture, it is the ethical, which teaches to venture everything for nothing, to risk everything, and also therefore to renounce the flattery of the world-historical . . . the ethical is the absolute, and in all eternity the highest value. . . .
>
> Besides, a daring venture is surely not merely a high-sounding phrase, or a bold ejaculation, but a toilsome labor; a daring venture is not a tumultuous shriek, however reckless, but a quiet consecration which makes sure of nothing beforehand, but risks everything. . . . Dare, dare to become nothing at all, to become a particular individual.[31]

And then in 1955 he writes a piece that seems to take the opposite tack from the wall-ceiling piece, entitled as it is, "A Painting Must Make Human Contact." I love painting, says Motherwell here, in that it can be "a vehicle for human intercourse." More radically still, "If a painting does not make a human contact, it is nothing."[32] Part of the risk now is this contacting and conversing, no longer only with the wall or ceiling but with the collectors and audience.

America–La France Variations III, 1984.
Lithograph, collage, 48 in. × 30.25 in.

Printed and published by Tyler Graphics Ltd. Photo credit: Steve Sloman. © 1984
Robert Motherwell/Tyler Graphics Ltd.

The lesson to be communicated is serious; it is, in this time of postwar uncertainty, deeply felt. Any question about objects and object relations is less significant than the moral attitudes that are, properly, "the real subject of painting."[33] The link with Sartrean existentialism (typified by the leanings of the *Partisan Review* of 1947 and later) remains clear and firm, says Dore Ashton.[34] In the moment of creative choice, artists make themselves, always, apart. This exactly goes along with the involvement that the existentialist requires—being "engaged" in one's own situation or situatedness.

Everything can be seen as part of this psychological engagement: Jackson Pollock painting on the floor without easel, palette, or brushes, in order to keep within his painting; De Kooning's uncompromising attitude toward dealers, the public, and himself; Motherwell's choice of the collage medium to capture the ongoing everydayness of his life, made into art, or then, on the other hand, his gigantic scrawl *Je t'aime* over a canvas, so the expression of love writ large makes up both the sense of the work and its feeling. It was Matta who suggested, in 1943 when Motherwell had made his earliest collages in Pollock's studio, that he increase their size—and so he did, producing during the next four months *Pancho Villa, Dead and Alive, The Joy of Living,* and *Surprise and Imagination.*[35]

The large gesture matches the heroic stance adopted by the artists of what we now call the New York School. Ashton, quoting the Nietzsche passage that accompanied a drawing by Theodore Stamos in the third issue of *Tiger's Eye,* points out how this oracular poetic tone accords with the spirit of those painters. Here is Nietzsche:

> I shall keep my eyes fixed on the two artistic deities of the Greeks, Apollo and Dionysus, and recognize in them the living and conspicuous representatives of two worlds of art differing in their intrinsic essence and in the highest aims. I see Apollo as the transfiguring genius of the **principium individiationis** through which alone the redemption in appearance is truly to be obtained; while by the mystical, triumphant cry of Dionysus the spell of individuation is broken, and the way lies open to the mothers of being, in the innermost heart of things.[36]

Such high lyricism harmonizes completely with the surrealist tone; all of the romantic, heroic, gestural attitude tinged with the tragic works together to inform the writing, the art, and the life of this group at this moment, however individuated they are.

"Every intelligent painter carries the whole of modern painting around with him," Motherwell liked to say. Against that background, the Sartrean tenet that whatever you choose, you choose for everyone takes on grave connotations. Since there is no purely individual, irresponsible choice, you have to believe that your selection of one form over another, one idea over the next one, will matter for many. When the slightest scribble has to be read as a significant brooding of your hand and mind, artists are linked in a moral intellectual mode, apart from other dwellers in modern American society.

Antibourgeois, bohemian in its feeling, this art does not require of its practitioners anything like an ascetic life. Some of these New York School artists lived that, some did not. The question is, as it has to be, irrelevant to the thrust of the art work itself. The *work* feels like a solitary gesture thrown, hurled into space: like Heidegger's "thrownness" of things. This is not about politics or even about group behavior—this is about art. American art.

Hollowness, Postsymbolist Style

This is the dead land
This is cactus land
Here the stone images
Are raised.
T. S. Eliot, *"The Hollow Men" (1925)*

The Hollow Men of 1983 has the shape of an *Elegy,* with its ochre ovals, thick and linked under a black sky. Those elegies for all of us, and not just for the Spanish Republic, those paintings that reach past their original gesture, find an apt response in the tragedy of hollowness. Like something that is nothing at its core.

Postsymbolism has, as symbolism did, a romantic aura to it. Dore Ashton leads off her essay "On Motherwell" with the reflection on the dark sounds of the *duende* already quoted in relation to Lorca and to the *Spanish Elegies,* but those sounds are introduced by a meditation on the romantic temperament that was Motherwell's, which "seeks to exclude all but the most tremulous of emotions, dark or bright. He craves the edge."[37] Motherwell's blacks, in their struggle with and play against his whites, have for their background a firm basis in the literature that was so crucial for him. Here the literary and visual sensitivities with which he was so gifted raise each other to an intensity inconceivable in an art less informed by poetry.

Those black rhythms of Wallace Stevens in their dominating rhythms "turning . . . turning," raised to the point of ultimate intensity, are put in symbolist play against the white images of his man of snow and crystal "listening to the nothing that is" and his bowl of carnations in "Journey to the Interior" to be read along with the snow. Among the junctions of symbols and spirit that go to make up the density of great works of art in neighboring fields, none is more convincing than this

The Hollow Men, 1985.
Acrylic and charcoal on canvas, 88 in. × 176 in. (224 cm × 447 cm).

Private collection. Photo credit: Zindman/Fremont. © 1994 Dedalus Foundation, Inc.

wide-ranging and deep-moving correspondence of color and craft in the interplay of black and white: of abyss, darkness, bullfight, and death, with swan, snow, frozen lake, and bowl of carnations.

The whole panoply of symbolist and postsymbolist imagination is at work here, starting with Baudelaire's black despair in the Spleen poems with their pluviose country of "ennui," the driving rain making up their prison bars, their heavy lids weighing on the universe. Insisting on the way correspondences work to link things by the whirling harmonies of senses or synesthesia, Baudelaire's celebrated sonnet of "Correspondences" concludes with a famous statement of this intermingling:

> Comme de longs échos qui de loin se confondent
> Dans une ténébreuse et profonde unité
> [Like long-held echoes, blending somewhere else
> into one deep and shadowy unison][38]

Baudelaire's poet as albatross, with wings so large he is ill at ease on the land, is linked to the poet as swan in Mallarmé, as to the *Wild Duck* in Ibsen's drama by the same name, which Motherwell painted in 1974. He refers this symbolic majestic bird to Kierkegaard's tale of the wild goose who could become a tame goose, although a tame one could not become a wild one.[39] The less risky is bound to win out, more often than not. So, in Kierkegaard, "The wild goose had so committed himself to the tame goose that it had authority over him."[40] That Motherwell used to love to tell this tale indicates, I think, his attraction to eccentricity, his fear of being classed with the "assis," those sedentary bourgeois characters so despised of Rimbaud and the other symbolists. The point was to set the swan aloft—it was never to tame or reduce the swan to pigeon or the goose to mouse.

Among other postsymbolists, we have to consider the poet who served at once as warning and appeal to Motherwell: T. S. Eliot, whose "The Hollow Men" of 1925 gave the impulse to Motherwell's great canvas *The Hollow Men*. The problem here (see the interview in chapter 6 dealing with this topic) was that Eliot was known as a right-wing rather anti-Semitic Anglo-Catholic royalist, and that Motherwell's detractors were, according to him at least, frequently given to comparing him with Eliot, since he was a Scottish-Irish Episcopalian.

Motherwell, in his *The Homely Protestant* and his *The Hollow Men* was well aware of the self-portrait he was sketching through the words of Eliot. In the study for *The Homely Protestant*, his collar sits high and white over a well-groomed exterior. These are the origins of his "social tribe," neatly bounded; in the finished work the neat boundaries disappear as the social appearance dissolves and the collar is absorbed in the rest.[41] James Breslin, who points this out, adds that *homely* in this sense means "stay-at-home," and links Motherwell's attitude about it to his abused childhood, when both his parents, especially his Irish-Scottish mother, would, ac-

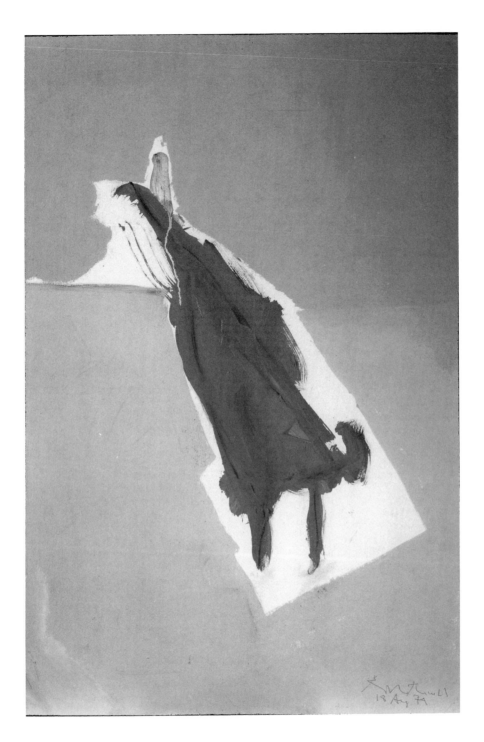

The Wild Duck, 1974.

Acrylic on board, 36 in. × 24 in. (91 cm × 61 cm).

Private collection. Photo credit: Steven Sloman. © 1994 Dedalus Foundation, Inc.

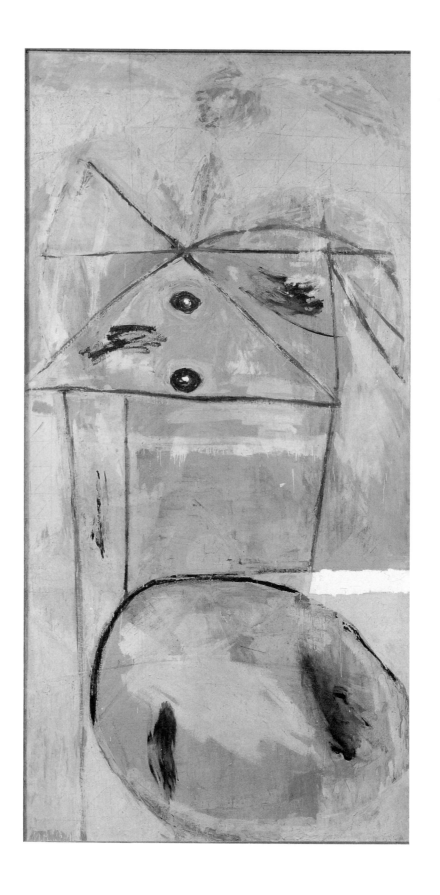

cording to Breslin's account, "beat the hell" out of him and his sister until their "heads were bloody"; his father would hit him with his brand-new shoes and then put them back in tissue paper in the closet. Small wonder the child developed asthma, and small wonder that the boundaries enclosing the figure will eventually break. The self was not to be bounded, or suffocated, at home or away.

This odd picture of the self will be linked with *The Hollow Men:* we grow up, all of us, from bounded beings to beings hollow at the core, unless we pay attention to what is central, unless we refuse to let ourselves be cut off from each other and ourselves. Motherwell recognizes himself in isolation as vacuous, as a meaning unfilled and unfulfilled. The subtitle for Eliot's "The Hollow Men" invokes Joseph Conrad's dark, grim novel *Heart of Darkness,* at whose center is the announcement of death, like an annunciation in reverse: "Mistah Kurtz—he dead." The novel continues with a dedication to a figure of straw, the straw man or Old Guy burned on Guy Fawkes' Day in a bonfire that will be later read as leading to the world's end. We are all of straw only, flammable, empty, and hollow at the core, dead like Mistah Kurtz, and knowing it. The Waste Land is our inheritance, and in a terrible sense our home.

Do you have to be an Episcopalian or Anglo-Catholic to feel Eliot's anguish? to picture it? No, but it certainly helps, as does the gloom of Irish Catholicism for Beckett and Motherwell's favorite Irishman, James Joyce. Motherwell's early mistreatment at the hands of his parents enters here with dark Celtic foreboding and dark repercussions. The litanic rhythms, the unfinished statements, and the falling of the shadow are all part of this markedly sentimental, powerfully confessed state of the heart and soul. Motherwell's Celtic heritage could not have responded any way other than strongly to this text, as singular in its own right as his work is singular in our time. Eliot begins with an unforgettable collective confession that will echo in Motherwell's work by the same name:

> We are the hollow men
> We are the stuffed men
> Leaning together
> Headpiece filled with straw. Alas![42]

This poem of straw dedicates itself implicitly to Death's darkness and reign, while its unfinished phrases tear at our eschatological consciousness with their recall of the Lord's Prayer ("For Thine is the Kingdom, the power and the glory, for ever and ever Amen"). But here, after the whisperings and rustlings of the straw

beings we are, there will be no glory, only the Shadow and a whimper, unfinished in its phrases, undramatic in its mild response to drama, for ever and ever:

> *For Thine is the Kingdom*
> For Thine is
> Life is
> For Thine is the
>
> *This is the way the world ends*
> *This is the way the world ends*
> *This is the way the world ends*
> *Not with a bang but a whimper.*

This extraordinary confession of collective emptiness in 1925 is followed by the powerfully sensed poem "Ash Wednesday" of 1930, which marks Eliot's official conversion to Anglo-Catholicism and royalism. Its litany of Lenten confession is no longer collective, for the "we" has given way to the singular and singularly sad "I." Its famous beginning, which calls on a primitive melancholy, has the same dominating rhythms as Stevens's "Domination of Black" and "The Snow Men," poems in which the gerundive leads the way:

> Because I do not hope to turn again
> Because I do not hope
> Because I do not hope to turn

I see the verbs of turning and spinning, and their gerundive forms turning, listening, blowing, as the parallel of dramatic action painting—they are about activity, process, ongoing gesture.

Passionately interested in Mallarmé, in his obsession with nothingness, absence, and the swan, Motherwell was attracted to and influenced by the symbolism that poet incarnated, as by the postsymbolism of Stevens. Furthermore, Motherwell never overcame his fascination with Eliot, although he dreaded to be associated with the latter's seeming conservatism. Eliot has his words turning in the tormenting spin that is equivalent to Motherwell's scribble, the initially unmeaning whirl of lines as a trancelike anticipation of meaning:

> If the lost word is lost, if the spent word is spent
> If the unheard, unspoken
> Word is unspoken, unheard;
> Still is the unspoken word, the Word unheard,
> The Word without a word, the Word within
> The world and for the world.

What will emerge, in the poem's own time, is the prayer of meaning in the dark night of the soul, with a line indented from the main body of the poem like another voice, voicing the lament of a wrong done somehow, a mythical collective fault here assumed by the singular pronominal voice:

O my people, what have I done unto thee.

As the opening "Because" leads to a concessive "Although," the litanic ac-knowledgement of too-lateness returns, heralding the longing for peace, for sitting still, for conciliation, nonseparation, and private meditation on the circle of the poem, like some magic incantation, some Zen poem-in-process, or stroke-as-meaning. Whatever there may be in our tormented minds, there is still this:

Although I do not hope to turn again
Although I do not hope
Although I do not hope to turn

. . .

Teach us to care and not to care
Teach us to sit still

. . .

Suffer me not to be separated

And let my cry come unto Thee.[43]

Here finally all is gathered up into the cry: the "I," the "we," the "us," and the "me." More than a point about religion, whether Anglo-Catholicism or any other, I am making a point about the ingrown rhythms like automatic incantations, and how they relate to the initial turn of the stroke or scribble on the canvas. And a second point about how the confessional tone lends depth to the picture, like the black lines and swashes Motherwell will add. In the series form, the sense of deathly darkness provides the greatest life to the art.

The *Night Music* series will bear this out.

Open Possibilities

> The problem of the artist is to wait until reality speaks to him.
> Motherwell, *draft of a preface for the journal* possibilities, *1947–1948*

So Many Possibilities

Peculiarly American in size and conception, and in its massiveness and monumentality of conception, Motherwell's work has about it everywhere a passion for the sense of *process* formulated by the American pragmatist John Dewey. He had read Dewey's *Art as Experience* at Stanford and referred to it as one of his "early Bibles." Art's power of expression, says Dewey, has its source not in the mimetic representation of any subject but rather in the possibilities of forms and colors interacting. "I owe Dewey part of my sense of process. He demonstrated philosophically that abstract rhythms, immediately felt, could be an expression of the inner self."[1] It is all a matter of what you *abstract* from experience, on what you lay the emphasis. "My painting," says Motherwell, "tends toward a certain form of simplification." From that simplification itself—another way of speaking of abstraction—there is generated an immense power of concentration.

Speaking of the abstract in 1951, Motherwell celebrates within it a kind of lyricism we would do well to remember and to treasure:

One of the most striking aspects of abstract art's appearance is her nakedness, an art stripped bare. How many rejections on the part of her artists! Whole worlds—the world of objects, the world of power and propaganda, the world of anecdotes, the world of fetishes and ancestor worship . . . Nothing as drastic an innovation as abstract art could have come into exis-

tence, save as the consequence of a most profound, relentless, unquenchable need.[2]

Optimism about abstraction and the use of rhythm and gesture as sources of aesthetic power make up between them one of the major *possibles* that underlay the development of the journal *possibilities*. The small manifesto in the single issue of the journal (winter of 1947–48) as a magazine of practicing artists and writers ("Robert Motherwell, art, Harold Rosenberg, writing, Pierre Chareau, architecture, John Cage, music") speaks of experience without any formula that would seek to transcend it. It sufficiently defines possibility as *openness*.

One of Motherwell's drafts of an essay for the journal, on the subject of uncommitted attention, reveals just how close he is to the originating surrealist message: what is to be treasured is the *état d'attente*, the state of expectation itself. What is to be shunned is anything already-thought, anything that is not still to be thought out. "The strong man," he quotes from Nietzsche as an epigraph, "is the one who can wait"; this is followed, in one of the drafts, by the statement: "*the problem of the artist is to wait until reality speaks to him . . . to do nothing until a work, an image, a clear structure begins to unfold its meaning.*" Although these drafts were not used in the final state of the preface, it is likely that the first three of its sentences, which echo this thought, are his, and the remainder of the preface, about political commitment, Rosenberg's. The preface begins with an assurance about the artists and writers practicing in their work their own experience

> without seeking to transcend it in academic, group or political formulas. . . .
> Such practice implies the belief that through conversion of energy something valid may come out, whatever situation one is forced to begin with.
> The question of what will emerge is left open. One functions in an attitude of expectancy. As Juan Gris said: "You are lost the instant you know what the result will be."[3]

Here, in the trace of what was originally the attitude of the journal as Motherwell intended, and then later in his own *Open* series, "conversion of energy" is exactly the point, as it passes from the work of art to the onlooker, for both of whom the attitude of openness is the essential. As Motherwell learned from Wolfgang Paalen, even more than from Matta, art predicts and life follows. This is what André Breton had always held, claiming that in the surrealist world "the imagined tends to become the real." Motherwell translates an article by Paalen, in which the latter says:

> The true value of the image, through which artistic activity is connected with human development, lies in its capacity to project a new representation

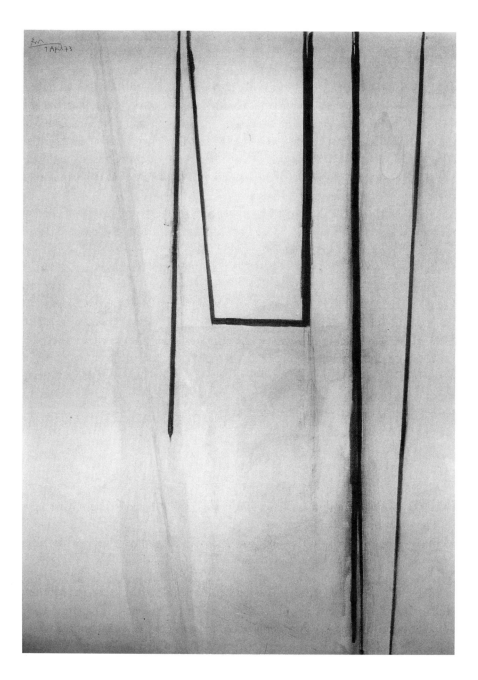

Untitled (Blue Open), 1973.
Acrylic and charcoal on canvas, 61 in. × 44 in. (154.91 cm × 111.76 cm).

Private collection. Photo credit: Steven Sloman. © 1994 Dedalus Foundation, Inc.
{see color plate}

which does not have to be referred for its meaning *to any object already existing. . . .* The true value of the artistic experience does not depend on its capacity to *represent,* but on its capacity to *prefigure,* i.e., on its capacity to express a potentially new order of things.[4]

Of course, this was always André Breton's point about how an acute sense of the possible, without any actual reference, allows what is only imagined in the beginning to become, in the long run, the real ("le possible tend à devenir le réel"). Surrealist faith is intense in what opens out into the unpredicted, or it is no faith at all. This is a world of absolutes, expressed by surrealist Breton's celebrated statement: "Beauty will be convulsive, or will not be."

"One of the tasks that modern art set itself was to find a language that would be closer to the structure of the human mind," says Motherwell in 1982.[5] Such extreme, even "extremist faith in sheer possibility" is necessary in a time when what he and Rosenberg call "the political trap" seems to close in on the artist, the writer, and everyone else. In her *New York School: A Cultural Reckoning,* Dore Ashton describes the "rueful, pessimistic undertone" of Motherwell's essay "The Modern Painter's World," with its indecision as to value in a society war-prone, bourgeois, and unhappy at its core: "The artist's problem is *with what to identify himself.*"[6] Since the only possession of the artist or writer is the action on the canvas or paper, the floor or the page, it is only these individual acts and faith in their making and meaning that can confer value. As to what will become of them, that is for another time—the point is to make the existential gesture and to believe in the importance of making it.

The gesture is important because it is lonely, as lonely as it is meaningful, one *because* it is the other. The very particular isolation of these very particular artists was a current theme of the New York School: they felt themselves to be misunderstood, marginal, misfits. Clement Greenberg agreed with this opinion they had of themselves, writing, calling their isolation "inconceivable, crushing, unbroken, damning."[7] His celebration of the New York School required that all outside references, to the "world" but also to the world of other arts, be absent—heroically absent—from their truest work.[8] Barnett Newman and the other painters thought of themselves as the true revolutionaries, philosophers, scientists, thinkers. As Motherwell said in 1944, these artists tended to paint "for each other," not knowing for whom else they might be creating. Risk, individualism, heroism, the ability to create meaning by the force of work: these themes echo endlessly in the writings, the criticism, and the self-expressive statements of the period. They are judgments from outside and in, placing the artist as romantic loner, combining nineteenth-century legend and twentieth-century avant-garde.

This construction of a myth that was in part true is strengthened from another side. Motherwell was always to stress the importance of Freud. He himself had written on the psychoanalytic interpretation of Eugene O'Neill in college, and

would discuss Joyce's *Ulysses* in Freudian terms, but he was, for a while at least, equally fascinated by Jung. This interest arose first in his contacts with Wolfgang Paalen in Mexico, when he was there with Matta. Paalen, who had studied Indian art in Alaska and Canada, organized an International Surrealist exhibition in Mexico, and exhibited in 1940 at the Julien Levy Gallery, had become enthusiastic first over the pragmatism of John Dewey. This philosophy, directly opposed to the mystic tone of the surrealists, and then to Jung and his collective unconscious,[9] was of increasing importance to Motherwell. Ashton cites one of his "vague cosmological" statements about the dream, made in December 1941,[10] where Jung's voice can be heard, even though he is not quoted.

Motherwell's work is published in Paalen's journal *DYN* (the term taken from Greek *dynaton:* the possible). The title itself, recalled by the later journal *possibilities,* indicates the closeness of their views. Specifically, Motherwell's writings on "The Creative Use of the Unconscious" seem to be influenced by this early exposure to the Jungian emphasis on creativity. As for Dewey, Ashton points out, it is through his philosophy that Motherwell learned to "regard abstract rhythms as an expression of the inner self."[11] Motherwell combines a belief in the infinite possibilities of the individual expression, of the pragmatic gesture American-style, with a European sensitivity to the psychoanalytic approach. His temperament and openness lead him to mediate between two approaches, here as elsewhere.

The *Open* Series

Longing, we say, because desire is full of endless distance.
<div style="text-align:right">Robert Hass, *"Meditation at Lagunitas"*</div>

Motherwell tells of the way the *Open* paintings came into being. One day a smaller canvas was leaning against a larger one, and he considered that outline. It was as if a door could be pushed ajar in the painting. Then he lifted that door to the top of the canvas, with its outline reversed, and it became a window, freeing a new opening space above. So the extensive series of *Opens* began.

One of the peculiar satisfactions in these canvasses is the way the framing element, with its verticals and horizontals, finds a perfect repetition. In his celebrated piece on framing, "Field and Vehicle in Image-Signs," Meyer Schapiro discusses how such non-mimetic elements as ground and frame affect the meaning of the imagery "and in particular their expressive sense" and how, at an earlier epoch, "their functions in representation in turn lead to new functions of expression and constructive order in a later non-mimetic art."[12] The same arguments apply, of course, to Motherwell's *Lyric Suite* and *Beside the Sea* series, where the strong bottom line *within* the picture acts to reinforce the bottom of the frame.

Motherwell's *Open* paintings contain in themselves, as in their intention, an incontrovertible breathing space. They have sills and urge us to think of thresh-

Open No. 1, 1967.
Acrylic on canvas, 114 in. × 83 in.

Photo: Ken Cohen. Courtesy Knoedler and Company, New York {see color plate}

olds. They are related to the conception and realization of the heavily rectangular and brightly colored *Garden Window* and the *Summer Seaside Doorway* with their immensely colorful statements about framing and openness at once, and their remembrance of Matisse's *Porte-Fenêtre à Collioure.* Some of the many definitions of the term *open* that the artist adduces from Webster's, saluting its multiple possibilities, express quite precisely the feeling of this participatory painting "exposed to general view," "acting publicly or without concealment." They are open and opening gestures: they "give access" and "render accessible to knowledge," even as they "unfold and expand" in space. As they abolish perspective, they give into a great spaciousness: "A door imprisons, and it suggests the entrance to a cave or temple, whereas I seek the opposite: an opening into an airy, rising world."[13] Doorways in Motherwell's work are treated as openings and not closures: the interplay of colors in the blue, vertically striped *Greek Door* (1980–1981) and the deep yellow expanse to its left has as much joy and openness as the *Opens* themselves. The white Mediterranean light suffusing the whole permits access to this "airy world."

In 1982 Motherwell would meditate on the importance of the *nothing* in his own art, and in relation to Oriental philosophy, linking it to the idea of *beingness.* It is all connected: the animation of the void—strongest in his *Open* series—the particular state of the medium—its viscosity—and the state of mindlessness in which the hand takes over. His testimony is invaluable about the affinity between Oriental painting, especially Japanese Zen painting, and his own. The metaphysical void, he says,

> is perhaps the strongest in the *Opens,* built on a conception analogous to the Oriental conception of the absolute void: that you start with empty space, and that the subject is that which animates the great space. . . . You learn of Japanese calligraphy to let the hand take over; then you begin to watch the hand as though it is not yours. . . . When the viscosity is right, it is close to (as the Orientals are always trying to express) mindlessness, or to pure essences, with nothing between your beingness and the external world. As though your beingness were transmitted without intervention.[14]

For the *Opens*

Among other philosophers of the open and openness, Martin Heidegger comes closest, I think, to providing us a thoughtful basis from which to meditate on the *Opens.* In his celebrated essay "The Origin of the Work of Art" he makes a claim sufficiently large to respond to Motherwell's generous idea of openness: "To be a work," he says, "is to set up a world."[15] The work has to *make space for spaciousness,* meaning to provide room for and establish openness. "The Open," in its structure—the architecture of poetry, by which Heidegger means literature at pre-

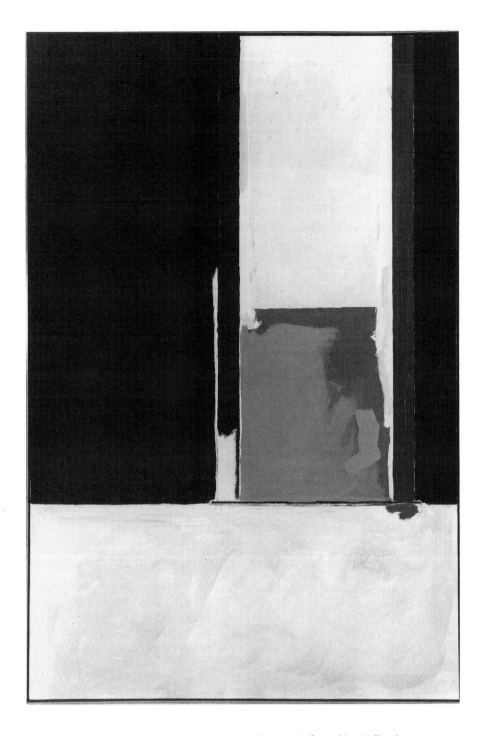

Garden Window (formerly *Open No. 110*), 1969.
Acrylic on canvas, 61 in. × 41 in. (152 cm × 124 cm).

Collection The Modern Art Museum of Fort Worth, Fort Worth, Texas (Gift of the
Friends of Art, by Exchange and Gift of the Dedalus Foundation). Photo credit: Ken
Cohen. © 1994 Dedalus Foundation, Inc. {see color plate}

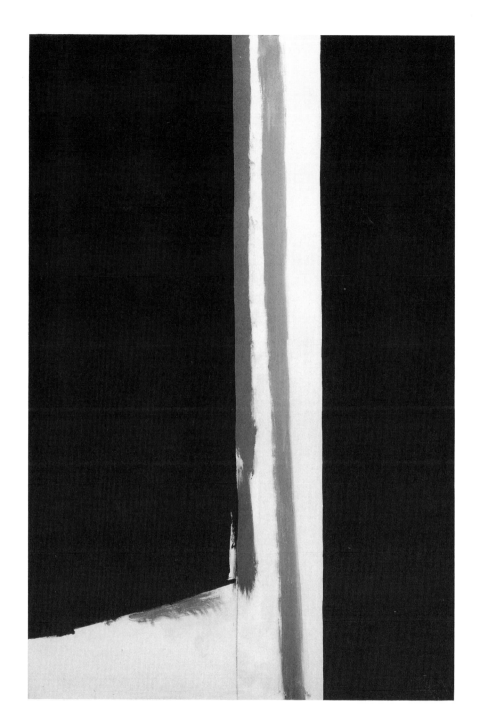

Summer Seaside Doorway, 1971.
Oil on canvas, 60 in. × 40 in.
Frederick Weisman Company, Los Angeles, California {see color plate}

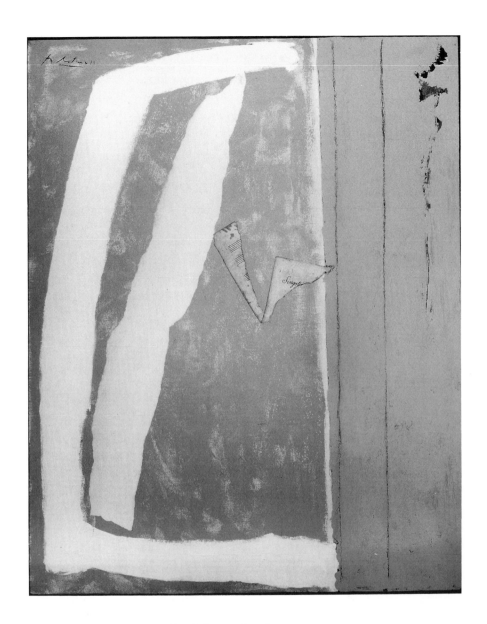

Greek Door, 1980–1981.
Collage and acrylic on canvas panel, 30 in. × 24 in.
(76.20 cm × 60.96 cm).

Private collection, Madrid. © 1994 Dedalus Foundation, Inc. {see color plate}

cisely its most open or most present—does battle against everything closed off and in.

"The work as work, in its presencing, is a setting forth, a making."[16] What could be closer to Motherwell's project than this expression—this unfolding—of the kind of presence intended, accomplished even, in the work of the *Opens*? In the center of this deliberate "unconcealedness," this rough spatial texture you can walk around, there is a central lighted clearing, in continual dynamic action against what is hidden. An energetics of openness, we might say: "This work's 'being' is *energeia,* which gathers infinitely more movement within itself than do the modern 'energies.'"[17]

Already the series title "the *Opens*" conveys an extraordinary sense of possibility. "The *Open* series," I say to myself: the art of the possible—in the title but also in the *lineage* of the thing. I am thinking of the way the window lines tremble in places, hand-drawn, like the trace of the pulse. They vibrate dark against the color of the field: yellow, blue, red, with such force that on occasion, and in response, the edge of the thick paper seems to vibrate uneven against its mat. The rhythm feels syncopated but not tentative. The lines in these *Opens* can be drawn, in charcoal, or scratched—they give the feeling both of "additive" and "subtractive"—of a digging into the heart of the matter and an overlay of interest in the surface texture. They go beyond the minimal, to what feels like the source of emotion.

One of the *Red Opens* is broken: *Broken Open.* Where we expect the rectangle to complete itself on the right is a jagged form, all the more upsetting since we are used to the door/window, with its closure; here the window itself is broken open. No escape: the violence is inconceivable, brilliant in its red statement. I can do what you would not expect—look!

Mallarmé's sonnet "Victorieusement fui le suicide beau" comes to mind, with its gleaming sunset departed in triumph: "Victoriously fled the lovely suicide." "Victorieusement"—victoriously: the adverb has the kind of resonance associated with this work of a gesture always in process. The work is open like its title. It is not at all as if something had left—rather more as if something could now come to be. Motherwell's strong forms have nothing to do with departing, with fading. His light always seems, on the contrary, informed by fullness in the bright flat certainty of noon—that kind of sharpness, that kind of vibrancy. His forms have Mallarmé's strength of structure.

That color red is like the crimson edge of the volumes Mallarmé paid such close attention to, in his study of the form of the book open in a V, the sensuality of its red is like that fire Mallarmé saw flashing from syllable to syllable when language was in its red heat, each element reflecting off the rest. "Sometimes," Motherwell wrote in 1951, "I have an imaginary picture in my mind of the poet Mallarmé in his study late at night—changing, blotting, transferring, transforming each word and its relations with such care—and I think that the sustained energy for the travail

Broken Open, 1981–1987.
Acrylic on canvas, 72 in. × 84 in. (182.88 cm × 213.36 cm).

Private collection, California. Photo credit: Ken Cohen. © 1994 Dedalus Foundation, Inc. {see color plate}

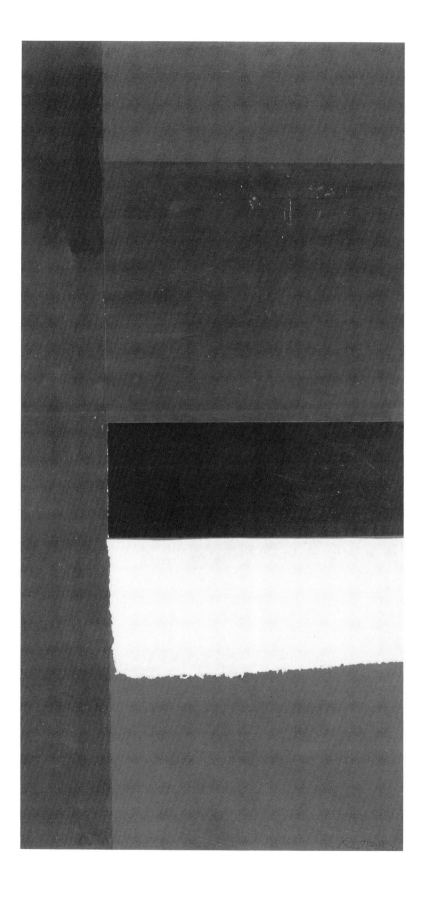

must have come from the secret knowledge that each word was a link in the chain he was forging to bind himself to the universe."[18]

Can the red of this work be called "crimson"? Perhaps, but perhaps only in the French sense: it has the sensuality of a celebrated baroque sonnet in red by Jean de La Ceppède in the seventeenth century. Concerning a victory in the spiritual sense, it is no less sensual for that, opening like a trumpet call:

> Aux monarques vainqueurs la rouge cotte d'armes
> Appartient justement. Ce Roi victorieux . . .
> [To conquering monarchs the tunic's red
> Justly belongs. This victorious King . . .][19]

The progress in the poem is a meditation in process. It leads through the victory of the King, who lends his glorious cloak, bloodred, for us to contemplate. This ambivalent crimson glory ("ô pourpre") figures him forth as prince and mocked majesty. The flesh of the poem is in its turn reddened by the repentance of the reader shedding "mille pouprines larmes," a thousand crimsoned tears, over his "red" sins. This symbolic red (of the cloak, the poem, the sins) remains more essentially still the red color in itself, to become the very being of Christ the King absorbing and redeeming, yet addressed in the familiar form: "les sanglants replis du manteau de ta chair" ("the bleeding folds of the cloak of your flesh").

Now the resounding red of such an *Open* as the one I am thinking of clashes joyous and passionate—against the blacks of Motherwell's massive *Elegies for the Spanish Republic*. It opens in and against their white spaces, making a triumphant baroque palette, resounding high. ("Baroque: I think of your paintings as baroque," I say to Robert Motherwell. He replies: "You have found just the right word: *baroque*."[20]) In *Voluptuousness with Bar Sinister* of 1976, the black stripe plays against the vast red expanse with the equal-sized white bar of cloth below it, resoundingly three-colored like a great romantic-baroque expanse of erotic *liebestod*, a voluptuous struggle to the end. It is as if the bars of musical scores and the harmonies of life and art were to be set resounding in the mind.

Motherwell's whole attitude toward the livingness of colors, his full-scale plunge into them, depends on their mingling, their multiple vitalities: witness his sense of blueness and the ocean he prefers to the mountains (*Summer Seaside Doorway* of 1971; *Blueness of Blue* and *Summer Open with Mediterranean Blue*, both of 1974). No less vital is his sense of white and black and ochre: these experiential modes are the best expressions of feeling in the work of art. I think of his works on red, on blue—of a red *Open*, where the window outline is in white, with the far

Summer Open with Mediterranean Blue, 1974.
Acrylic on canvas, 48 in. × 108 in. (121.9 cm × 274.3 cm).

Collection The Modern Art Museum of Fort Worth, Fort Worth, Texas (Gift of the
Friends of Art, by Exchange and Gift of the Dedalus Foundation). Photo credit: Ken
Cohen. © 1994 Dedalus Foundation, Inc. {see color plate}

right line repeating in triplet form, filled in with a light blue, like a reflection on the tricolor of the French flag—of *Opens* in ochre, tan, and black—and above all of their warmth. Even Motherwell's grays can be warm, and his blacks can burn.

His colors are in movement. Indeed the *Open* series in particular serves as a model for implicit motion, out past whatever would hold us down. *Open No. 104 (The Brown Easel)* of 1969, for example, can be read as a meditation on sharing and on threshold, for the implicit motion, now finished, of the hand, and the never-finished motion of the eye. The upper three-sided figure in its open rectangle, sharing a line with the lower figure, is two-sided or three-sided, open or closed, depending on how we conceive of the sharing of the line and the space and the form, depending more perhaps on our own sense of ambivalence and holding, on our own participatory reading. At stake here is our conception of threshold and of sharing, as of art.[21]

The very inside-outsideness that some of us learned through French surrealist texts (as in Breton's reiterated affirmation about the eye merging with what it sees, and as in Magritte's painting of *The False Mirror*, with the clouds interpenetrating with the eye itself[22]) was there too in Matisse's great purple-toned *Porte-Fenêtre à Collioure* of 1914, whose rectangle extends from top to bottom, bottom to top, taking up all the breathing space by its implication. "Matisse pierced me," says Motherwell of seeing, in the clear California light, those canvasses for the first time. . . . Pierced, as a window pierces a wall, makes room in the opacity for light.[23]

They are always taking their chances, these pictures. Motherwell makes it painfully clear, referring—again, implicitly—to Mallarmé's epic salute to modernism: "Un coup de dés jamais n'abolira le hasard" ("A throw of the dice never will abolish chance"):

> It is not commonly understood that the linear so-called "window" shapes of the *Open* series are as much a one-shot throw of the dice, in execution, as my more gestural works. . . . In short, the lines in the *Opens* are not measured or mathematically proportioned but purely intuitional and immediate.[24]

We have much this feeling, for example, in *Yellow Wall,* where the unevenness of the line spills over into the background, clearly unmeasured, immediate, intuitional.

The open window made of the former canvas leaning against a larger one, up-ended and opened toward the top, continues even now to suggest a whole potential openness to the reader of that specific *Garden Window* of 1969, formerly in the *Open* series, and still participating in it by right, yet opened out now, into the outside yet unseen. The swan can now take off into the unknown, as can the artist. How many directions he could have taken—Motherwell's work is concerned, at its finest, with painterly decisions felt as moral ones. To see the world as Motherwell did, you have to be convinced that aesthetic decisions count; they *are,* in fact,

Open No. 104 (The Brown Easel), 1969.

Acrylic on canvas, 54 in. × 60 in. (137.16 cm × 152.40 cm).

Private collection. Photo credit: Zindman/Fremont. © 1994 Dedalus Foundation, Inc.

Yellow Wall, 1973.
Acrylic on canvas, 72 in. × 48 in. (182.88 cm × 121.92 cm).

Private collection. Photo credit: Zindman/Fremont. © 1994 Dedalus Foundation, Inc.

the moral choices that painters make. As Dore Ashton points out, Motherwell was fond of quoting Kierkegaard's dictum: "It's one thing to think and another to exist in what is thought."[25] Each of Motherwell's decisions about the *Opens* involves a particular choice, as the whole series involves something more general. Some of these works, done when the artist had been drinking heavily, form one kind of solution to the question: how do you come back from there? They have seemed, to many, to be allied with minimalist art—but that was not the way Motherwell saw them. They are all, as the title declares, about leaving things open.

One of my favorites is the wonderful small print called *The Green Studio*. How simply it is just that: a rectangular shape, suspended from the top, attached by two thin ribbons to an equally thin line stopping a quarter of the way down the page on the right, and then a lower part, with an irregular line above a low green swash, ending unevenly in the lower right corner. This is now called *The Green Studio*, thirty years after it began as an *Open;* a version is included in the volume Motherwell did with Alberti, *A la pintura*. Then the artist simply added the swash of green to the lower part, transforming the whole. What is changed here is our whole way of looking. The brilliance of the green dominates the whole, and the simplicity of the conception takes over our vision: this is green the way we hadn't seen it before. I am thinking also of the *River Liffey*, the work so closely connected with his beloved Joyce,[26] where a muddier lighter green plays the main role. We do not associate Motherwell with green, as we do with blacks and whites and blues and reds— yet these two works are unforgettable and unmistakably from his hand and eye. If some of the *Irish Elegies*, done in green, seem stronger than the others, you always have the sense that they are referring back to the others, in Ur-black.

The other choice was adding black to one of his *Opens* that was originally just blue and red. I asked him to tell me how it changed: had it had only those two colors before?

—Yes. And it wasn't functioning. I mean it was all right, but it had no magic to it.

So now it had magic. Both these choices function like that: something is added, and everything evolves. Never to add too much, preferring to have less than even a token of excess, Motherwell will struggle. He always said that art is more about what it refuses than what it includes. What it refuses, above all, is facility, the pettiness of paths already decided on, or anything reeking of authoritarianism.

Motherwell's decisions, his refusal of facility of choice, are as much about what path was and was not taken as Robert Frost's "The Road Not Taken":

> Two roads diverged in a yellow wood,
> And sorry I could not travel both
> And be one traveler, long I stood . . .

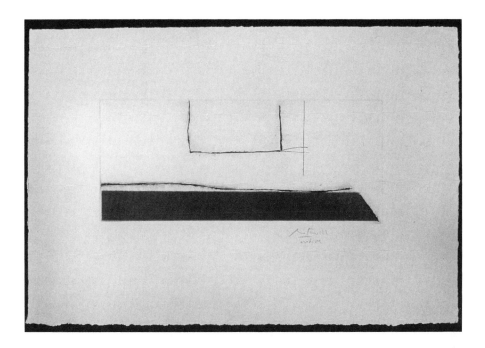

The Green Studio, 1986.
*Etching and aquatint from two copper plates printed in green and black,
12 in. × 18 in. (30.48 cm × 35.72 cm).*

Photo credit: Ken Cohen. © 1994 Dedalus Foundation, Inc. {see color plate}

A La Pintura No. 7, 1974.
Acrylic and charcoal on canvas, 80 in. × 85 in. (203.20 cm × 215.90 cm).

Collection Bernar Venet, New York. Photo credit: Steven Sloman. © 1994 Dedalus
Foundation, Inc.

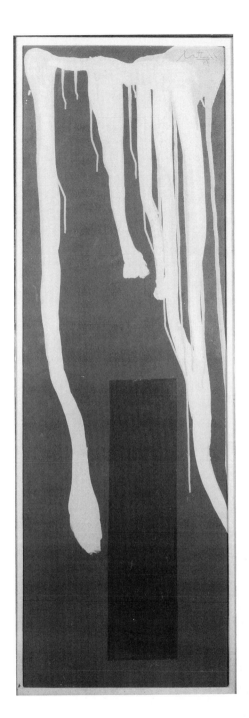

The River Liffey, Dublin (for James Joyce), 1975.

Acrylic and collage on canvasboard, 72 in. × 24 in. (180.9 cm × 60.9 cm).

Private collection. Photo credit: Zindman/Fremont. © 1994 Dedalus Foundation, Inc.

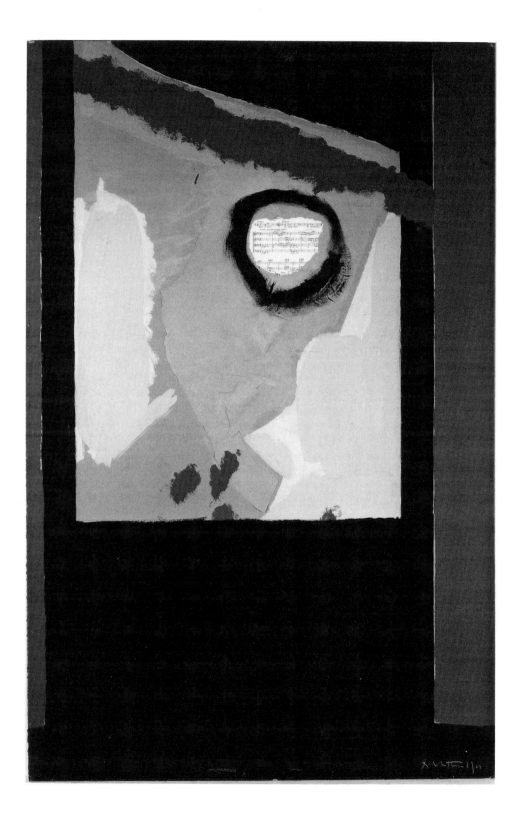

Choosing the path through the woods that seems the least frequently taken, the narrator still wonders over his choice; each choice, in each work, matters:

> And both that morning equally lay
> In leaves no step had trodden black.
> Oh, I kept the first for another day!
> Yet knowing how way leads on to way,
> I doubted if I should ever come back.
>
> I shall be telling this with a sigh
> Somewhere ages and ages hence:
> Two roads diverged in a wood, and I—
> I took the one less traveled by,
> And that has made all the difference.[27]

Selecting the possibility with the greater risk, heroic in temperament as it is, in no way guarantees the absence of regret. The sigh the poem is told with marks the decision as honest.

Tree of My Window (Robert Frost) was Motherwell's first work in his Greenwich house: it reads as one of his rare salutes to nature, as he puts it.[28] In consequence, this work holds great significance for him and us. He has had to frame the tree doubly, by a poet and by a window, before the treeness of the tree can interest him. This collage of 1969 manages to merge the scene and the window opening out on it as simply as a wall mends, speaking against separation in a quiet voice. This is not the dramatically enigmatic announcement of Magritte, rather a philosophical will toward junction, without spilling over into the sentimental.

Every stroke is a decision, says Robert Motherwell of the tens of thousands of strokes that make up these statements. Surely every reading is a decision too, like some voyage starting up, out of the impasse of the already-seen, already-accomplished. Baudelaire's great epic poem "Le Voyage" traces in a most singular way not just the setting out of any artist, any poet, any thinker, but specifically Motherwell's own experience. His own *Voyage* is his response to poetry and to himself. In his youth, when he finished his assignments in school too quickly and was bored, he would look up pictures in the *Encyclopedia Britannica* under *modernism*—see one of our 1989 interviews in this book—and this is indeed what set him out on his long voyage into art. Baudelaire begins:

> Pour l'enfant, amoureux de cartes et d'estampes,
> L'univers est égal à son vaste appétit.
> [For the child enthralled by maps and pictures
> The world is big enough to satisfy.]29

That he should have returned from his adventure saddened, into age, answers to the experience of all of us, artists and not:

> Ah! que le monde est grand à la clarté des lampes!
> Aux yeux du souvenir que le monde est petit!
> [Ah, how large the world is under the lamps!
> How small is the world in memory's eyes!]

True travelers are, as we know too, those who "leave in order to leave" ("qui partent pour partir"), and Motherwell was, like the wild goose of such symbolic import to him, always ready to leave in his mind. This is one of the paradoxical reasons for his staying power.

Two kinds of certainties would hold against the fear of a hollow center. One was precisely the conviction that one *could* always set sail; the other, this possibility's polar opposite, was that of repetition, of turning, of "doodling" or tracing lines without initial meaning in a repeating pattern itself capable of creating the basis for a picture, a conception, a life. All the poets Motherwell loved were great repeaters: Stevens and Eliot turning and turning; Lorca's "A las cinco de la tarde"; Baudelaire questioning, as in "Le Voyage,"

> Et puis, et puis encore?
> [And then, and then?]

Like an incantation, this density of verbiage might—can—by its intensity of awareness save us from the nothingness at the heart of everything:

> Amer savoir, celui qu'on tire du voyage!
> Le monde, monotone et petit, aujourd'hui,
> Hier, demain, toujours, nous fait voir notre image:
> Une oasis d'horreur dans un désert d'ennui.
> [Bitter knowing, that we take from traveling!
> The world, monotonous and small, today,
> Yesterday, tomorrow, always, makes us see ourselves:
> An oasis of horror in a desert of ennui.]

Already here resounds that night music which we know even now will be sounding at the end of Motherwell's work, and our own.

The artist speaks at some length of *The Voyage: Ten Years After* and of *The Golden Fleece*, both of 1961 and closely associated by the cloud moving across their midst, gesturing back perhaps to the cloud of Duchamp's *Great Glass*, but going their own way, through the newly opened window:

> These paintings I now see as representing two possibilities, two polarities, the "automatic" once having been explored in *Chi Ama, Crede*, and the one that I was to choose to develop five years later in the *Open* series, with its inside/outside window metaphor. Internally contradictory as these pictures here may be, in retrospect I like their expansiveness and lyricism, their breaking out of imprisoned space, and in certain ways regret that I then chose to explore the *Open* series, rather than building on these "automatic" works, which perhaps represent a profounder possibility. But in the late 1970s I have again taken up this theme, or, more exactly, procedure, though I was able to incorporate its basic impulse in one *Open* painting: *In Plato's Cave No. 1.*[30]

Opening Onto Poetry: *In Plato's Cave,* 1972–*Les Caves,* 1976

The poet Delmore Schwartz reminds us that the metaphor is a "bearing-across, or a bringing-together of things by means of words."[31] The very activeness of the bearing and the bringing is so strongly present in Motherwell's work as to energize the transmission from source through work to spectator, as in Charles Olson's description of what happens in projective poetry, concerning "the *kinetics* of the thing. A poem is energy transferred from where the poet got it . . . by way of the poem itself to, all the way over to, the reader. Okay."[32] Olson's emphasis on the breathing and the listening of the one who writes, on the idea of composition by field as opposed to the inherited notions of stanzas and lines, on the perception that must instantly lead to a further perception, is quite as useful for approaching the art of Motherwell as for that of any modern poet. But it is above all his specific concepts of openness and process that strike such a remarkably similar note. In the *Composition by Field,* the artist "puts himself in the open—he can go by no track other than the one the poem under hand declares for itself."

After this resounding description of openness, Olson turns as it were directly toward the creator whose breathing he hears: "And if you also set up as a poet, USE USE USE the process at all points, in any given poem always, always one perception must must must MOVE, INSTANTER, ON ANOTHER!"[33] William Carlos Williams quotes this projective manifesto at length, for his own encomium of Charles Sheeler, constructing his small house on a large estate, building on and into the very land: "Nothing can grow," he says finally, "unless it taps into the soil."[34] You could say of Motherwell's *Opens* that they do indeed tap into the soil. They are joined to something solid and ongoing. They are not about some unjoined sky,

■ ■ ■

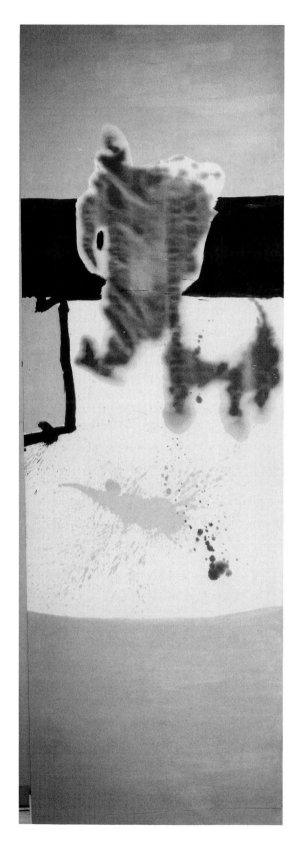

The Voyage: Ten Years After, 1961.
Acrylic on canvas, 68.75 in. × 205.75 in. (175 cm × 523 cm).

Private collection. Photo credit: Zindman/Fremont. © 1994 Dedalus Foundation, Inc.

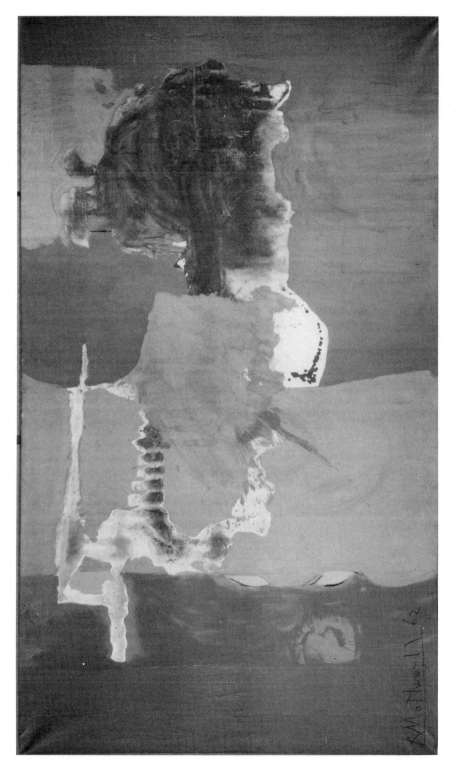

Chi Ama, Crede, 1962.
Oil on canvas, 82 in. × 141 in. (208 cm × 358 cm).

Private collection. Photo credit: Steven Sloman. © 1994 Dedalus Foundation, Inc.

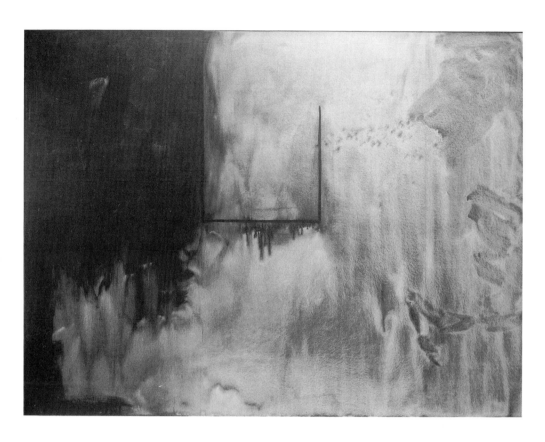

In Plato's Cave No. 1, 1972.
Acrylic on canvas, 72 in. × 96 in. (183 cm × 244 cm).

Private collection. Photo credit: Steven Sloman. © 1994 Dedalus Foundation, Inc.

taking off on its own, rather about our perception of that process and that blue and that sky, in a conjoined energy of process and perception.

Clement Greenberg's laudatory remarks about the New York School as opposed to the French avant-garde exactly fit in here. He describes the work of the New York artists as having a "fresher, opener, more immediate surface" that *breathes*. "There is," he says, "no insulating finish, nor is pictorial space created 'pictorially,' by deep, veiled color, but rather by blunt corporeal contrasts. . . . The canvas is treated less as a given receptacle than as an open field."[35]

The relation that Motherwell's *In Plato's Cave* bears to the *Open* series in this context of energizing vision is deepened and widened by Delmore Schwartz's poem "In the Naked Bed, in Plato's Cave,"[36] to which Motherwell's painting refers. We cannot help but look back to the walls of *The Little Spanish Prison,* where the bars were visible, and where, in the brightness, the small yellow horizontal piece stands out like a label of death. These are reminiscent of the yellow of the *calaveras,* or death skulls, that so fascinated Motherwell in Mexico; at our last meeting before his death we looked at a short row of them, in bright yellow sugar. Between the verticals of the prison bars here, you can see a dull pink, like the haze of a bygone blood stain.

In this cave, more like a metaphysical prison, there are no bars, but only a slit, as of a great eye weeping. This is an interior theater, for the mind. Little wonder that Delmore Schwartz's poem made such an impression on Motherwell; it works out a remarkable union between the intrusions of the outside and the shadows cast on the walls inside, for the waking couple to view:

> In the naked bed, in Plato's cave,
> Reflected headlights slowly slid the wall . . .

So it begins, and the rhythms, the *strains* really, of Hart Crane are heard in the terse style, already evident in the telescoping of the first line ("the naked bed") and in the ellipsis of the second line ("slid the wall"). We are set up for an intensity of feeling the poem does nothing to deceive.

It is, as in the cave image, the relation of what we see from within the cave, of the shifting forms on the cave walls, to the Idea that matters. The anxiety of everything around is stressed: the milkman "strives up the stair" and the horse waits while the bottles chink and a cigarette is lit. Expectancy and exhaustion struggle, and as to a cave, the narrator turns back to bed. When it is time to arise, to regain the sunlight and "the real," the furniture will rise from its watery dream, while the sounds continue, with the oddness of misperception:

> Strangeness grew in the motionless air. The loose
> Film grayed . . .

It is less the dream state awakened from that appears strange here than what one is waking toward. The line itself is passing strange, loose at its end.

Precision grays down, though, and the color predominant in Motherwell's series *In Plato's Cave* is gray—black for the line that looks strangely like a closed eyelid, with its dripping paint as tears, but gray for the stuff and substance of the wall, the support, the background convincingly cavelike and claustrophobic. The grays of this series as they range from deeper to lighter have the muscular roughness of the caves at Altamira in Spain, at Lascaux and Les Eyzies in France, where the unevenness makes up the forms of the animal's back and his strength, natural in every sinew. That feels true of this art too, itself natural in every sinew, even in the work of its thinking out, its massively occupying presence. Even if the eye keeps weeping in its darkness, with the paint still dripping down, it was all the same miraculously caught and cradled by the painter, as he says of the making of the work. It was held, against its lack of control. Motherwell's gesture will always have been one of holding and of holding out, offering and enduring, from the time of the *Open* series, of which these caves are the offshoot. We think of such titles as the *Reconciliation Elegy*, as *Chi Ama, Crede* (Whoever Loves, Believes), as *Gift*.

In the cavernous darkness, the human is clung to: the car coughs, starting, like a person beginning a day, and ordinary daylight makes its quiet approach, here tinged with heat and fire:

> . . . Morning, softly
> Melting the air, lifted the half-covered chair
> From underseas, kindled the looking-glass,
> Distinguished the dresser and the white wall.

Here in the room, in the poem we awake in, a bird call is tentative, but signaled as peremptory: "So!" against the softness of the morning. The same feeling illuminates the waking in Virginia Woolf's *The Waves*, where the bird call is as piercing, and the light distinguishes in the same natural cycle, as the "edge of being is sharpened":

> In the garden where the trees stood thick over flowerbeds, ponds, and greenhouses, the birds sang in the hot sunshine, each alone. One sang under the bedroom window; another on the topmost twig of the lilac bush; another on the edge of the wall. Each sang stridently, with passion and vehemence, as if to let the song burst out of it, no matter if it shattered the song of another bird with harsh discord. . . . They sang as if the song were urged out of them by the pressure of the morning. They sang as if the edge of being were sharpened and must cut, must split the softness of the bluegreen light, the

dampness of the wet earth . . . on all the sodden, the damp-spotted, the curled with wetness, they descended, dry-beaked, ruthless, abrupt.[37]

At the end of the Schwartz poem, the word *so* is picked up in the human dimension as echo to the bird call, as the life starting over acknowledges itself attempting, through the unknowing of darkness, to plunge into the birthing work of day. The *travail* of the early morning is reminiscent of, but separate from, the cycle of contextual, historical suffering that cannot be forgotten:

> . . . So, so
> O son of man, the ignorant night, the travail
> Of early morning, the mystery of beginning
> Again and again,
> while History is unforgiven.

That *history* should rhyme with *mystery* works against the only factual presuppositions of the former. Of course, unforgivingness is part of the problematics of reading in the cave. What, finally, can be forgiven? Schwartz was always to call for nonconformist attitudes, taking society to task for its will to paper over actual instability with the politeness of the social herd.

Something can be added, all the same, to put the history of the poem and our reading of Motherwell's *Night Music* series of 1989 in another perspective. The morning waking here is placed in tandem with another waking. Included in the volume of poems with "Plato's Cave" is "A Little Morning Music," from 1958. Motherwell's *Night Music Opus*, based on music by Alban Berg, seems to be, at least in some implicit sense, a response to this other, earlier music. "Little" it is not, in any case, however modest in length, and so contains only an ironic reference to Mozart's *Eine kleine Nachtmusik*.[38] Even in its less than monumental size, not making the same public statement as the *Elegy*, exactly as Motherwell has always said of his collages—these memories like jottings of daily life—it goes deep past its rice paper into a history of the *memento mori*. Indeed some little morning music might lead to this superbly restrained and grave night music, resounding in the same philosophical space as *Plato's Cave*.

The links between Motherwell's graying cave and the rubbed-out window in one of the *Open* series are firmly forged and reveal the profundity of the cyclical impulse, even as it concerns seeing through and seeing against. The reflections from the outer world of the Ideas were glimpsed against the cave wall; yet we after Plato still tend to take the Idea of the cave as metaphoric and the reflections as real.

When the painter cradles the paint on the canvas, taking the birth process into his own hands, the reader of that canvas may well hear not only the haunting tones of the Schwartz poem, but also the majestic and troubling strains of the end of

André Malraux's *Voices of Silence,* where all the fates and all the ages watch as Rembrandt takes into his trembling fingers a brush . . .

> What does Rembrandt matter in the rush of the nebulae? But it is man that the stars negate, and it is to man that Rembrandt speaks. Pitiful bodies gone without trace, that humanity should be this nothingness where poor hands can draw forever, from the earth that bears the marks of the Aurignacian half-beast and those of the death of empires, images whose indifference or communion bear the same witness to your dignity: no grandeur is separable from what sustains it. . . .
>
> In the evening where Rembrandt is still drawing, all the illustrious shadows, and those of the cave painters, are watching the hesitant hand preparing their new survival or their new sleep.[39]

It was Malraux whom Motherwell heard in California, speaking in 1937 on the Spanish Civil War, Malraux whose novel *Man's Hope* he read, thinking of the struggle of the Spanish people against their prison, of which his *Little Spanish Prison* is the emblem.

To be sure, the voices speaking to us through our individual reader's and observer's memories as we reflect on the cave of such a painting are various, as are our reflections. Yet what they give voice to may well go past our particular silence to an effort at some perception we can share, whatever our situation. For holding is the opposite of holding down. The way the *Night Music* is heard to play against and with the *Open* series: this is not just a brief night music, but a great moral joy.

Giving, Sending, and Looking

Collage and Box: Motherwell and Cornell

At first sight, there could not be two artists more dissimilar than Cornell—a worker in the art of the enclosed, the mental theater of a glassed-in shadow box—and Motherwell, with his deliberately wide-scope, wide-range gesture. To discuss Cornell with Motherwell, as I did at length during some of the interviews included in this book, was to become aware of their radical differences, as perceived by Motherwell. Although both based their aesthetic judgments and impulses to a large extent on European models, in Motherwell's opinion Cornell was clearly in the romantic tradition, while he himself was clearly in the symbolist tradition.

To be sure—and yet in each man these traditions were colored by their basic Americanness—a characteristic on which Motherwell was to insist loudly up to the very end of his life, partly as a defense against what some thought of as his French kind of elegance, in living and painting. Encouragement of distinctive selfhood[1] and permission to eccentricity (James's "Don't try to be anyone else") were crucial to the thinking of both artists. They both preferred, on every occasion, the irregular and handmade, however unlovely, to the ironed-out and smooth, finding meaning in what was "crabbed and ugly as our own pine knots," in Melville's words. "Too slick, too smooth," Robert Motherwell would repeat about an artwork he found ultimately boring. American criticism too has had the courage to prefer, on occasion, the knotty to the ironed-out, especially since the untidy road often feels as if it has the potential to lead further, as in Henry James's definition of

the American spirit already quoted: "'intrinsically and actively ample, reaching westward, southward, anywhere, everywhere,' with a mind 'incapable of the shut door in any direction.'"

If it is clear how this Americanness functions in the case of the wideness of Motherwell's scope and massive gesture, it would seem to be far less so in the case of Joseph Cornell, with his monologues in the form of boxed-in worlds, theaters of the mind and shadows, miniature representatives of a universe like small and apparently fetichizing prose poems. Yet that gathering-up impulse is also Motherwell's, who collected in his collages the objects or reminders of the moments of everyday life he treasured, surrounding them with a backdrop that served to iconicize them. Like Cornell's objects, they too recall another time; as when some souvenir of a dead ballerina is placed with, say, a ring and chain, and a clay pipe to signal the dreaming process, Motherwell's objects in his collages too are matched with other objects, taken from another space into this one. In the *N.R.F. Collages* a Gauloises cigarette box wrapper may meet an envelope from a Paris address in this so-American creation, with the envelope or some wrapping paper or postage stamps serving as a reminder of the distance within the imagination itself.

Such an exemplary drama as the *N.R.F. Collage No. 2* sets out a spectacular and plausible interaction of verbal and visual, where four vertical drips from a swash of color connect down to the four horizontal lines in the middle. These lines themselves center a wrapper from the publishing house Gallimard above a customs label ("Douane") to the left and a postage mark to the right, resting on an Oriental wave shape, in a brilliant tripartite construction. If Cornell's constructions are about dream, Motherwell's are about imagination. They both serve to construct memories, like a window open into a past and onto somewhere else.

These objects so contained and held by memory and art are themselves the treasure, even as they *open out*. They exemplify not just the cut-off mirrors of one person's obsessive dreaming but what Marianne Moore calls, speaking of Wallace Stevens, "a compactness beyond compare" or "accord of repetitions." If they do not have the largesse of what we think of as the New York School's action painting, the generosity of the epic gesture, or the monumentality of Motherwell's more public elegiac statements, they are quiet elegies keyed to the lyric mode of his personal deeds, desires, and remembrances.

As such, they set off the public's statements by contrast. Impregnated with French culture, associated at one time with the surrealist group in New York, both artists partake of a Proustian project about seizing the moment at the height of its epiphany, about recalling and preserving it. Both work at opening whatever space they deal with into a large stretch of the mind. It is a matter of what Cornell's boxes have the potentiality to open out on, what Motherwell's collages know how to share. His life, but also what it sends out as a message.

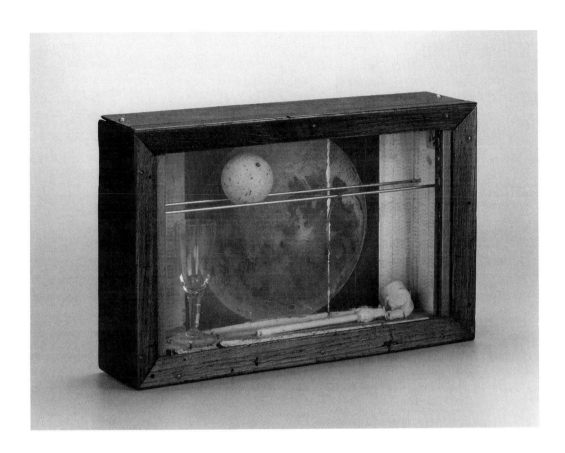

Joseph Cornell, *Dream World (Soap Bubble Set)*.

Stained, glazed wooden box with paper backing for a kinetic assemblage of wood, paint, charts, clipping, postage stamp. metal rods and ring, painted cork bead, glass marble, cordial glass, nails, and broken clay pipe, 23.2 cm × 36.8 cm × 9.5 cm.

The Lindy and Edwin Bergman Joseph Cornell Collection, 1982.1848. © 1994 The Art Institute of Chicago

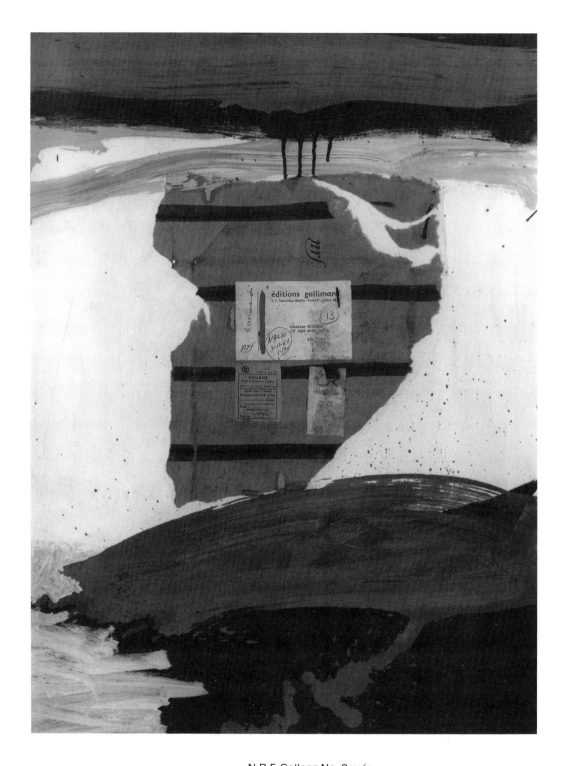

N.R.F. Collage No. 2, 1960.

Oil and collage on paper, 28.125 in. × 21.5 in. (71.4 cm × 54.6 cm).

Collection of the Whitney Museum of American Art, Purchase, with funds from the
Friends of the Whitney Museum of American Art, New York, 61.34 {see color plate}

The painting mind is put into motion, probing, finding, completing
ROBERT MOTHERWELL, *"Beyond the Aesthetic" (1946)*

Collage, for Motherwell, is associated with joy, whereas painting is more austere. Collage, which he thinks of as a modern form of still life, relates to feeling but also to the idea of relations themselves. Since it is composed of fragments serving as witnesses to moments gone by and to the places in which they were experienced— the label from the wrapping paper of something sent from somewhere to someone at one particular time, the cover of some Gauloises cigarettes purchased by someone in some store or at some stand on some day in some month, the musical score which someone played and will play again—it has a thickness to it both temporal and spatial. The collage is a buildup of experience, a memorial, however modest, to some state of events; it is pragmatism itself.

Collage is a way of going beyond the self toward the surrounding world. Motherwell says of it: "To pick up a cigarette wrapper or wine label or an old letter or the end of a carton is my way of dealing with those things that do not originate in me, in my I. . . . You pick up objects that are in the room and simply put them in the picture. Collage is both placing and ellipsis."[2] Ellipsis is a frequent and strong element in Motherwell's work. Take the title *In Ochre with Gauloises* of 1968; this collage of acrylic on paper, as well as many with like titles, bears all the potential significance of what the observer necessarily inserts before the preposition *in*. Such a title as *Collage in Ochre,* for instance, would lose the very dynamism of the unsaid, the possibility of including everything. (See my remarks in chapter 5 on the generosity of prepositions.)

In a conversation of 1950 Motherwell insists on the relation between the work of art and what is beyond and around it:

It would be very difficult to formulate a position in which there were no external relations. I cannot imagine any structure being defined as though it only has internal meaning.[3]

The artist's operation on the world through gesture is above all inventive. The self-invention that he claims as the business of the artist can be made visible in this medium, passionately felt:

The passions are a kind of thirst, inexorable and intense, for certain feelings or felt states. To find or invent "objects" (which are, more strictly speaking, relational structures) whose felt quality satisfies the passions—that for me is the activity of the artist, an activity which does not cease even in sleep. No wonder the artist is constantly placing and displacing, relating and rupturing

Robert Motherwell in his Greenwich studio working
on collages.

Photo by Renate Ponsold Motherwell, 1976. Owned by Renate Ponsold Motherwell

relations: his task is to find a complex of qualities whose feeling is just right—veering toward the unknown and chaos, yet ordered and related in order to be apprehended.[4]

If the accent for collage falls on relations, so in the case of lithographs it falls on the intensity of the medium. *The Stoneness of the Stone,* reads one lithograph title, as if remembering Stonehenge and all our past: this lithograph as the trace of stone is all that is left standing. (This same dense self-reference can be read also in the titles and renderings of *The Redness of Red* and many other instances.) As we set in contrast the ideas and realizations of *Elegies* and *Opens,* we could juxtapose the collage and lithograph modes in their clear philosophical and aesthetic differences.

Motherwell's collages turn the idea of elegy toward the positive: witness his collage *The Elegy* of 1948, the year in which his epic series *Elegies to the Spanish Republic* begins. Surrounded by a band of black on two sides (the predominant sides for a Western reading, top and right), with black creeping in below as in a strip to the

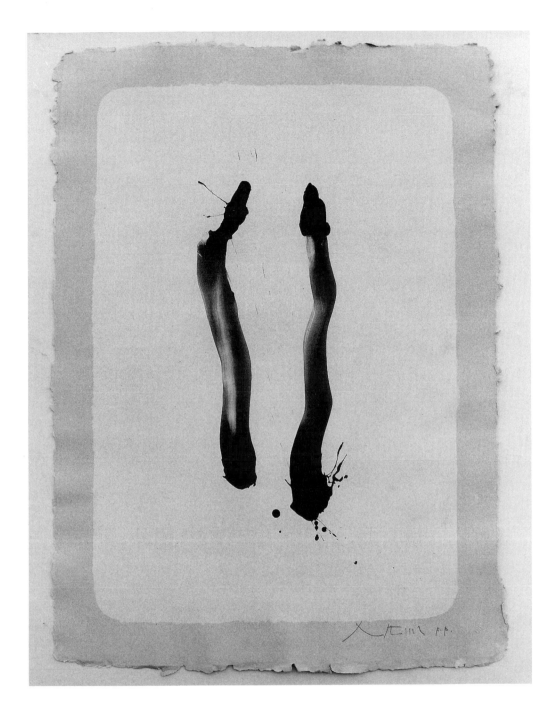

The Stoneness of the Stone, 1974.

Lithograph, 41 in. × 30 in.

Printed and published by Tyler Graphics Ltd. Photo credit: Betty Fiske. © 1974 Robert
Motherwell/Tyler Graphics Ltd.

left side, and a dappled passage bottom left, it is nevertheless centered on its blue, brown, and off-white shapes in their blue and ochre settings. It seems to speak as much of the determination to continue as of the menace at hand.

His collages, taken as a whole, find a way of holding on not to the epic, not to the tragic, but to the everyday. That day so simple in the memory: yesterday, say, or perhaps the day before. What they remember is generally modest in scope—and so, often smallish compared to Motherwell's epic canvasses. These collages are made from elements in the studio and fit, quite exactly, in the mind. In the workplace that the mind is, they fit with a kind of exactness that speaks of a long habit of seeing what is given with no fanfare, what is sent just in the line of work. "Generally, in collages," Motherwell remarks, "I only use things that happen to be in my studio. They represent familiarity and in a certain way domesticity."[5] These workings of the mind have the feeling of intimacy. They are never grand, so we are able to come close to them.

These episodes of thinking back are quite frequently composed, like *Gift,* of wrapping paper, light brown, wrinkled, with a bit of string, sent from Paris, in the working mode. They may include a snatch of a poem or a saying, or a cigarette carton, blue as a Provençal sky, set against an ochre backdrop like a wall, for building the memory of just some day or other, what life is built of and on. Quite unlike his *Elegies,* these productions of the real do not claim to be inserted *sub specie aeternitatis,* in a public commemoration. What they put together, with love, is not Life with a capital letter, not Tragedy, but living in the moment. They will hold just as firm.

These are postcards sent from the material of dailiness, to someone who knows you could write a letter instead and who knows what that style would be like. These are modest, not major. The cloth they are cut from is recognizable. We know at the present how it hangs, in its Motherwell blues and blacks, having long appreciated its enduring elegance. We see how each snippet is combined with others in a correspondence, layered with a lilt. What the collages decide on is the daily: now, they seem to say, this is enough.

Looking

But for a moment I had sat on the turf somewhere high above the flow of the sea and the sounds of the woods, had seen the house, the garden, and the waves breaking. The old nurse who turns the pages of the picture-book had stopped and had said, "Look. This is the truth."

Virginia Woolf, *The Waves*

Look. What Virginia Woolf teaches in *The Waves,* about how simple seeing is, is a lesson Motherwell always knew how to teach. "Look," he says, and shows us how. Working out his "constructs of reality," he assumes the communication of that power of sight as more than possible, as necessary. That is, in fact, what he is working at.

E. A. Carmean Jr. has shown in his exhibition catalogue *The Collages of Robert Motherwell*[6] the ways in which his "rectangular," "figural," "autobiographical" collages fit with the landscapes, the *Open* series, and the analytical collages, and in which those are properly related to abstract expressionism. Motherwell's investigations into the grid mechanism after Mondrian,[7] exemplified in such works as *White Painting* (1941) and *The Little Spanish Prison* (1941–1944), continue in his collages that link the center to the edges and those edges to the actual frame. As if he were developing a consistent philosophy on the subject of relationships, those of the work to its support and its sides, Motherwell makes even in the simplest of these works a metapoetic statement about constructing art as reality or reality as art. William Seitz has summed up the impression of such linear patterns, saying that "like cracks between planks of a barn door, they insist on the actuality of the surface."[8]

Little by little the artist investigates in his "dappled collages" the problem of containing the mottled within the linear, the doodle within the constructed, the automatic free gesture with the heavy attachment of vertical planes and the theme of captivity. The *Spanish Prison* painting is surely one of his most memorable works, with its magenta strip over and against the yellow and white, and its strong sense of imprisonment in form as in content. Its form is linked to that of the massive pictures *La Résistance* and *Pancho Villa, Dead and Alive*. But the rectangular areas will eventually be dropped in favor of the freedom that wins out: "The attachment principle of black lines, and the background role of collage, was inhibiting to the automatic procedure of generating images,"[9] and the automatic procedure seemed more urgent. Nevertheless, the continuing lines of attachment will not be dropped.

Doodling, or simply letting the hand wander, a technique used by the surrealist artists and taught by Matta to Motherwell, is one celebrated way of calling up the resources of the mind in its nonrepresentational mode.[10] Another, easily combined with it, is the operation of choosing and pasting the shapes that will construct, not from any prearranged model or idea, an original reality. Tristan Tzara, the Papa Dada par excellence, used to describe his method ironically but forcefully: you take a newspaper, tear out parts of it, shake them in a hat, and then at random draw out one after the other and paste them on a piece of paper. This autoportrait, he would say, will resemble you. So the "reality" constructed by this operation of collage on its basic working materials will be appropriate to the mind that works in that way, except that unlike Tzara's passive acceptance of whatever order the torn papers happen to appear in, this is an operation of work and choice and love for the basic elements, unembarrassed.

The linear nature of the magnificent work now called *Mallarmé's Swan* (1944–1947) brings back to mind *The Little Spanish Prison*, but with a difference. The vertical stripes, in yellow, blue, pink, and off-white, both tie down and captivate. Against them you sense the working of the beige oval toward the left top and its

echoes at the very bottom of the picture, one just a half-circle, quiet below the rectangle with the figure in it, and the other, a beige circle just in the center of the bottom, outlined heavily, as if to weight the circle as much as the stripe. This balance is not static but rather set in motion: first by the way the topmost beige oval pushes against the stripe;[11] next by the twist given to that oval, to the right, with the twist marks in the work itself, white dimly straining against the blue; third, and most important, by the sail-shape at the top just tangent to the oval shape, like a functioning thing set in motion, breaking away from the black rectangular square just visible in the center. To set sail. . . . Some of the freedom of the *Greek Window* is found on the right, with its yellow playing against the white.

The collage was originally called *Mallarmé's Dream,* until Joseph Cornell interpreted it as *Mallarmé's Swan,* a title Motherwell continued to love. As for the figure of the dream (or the swan) itself, it has somewhat the shape of a Rorschach image, an ink blot gone animal, repeating itself. The presence of the swan is summoned by the act of generosity that Motherwell accomplished in changing the dream into the swan, because it was so remembered by another in whose mind he was interested. Here he goes significantly past the ego and its limits—exactly the goal of his moral and aesthetic endeavor—permitting this figure and the work it represents to take symbolic sail, past the requirements of the linear and the figurative. This voyage makes its way into the interpretation with a twist that is encouraged by the oval in motion, the figure blotted against itself, and the notion of the swan as sign (in French, and thus in Mallarmé, *le cygne* is homophonic with *le signe,* the sign). It remains the sign of departure even against the great beauty of the colors, the forms, and the idea of an erstwhile prison changed into a place from which we can start out afresh. Unlike Mallarmé's famous sonnet about a swan or a sign stuck in a page, white like the ice, this swan is not stuck at all. It is instead on the way to something else. I take this work as an *ars poetica* of Motherwell's early creation.

Easel and Studio: Giving and Sending

Some of the more remarkable of Motherwell's collages in the 1950s are contained in the *Easel* series, begun in 1951. According to the painter, the prototypical example, *The Easel No. 1* of 1954, may represent "an unconscious insistence on the importance of 'painterliness'" to protest against the purely psychological content seen by Dr. Montague Ullman, the psychoanalyst with whom he was then working.[12] Carmean points out how it is based on Picasso's *Harlequin,* so that the rectangle held by the harlequin figure becomes "an abstract collage set upon 'the easel.'"

Whatever conscious or unconscious afterimages remain in this collage, the work is enormously strong. The deep brown of the vertical lines of the easel play against the ochre tones of the material set on it, with a suggestion of layering at once witty and complex. We *feel* the way in which the thin edge of the pasted paper

is set over against the heavy brown, read as the thick support of the easel. More particularly, in the upper left corner three torn bits of paper are painted, in echo of the white of the paper for the collage. Its 13 can be read upside down, like bad luck reversed into good, taking a technique from the humorous *Reversible Collage*, signed in both directions and reading both ways equally. We can also see here the motif of clouds moving across the sky behind the studio, giving a strong sense of the inside/outside intertwining threading its way through Motherwell's work, represented by the *porte-fenêtre*, or door-window image. It is reminiscent of André Breton's saying about surrealism and the sense of the marvelous configurations it could find: "The birds have never sung more beautifully than in this aquarium."

Part of the emotional charge in this collage comes from the close-up situation of the easel itself, which is not only parallel to the edge of the picture frame but almost fills the latter. We sense no distance between us and the *place* of work, nor indeed between us and the work we are given. Motherwell speaks to this point in his talk on "The Humanism of Abstraction,"[13] which he considered the most philosophical text he ever wrote; we had long discussions about the French translation, which he asked me to look over.

> For me, my work is *not remote*. . . . Moreover, I value human warmth, and I've insisted for the most part that my form of abstraction, in terms of feeling, be relatively "warm."[14]

In *The Easel* there is as strong a sense of Matisse and his studios as of Picasso—it is as if the three sturdy legs of the easel standing firm against the torn and irregular forms, were to give, by visual as well as verbal support, a strong basis for the continuity of art.

The warm rich colors of *The Easel* underline, with their easy communication, the idea of art as a universal language, a topic on which Motherwell used to wax particularly eloquent.[15] As in *The Easel,* the colors in the *Berggruen Collage* of 1967 are particularly rich. The red, the reddish-brown, and the crimson are set off against the ochre of the paper, whose very thickness and roughness appeal to a tactile sensibility. The *Blue Collage* of 1958 sets its torn and layered brown wrapping paper against a thick impasto heavy blue-green, the weight of one corresponding to the weight of the other. Like the *Yellow Envelope* and the *Berggruen Collage*, this work shows the relevance of Motherwell's statements about abstract art as the exact choosing and balancing of weights against each other. In each case the printing or writing seen at the center of these thick layerings speaks of what is at the center of the sending: a message simply proving that it can be sent.

In the *Berggruen Collage* the richness of the matter is emphasized, as in *Gift*, by the word *insurance*, "*Recommandé*," on the paper. You would only "insure" or "recommend" what had some value for you. Here again it is a matter of abstraction as choice: laying the stress on what is significant for the artist, what is able to awaken

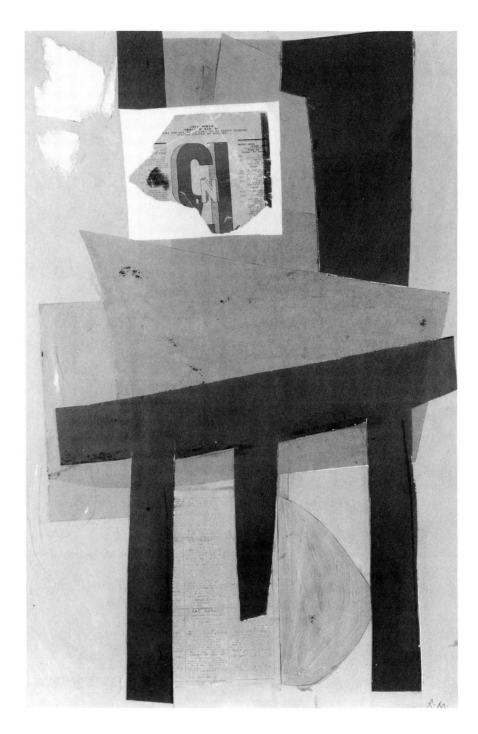

The Easel No. 1, 1954.
Paper collage and oil on board, 30 in. × 20 in. (76.20 cm × 50.80 cm).

Collection Dr. Montague Ullman. Photo credit: Steven Sloman. © 1994 Dedalus
Foundation, Inc.

feeling. So the collages of sending and giving are linked to the weight and the presence of this *Easel*. In the heat of its colors and the closeness of its relation to the reader, the easel itself feels bountiful, self-referential, and grounded in a working situation. The observer feels invited to participate in the fullness of color, in the conversation of painting.

The series of the *N.R.F. Collages* enters into the same mode: these works are not made up of messages, like the wrapping papers of the *Berggruen Collage*, but rather of things casually given, just by a neighbor, like the blue Gauloises cigarette packages brightening so many of Motherwell's warmest collages. Motherwell's ability to incorporate what he receives enters into the overall spirit of generosity. This network of giving, receiving, and sharing is part of the ethical basis for his aesthetics, linking givings and sendings, life and love, neighborliness, and the easel in the studio. The observer is invited to participate, as was the case in Cornell's renaming of the Mallarmé work: the studio is opened, what is sent is received.

The collage *Histoire d'un Peintre* of 1956, this "story of a painter," opens out differently on the world. Four modes of writing are inscribed here. The first three are: the signature of the artist at the top with its date; next, reading down, the printed words "Histoire d'un p" and then the French words "Réalité et abstraction"; and the handwritten "Jour la maison nuit la rue" (In the house by day, in the street by night), from a poem of the surrealist Paul Eluard, where the prostituting of talent and of the body make an ironic scene. The former notion is heightened in referential thickness by the "Histoire d'un p," where the word is torn off after the letter "p," short for "putain" or "prostitué(e)"—the latter, of either genre, since it is torn off, can equally well refer to the prostitution of a male, thus, of the artist himself. The fourth layer of verbal inscription is of course the stamp toward the bottom left, as if to put the seal of acceptance on the whole scene.

Yellow Envelope of 1956 makes further reference to the same double profession of day and night, for at the bottom, with some of the letters effaced, we read once again the inscription, now just a commemorating fragment: "jour la nuit l" and remember exactly what it says. As in reception theory, we fill in the gaps, and in so doing participate in the art. Here once more there are four layers of inscription, with the handwritten "jour la/ nuit l" set in a duet at the bottom, day singing against night. Directly above is a printed pipe tobacco packet, with *Light Special* acting as the illuminating description of the entire work, beneath its own seal just barely glimpsed. At the top is the Apollinairean phrase, printed out in full:

l'aventure
de l'art abstrait

This "adventure of abstract art" is one we are invited to share. Apollinaire's own *ars poetica* about the adventure of art and poetry, "Vous qui êtes l'ordre de l'aventure" (You who are the order of the adventure), finds its appropriate echo in the joyous

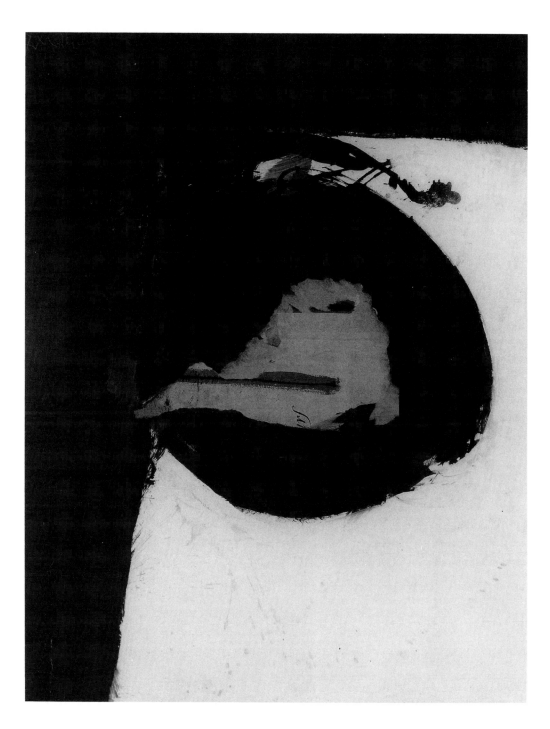

N.R.F. Collage No. 1, 1959.

Oil and collage on paper, 28.375 in. × 22.375 in. (72.1 cm × 56.8 cm).

Collection of the Whitney Museum of American Art Purchase, with funds from the
Friends of the Whitney Museum of Art, New York, 61.24

Histoire d'un Peintre, 1956.
Crayon and paper on ragboard, 16 in. × 12 in. (41 cm × 30 cm).

Private collection. Photo credit: Zindman/Fremont. © 1994 Dedalus Foundation, Inc.

distinctiveness of Motherwell's metapoetical collages, bearing their reference to themselves as to the world beyond.

As *The Easel* was provided with its outside reference in its clouds, and all the *Gift* or sending series participates in a richly communicative network of art speaking across the seas, generations, and genres, so the *Yellow Envelope* of 1956 labels itself in an especially warm light. The collage of 1973 originally entitled *Stamps* and now called *Sea and Sand,* in honor of its colors, takes a brown envelope and heads for New York. Like some map of the world with an ocean of blue between two ochre continents, it is on its way.

Many other layerings mark the history of acquisition. In *The French Drawing Block* of 1958, which Motherwell says is "more lyrical" than the other works in this series, made as it was "in St. Jean de Luz on honeymoon with Helen Frankenthaler,"[16] even the price of the paper is marked: 80 francs. In all these cases it is as if the observer were permitted to enter into the exchange. All these works marked as to their materials, sources, and sendings, all these wrapped, inscribed, stamped, printed, and hand-lettered objects are to be sent and received and read. If we choose, we really enter into a continuing conversation with the artist.

The History of a Violence

What is one to say, then, of the violent history and the anguishing cry of the collage called, again in self-reference, *The Tearingness of Collaging?* Motherwell tells us himself of the violent act this collage is. We do not have to guess at it, for since it was "Made during some of the most tormented and exhausted years of [his] life, the *tearing* was also equivalent to murdering, symbolically."[17] "Tearing" includes its own self-mourning, so the signature at the center reads as part of the anguish, as if in response to the scrawl in orange at the upper right corner. I am at the center of this self-rending, it says, at the center of this collage, with its pasted layers of experience, like so many things to be lived, thought, and self-constructed through—for *what is collage other than self-construction?* In this case, it is both the elegy of an experience and the experience itself.

Even this experience is marked as being sent, for the blue tobacco paper is labeled EXPORTATION. Beneath the paler blue layers, the rectangular outline ends in a noose shape. The memory of this collage is likely to last.

Giving

For exactness of weights of feeling is everything in art.

Robert Motherwell, *"The Scholar Cornered" (1970)*

Motherwell claims that modernism is, among other things, "the effort to get rid of rhetoric in art." What matters within it will be precise and fitting in the relations

Sand and Sea, 1973.

Acrylic and collage on board, 36 in. × 48 in. (91.44 cm × 121.9 cm).

Private collection. Photo credit: Zindman/Fremont. © 1994 Dedalus Foundation, Inc.

The Tearingness of Collaging, 1957.

Collage and oil on board, 30 in. × 22 in. (76.20 cm × 50.80 cm).

Collection Mr. and Mrs. Max Zurier, Beverly Hills, California. Photo credit:
I. Serisawa, Los Angeles. © 1994 Dedalus Foundation, Inc.

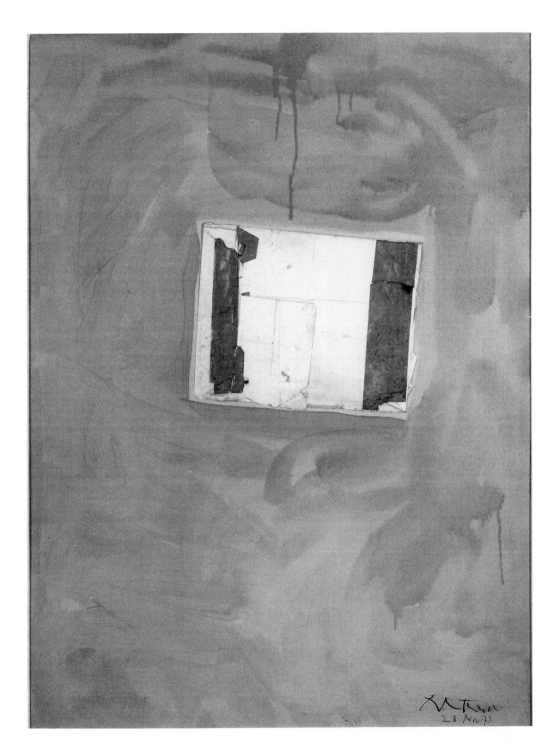

Gift, 1973.
Acrylic and paper on Upsom board, 48 in. × 36 in. (121.9 cm × 91.44 cm).

Private collection. Photo credit: Ken Cohen. © 1994 Dedalus Foundation, Inc.
{see color plate}

between its elements, in itself and its substance. So the color ochre, for example, in its relation to what is central, nourishes my text here. I remember: the artist and I are looking together at two works of an ochre hue, one recent oil on canvas, problematic in its color because of *not having the intensity desired,* as he says, and one of 1973, where the wash over the cardboard is even and glowing, as if it had absorbed the light, to yield it forth incessantly.

In the former, the folded packet in the middle, an envelope of a lighter color, was used to contain something. The work is entitled *Gift.* As a gift it is double, first sent to the artist, and then passed on to us. It is unspecified as to its content, ephemeral because the colored wash on the wood pulp will not last fifty years, will not endure like the oil on the canvas, and yet is so golden you feel the light will last. The gift as such is gone from the envelope materially, just as the wash will not last, yet the gift as metaphor remains, like the memory of that special ochre aglow.

What lasts? In the strange way that such a glow may endure longest in the memory, such a work turns out to be its own *memento mori,* a reminder of itself in evanescence and all the more powerful for its consciously momentary presentness. As we look at these works side by side, in silence, there is no room or need for any rhetoric. No language will match that relation of hue to hue, presence to presence. A presence perfectly *weighted* and then held out. In a work about the gift, the relation of the idea of giving can be a quiet one. I am thinking of two lines by the American poet Robert Hass, counterinterpreting, and correctly, the defeat and triumph within the gift:

> The given, as in given up
> or given out, as in testimony.[18]

Implicit in our conversation are both the first and the second givens.

I see a counterpart to this collage in a piece of 1967 called the *Berggruen Collage,* which commemorates the occasion of the Motherwell exhibit in Paris at the Berggruen Gallery. The paper in which the catalogue of this exhibit was sent to the artist is reused in the collage. Against it is the French postage mark *Recommandé,* meaning, as I said earlier, "insured." In its reuse, and its insurance of that reuse, it also recommends implicitly what is now absent from the package. As in the case of the collage-painting called *Gift,* what once contained is now simply the shell of the event, the sign that the sending—and the reception—took place.

Are we to read these also as a commemorations of a once-presence now an absence? Or as the commemoration of the event itself, with the emotional charge

unembarrassed and clear within the transmission even now? It is certainly not emptiness that is being recommended, rather the opposite. Look at the very sensual fullness of the paper stuck on, its folds and texture *insuring* the sending and the reception. It is recommended that we send on some mark of events, as I am here sending on the mark of that double reading of the color ochre. Interpretations have their own texture, composed of what they enfold and insure. They take their own risk.

Lewis Hyde's classic study of giving stresses the importance of passing on what you receive: "a gift that cannot be given away ceases to be a gift."[19] I have wanted to pass on what I could of my encounters with Motherwell and his art. The enclosure of *Gift* leads me to reflect on other enclosures, other inclusions explicit and implicit.

Holding and Setting Out

The reason I've made so many works (out of whatever I've made)
that could be called series . . . is simply because I feel that I've
never fully resolved any of them. They remain an endless challenge.
Robert Motherwell, *interview in 1977*

The *Night Music* Series

What do I remember of my first encounter with Motherwell's *Night Music* series?
Looking like the binding of an ochre-colored sheaf of wheat, the black horizontal
seemed—I think I saw it so—to be reaching across, to hold those ochre-beige
colors and torn quasi-rectangular shapes straight up against the night. It is no acci-
dent that the binding is black. It participates in what it holds against. Indeed these
works nourish as if they were those full sheaves of wheat they so resemble. They
appear to hold firm, even against despair. I am remembering André Breton quot-
ing Matisse's statement that art had to hold its own against a wheat field and then
saying later, more urgently still, that it must hold also even against famine. If I try
to say how Motherwell's work strikes me with a moral force, it is that holding I am
speaking of, among other things, and which gives its title to this book. It is a title
Motherwell loved.

That binding strip, that dark holding—how strong it feels in its blackness. I am
looking back in my mind at his *Metaphor and Movement* from 1974, where the hor-
izontal black rectangle stands against an earth-toned background, held by a white
torn bit of paper and yet moving toward the left, to a smaller beige rectangle, at-
tached by bands of an ochre hue. (Paul Feeley says to Motherwell in the 1960s:
"You've made it impossible for anyone else to use ochre.") The earth feeling of that
warm ochre joins the work of art to something fundamental, earthy, essential: the
color of wheat, the color of the sun, and all those *sun-struck gifts*.

Robert Motherwell's Greenwich studio, with works from
The Night Music Opus collage series of 1988–1989
(February 1989).

Photo credit: Ken Cohen. © 1994 Dedalus Foundation, Inc.

The colors of the *Night Music* series are those of the *Voyage* of 1949, with its
Baudelairean resonance from "Le Voyage": "Traveler, what have you seen?" and the
answer: "I have seen . . ." I have seen . . . The white, ochre, and black have here
the same piercing authenticity as Baudelaire's unforgettable recounting of a quest.
On the walls of the Lascaux cave, Georges Bataille detected a tiny grid at a bison's
foot, of black, ochre, and white. So the power of these colors made from the earth
reaches as far back as we know, into the earth's bowels and crevices. *The Voyage: Ten
Years After,* a re-reading by the artist of his own distance, is marked with its great
cloud drifting across the dark rectangle at the center. The night music reaches
backward and onward.

The 1974 collage *Metaphor and Movement* might represent relation itself, hold-
ing and moving at the same time. Some force seems to push toward a monumental

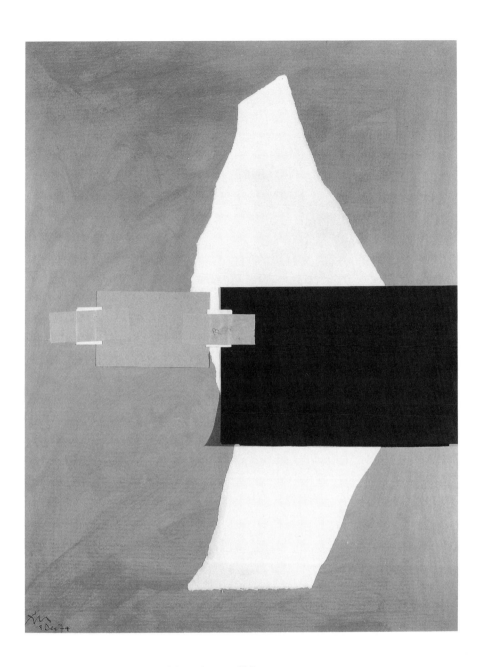

Metaphor and Movement, 1974.

Paper and acrylic on Upsomboard, 48 in. × 36 in.

Albright-Knox Art Gallery, Buffalo, New York, George B. and Jenny R. Mathews
Fund, 1977

convergence in Motherwell's work, luminous and grave. That representation of metaphor helps the reading of *Night Music*, as of the *Voyage*. "Vehement and compassionate," says Gabriella Drudi of his work.[1] *Vehement:* how right the word sounds here, like the intensity of the ochre color. The ochre holds, as long as it can, against the abyss, like wheat against death. *This is what I remember* from my first encounter with one work from the *Night Music* series, in Motherwell's studio, with him at my side.

A Positive Misremembering

I have gone back again, months later, to the *Night Music*. Now, to my surprise, the holding is of a different sort than I had remembered. No less powerful, but different. What I had remembered as a sheaf upstanding, in *Night Music Opus No. 7*—such is the force of the metaphoric imagination, bearing witness to its sway—is now two ochre strips, into the right one of which the thickish black strip seems to be penetrating. It is indeed held against the whitish form, but on its left the other partly hidden ochre form is partly free. And behind the black, the white, the ochre, part of a red-orange rectangular shape appears, against the black background. The black strips, then, both touch and leave open. What I had thought of as a straightforward holding is more complex by far.

These strips stand in a strong correspondence with the red strip stretching across three of the yellow and white bars to the top and left of *The Little Spanish Prison* of 1941–1944, where it stops mid-bar to show you it is outside, unimplicated, unimprisoned. It is not held in and does not restrain. The moral lesson takes on more layers, as we think of the relation of Motherwell to Mondrian, whom he so admired for his geometrical sense. When he visited Mondrian's paintings at the Peggy Guggenheim Gallery and at the Valentin Gallery in March 1942, he reviewed them for *VVV*, describing the work as falling "into the trap of loss of contact with historical reality," with the senses, with the irrational. His *Prison* did not do that, nor does his *Night Music*.

The freehand effect of Motherwell's vertical stripes here successfully conveys something of an emotional import. The feeling is both stable and uncertain, with the magenta bar or window reaching across to break the static lines, like the window in the *Spanish Picture with Window* of 1941. A slight wavering in the vertical bars humanizes them into a composite person/forest/column. A wonderful passage from Faulkner's *As I Lay Dying* comes to mind, a meditation on why

> the Lord put roads for traveling; why he laid them down flat on the earth. When He aims for something to be always a-moving, He makes it longways, like a road or a horse or a wagon, but when He aims for something to stay put, He makes it up-and-down ways, like a tree or a man.[2]

Motherwell's bars are of course meant to stay put, in one place. All the same these marks of the human hand make a political statement about freedom and non-freedom in Spain as, at the same time, they convey the problematic relation of man himself to imprisoning; people build prisons for other people. One day though, in a Motherwell work, Mallarmé's swan will sail free of prison as of page.

In all the works of this great opus the black bar repeats the night behind, echoes, holds, yet does not restrain. It can take the form of a simple square, a patch, a memory, with all the impact of that celebrated little patch of yellow wall in Vermeer's *View of Delft* that Proust's Bergotte rises from his bed to see one last time before he dies. This bar bespeaks the same mortal fascination in *Over the Edge* of 1988. In *Night Music No. 13* the upright white form is held against a luminous ochre background, while the black patch of a strip is itself echoed below by a bar, whose black color is dripping into the ochre, like the liquid black of *In Plato's Cave* that had to be *cradled* in its dripping, a birth-death cycle made explicit only in the painter's commentary.

I had forgotten too, in the force of my initial encounter and then remembrance, how deeply felt is the gesture of tearing, as in *The Tearingness of Collaging*, how violence enters the act:

> The sensation of physically operating on the world is very strong in the medium of the papier collé or collage, in which various kinds of paper are pasted to the canvas. One cuts and chooses and shifts and pastes, and sometimes tears off and begins again. In any case, shaping and arranging such a relational structure obliterates the need, and often the awareness, of representation. Without reference to likenesses, it possesses feeling because all the decisions in regard to it are ultimately made on the grounds of feelings.[3]

Had I been reading as a monolithic gesture something made up of parts, imposing my own rhythm on the reading of another's statement? Personal response holds as much danger of slippage as power to elicit. But I would not want, however, to lose the feeling of what spoke so loudly to me; passionate reading is also passionate listening.

Let me look again at the other examples of *Night Music* I had wanted to write about, to see them more clearly. In *Opus No. 12*, the black strip speaks again of insertion and of superimposition, and less of holding than I remember. Against the greenish-beige and slate gray vertical rice paper, the black bar of this section of *Night Music* reads still in response to the black background, yet also in horizontal correspondence with the pink-gray paper, with whose bottom edge its own almost coincides. I had eliminated in my memory the other horizontal form, so strong was my desire for the holding against the night. In the complexities of *Opus No. 3,*

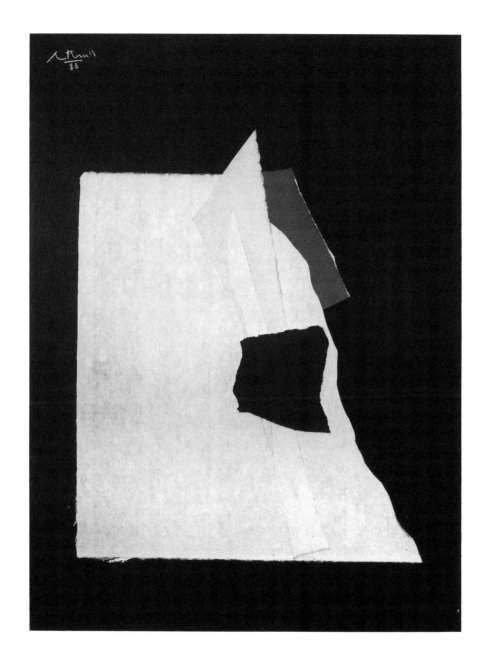

Night Music Opus No. 1 (Over the Edge), 1988.
Collage of rice paper and acrylic on canvasboard, 40.5 in. × 30.5 in.
(102.87 cm × 77.47 cm).

Collection Renate Ponsold Motherwell. Photo credit: Ken Cohen. © 1994 Dedalus
Foundation, Inc.

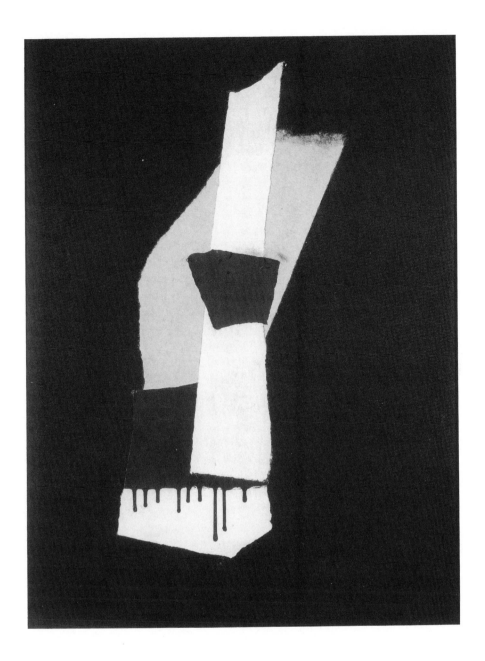

Night Music Opus No. 13, 1989.
*Collage of rice paper and acrylic on canvas panel, 32.25 in. × 26.25 in.
(82 cm × 67 cm).*

Private collection. Photo credit: Ken Cohen. © 1994 Dedalus Foundation, Inc.

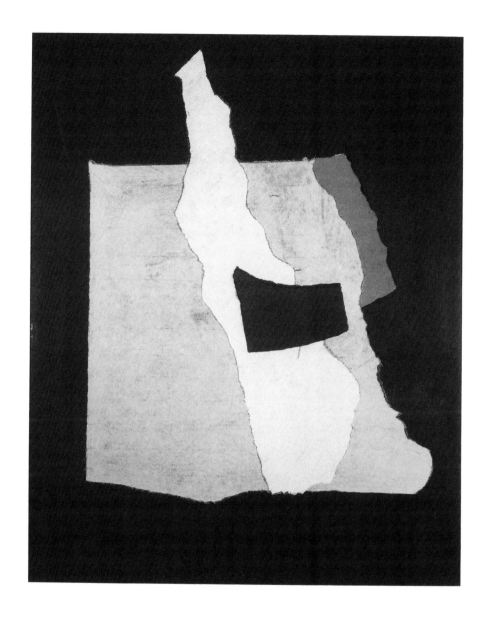

Night Music Opus No. 3, 1989.
*Collage of rice paper and acrylic on museum mounting board, 32.5 in. ×
26.25 in. (82.6 cm × 66.7 cm).*

Photo credit: Ken Cohen. © 1994 Dedalus Foundation, Inc.

where the layers of paper are clearest, each in its turn shows through the next in a system of echoes and overlappings. The black astride the cream-colored translucent strip falls over the next two layers, as the darker earth tones of the bottom one show slightly through. Again the slightly curved bottom edge of the black strip echoes the bottom form in its own slight curve of lower edge: I had read only the echoes of the night, and not of the other forms.

Of course, someone might answer. Of course you have to speak of works only as you are confronting them. Of course the memory betrays. What it fails to differentiate is the very ground of being of the work; what it misses is the art. Not entirely, I think. The art of response has to include that of remembrance, even if it is, as in the Cornell case, a *misremembrance*. The reading may speak of something else. Suggestion may unfold as wide as real matter. Mallarmé knew it, and we may tend to forget it, in our own attempts to remember *correctly*. George Santayana used to say that "nothing absorbs the consciousness so much as that which is not quite given."[4]

Anchors and Waterscapes

In a more joyous and completely different vein from the *Night Music* series, *The French Line* of 1960 sets sail, past the tearing experience. There are no scrawls, no noose suggested in a protrusion at the lower left, as in *The Tearingness of Collaging*. The strips or stripes reappear, calm in their verticality, and stand out against a square of white like a great ship rising gracefully from the blue water; the square is set on a sea of blue and white, a double frame under the peaceful ochre sky. Motherwell points out the humor of the line, "la ligne," as in the diet breadsticks represented in this collage, where even the bouche or mouth of "Labouchède" reads lightly. These were good years to look back on. Like the *Je t'aime* series, the work conveys a form of happiness directly to the observer.

The principle of the strong base, sometimes in thick horizontal lines as of the sea, as in the *Beside the Sea* series and the *Summertime* works, is visible also in such collages as *The Times in Havana* (1979). To the mixture of languages, English and Spanish, replies a mixture of shapes, as the torn, light-colored vertical paper is set in play with the newspaper to be read over and literally against it, and contrasted both with the awkward heavy horizontal oval shape at the bottom left and the few strands of wavy lines like hair to the bottom right of the newspaper. The concatenation of forms, although not particularly successful as a collage, is illustrative of Motherwell's experimentations with anchoring devices and with forms against which to read others.

The stability of the lower stripe, a reliable basis to anchor the other forms, is carried through the *Indian Summer* series, with an oval floating high above the stripe, reminding us of the first time the work set sail, in the key work now called *Mallarmé's Swan*. The oval has the feeling of plenitude, and the stripe, of stability. If sometimes a stripe floats across or behind the oval, as in *Indian Summer No. 1*, it

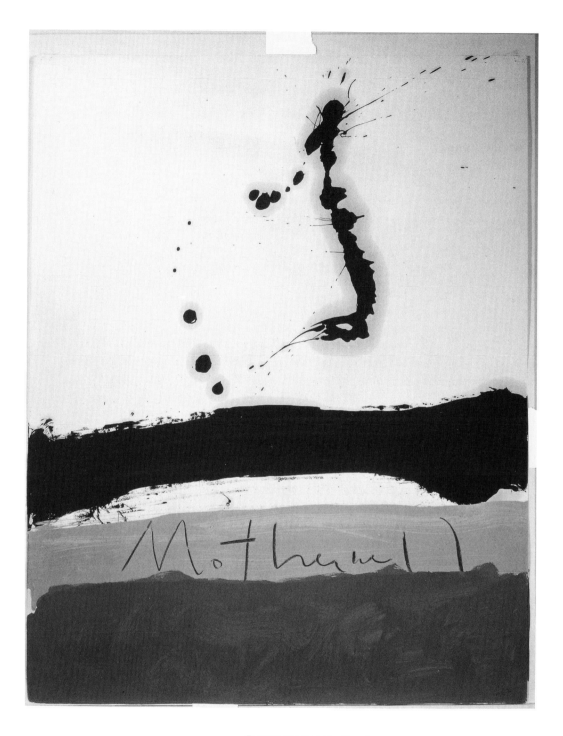

Beside the Sea No. 2, 1962.
Oil on paper, 29 in. × 23 in. (73.66 cm × 57.79 cm).

Private collection, Japan. Photo credit: Steven Sloman. © 1994 Dedalus Foundation, Inc.

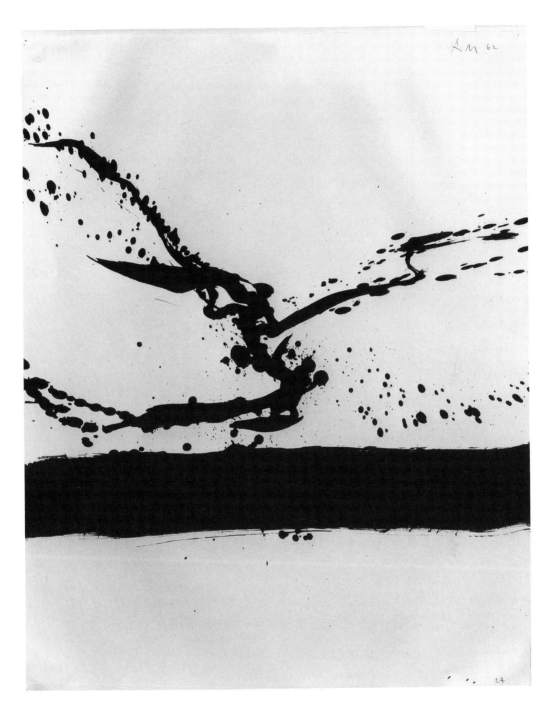

Beside the Sea No. 24, 1962.

Oil on paper, 29 in. × 23 in. (73.66 cm × 57.79 cm).

Collection The Modern Art Museum of Fort Worth, Fort Worth, Texas (Gift of the
Artist). Photo credit: Steven Sloman. © 1994 Dedalus Foundation, Inc.

is rather as if the moon were to be read in front of the clouds—nothing more urgent than that. The same calm pervades the simple outlines of *In Beige with White Oval* of 1968, so modest and so classic. The two sides of the rectangle at the top and right of the work are read like a Greek temple, some ruin that holds all of life in this oval it includes and refers to. Why should we need more than this? Even the initials here, RM, quite simple, as we read them in *In Beige with White No. 4,* also of 1968, say of these works: *Look—this is enough.* Here the cutout form is as quiet as one of the great Matisse collages, forming a monumental arch for the passage of thought.

Motherwell's sense of place is a sure one, enabling his frequent use of the preposition *in:* as "In Ochre." His setting out of his choice of color is made strikingly clear: *I have done this,* he is saying, *in the place ochre has given me.* The ships setting out in *The French Line,* the spray spurting high above the water in the *Beside the Sea* series, with its erotic thrusting and its strong large signature between the layers of the liquid stretches of sea at the base: these speak of the same force and yet the same stability. A view of Motherwell's studio/house in Provincetown, at high tide in a high wave, gives an idea of the original source of such energy. The *Summertime* works, like *Summertime in Italy* and other such pictures, have the same composition: a strong base of water often supporting a sail for setting forth, conveying a double feeling of strength and gladness.

The *Dover Beach* series, related to Matthew Arnold's poem of the same name,[5] flings up in the same way the matter of the poem and the art work:

> Listen! you hear the grating roar
> Of pebbles which the waves draw back, and fling,
> At their return, up the high strand,
> Begin, and cease, and then again begin,
> With tremulous cadence slow, and bring
> The eternal note of sadness in.

The End of Dover Beach (1953–1957) paints the struggles between two senses of ending—of the poem itself and of love—in this shadowy place the poem inhabits:

> Ah, love, let us be true
> To one another! for the world, which seems
> To lie before us like a land of dreams,

High tide in high wind at Provincetown (Motherwell's
house and studio).

Photo by Renate Ponsold, 1975. Photo owned by Renate Ponsold Motherwell

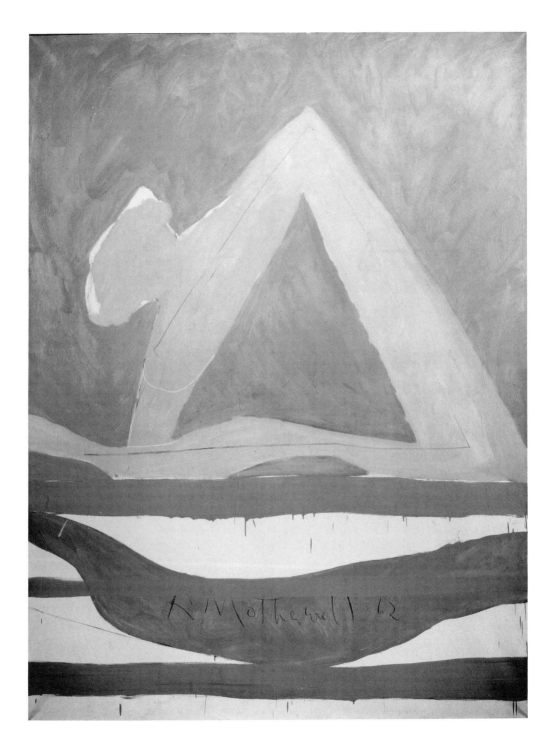

Summertime in Italy No. 28, 1962.

Oil on canvas, 96.5 in. × 72.5 in. (245.11 cm × 184.15 cm).

Private collection. Photo credit: Steven Sloman. © 1994 Dedalus Foundation, Inc.

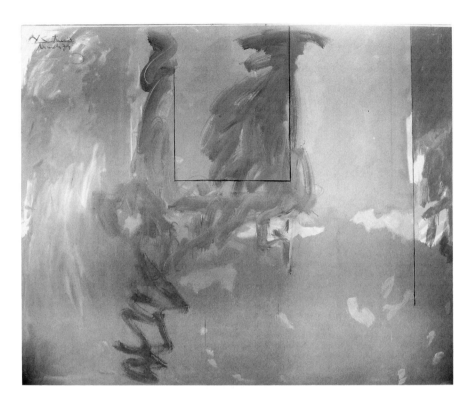

Dover Beach No. III, 1974.
Acrylic on canvas, 77 in. × 96 in. (195.58 cm × 243.84 cm).

Collection Jean-Paul Barbier-Muller, Geneva. Photo credit: Steven Sloman. © 1994
Dedalus Foundation, Inc.

So various, so beautiful, so new,
Hath really neither joy, nor love, nor light,
Nor certitude, nor peace, nor help for pain;
And we are here as on a darkling plain
Swept with confused alarms of struggle and flight,
Where ignorant armies clash by night.

The sheer impersonal exuberance of the sea flinging up its pebbles stands in terrible contrast to the eternal note of sadness, in our painful mortality, our struggle with the existence and stupidity about us, beached as we are, until our end.

Printed black on red, a wonderfully dynamic lithograph called *Wave* of 1989 shows the strength of the vertical ascent of thick black lines leaping up on the red paper in two columns, based on and anchored in a long stretch of liquid across the bottom of the page. It has the feeling of the *Samurai* series, and the black sings out against the red. This is the exact opposite of an *Elegy*, a celebration of life instead of loss. Instead of the heat and shadow of the bullfight at the origin of the *Spanish Elegies*, we feel the life-giving wave against the bloodred background. This seems to me one of Motherwell's most successful lithographs, wherein the two currents—the barbaric and the elegant—he recognized in his own work are called on to meet.

One of the more remarkable *Sea* works is the *Sea Lion with Red Stripe* of 1959: here the label comes from a Canadian sardine can, from which the artist tore off the word *Lion*, feeling it did not fit. The stripe marking the upper edge of the collage prevents the central circular form from taking off at the top, its sweep and mass linking it to the *Black Rumble* series, where the circular shape occupies the center and is also anchored by one or more stripes at the edge or edges. Indeed now, as Motherwell points out, "Only the 'Sea' shows in it."[6] With this conscious or unconscious *show* of the word *sea*, the observer is summoned to see, also: *See. Look.* Again, the stature of the artist is itself a summoning presence, so that his call for us to share his sight will not go overlooked.

Summertime in Italy of 1960 anchors its seascape with stripes of blue, white, and orange at the bottom of the work, with a brownish boat and sail shape sailing on it, interrupted by a few scraps of blue cloud and yellow-orange hues, as if in a haze of cheerfulness under a Mediterranean white sky. Motherwell's sailing works are as simple as they are joyous. *The America Cup* of 1963–1964 has a superb simplicity of form against form, an easy-to-read quality: white against blue, a great floating form of ship sailing against an unperturbed undifferentiated blue of horizon and sea. The calm of this quite beautiful collage is labeled with dimensions in its bottom right corner: another mark of stability, even in the center of a race.

With its swash of "Motherwell blue" highlighted with white, *Gulfstream* has two sides of the *Opens* window dividing up the heavily worked surface. They are

Gulfstream, 1980.
Acrylic on canvas, 36 in. × 72 in.

Collection Renate Ponsold Motherwell {see color plate}

really two simple lines extending from the top almost to the bottom with no connecting line, yet the viewer who knows the *Open* series might be likely to consider it a partial window opening, filling in the space mentally, as in some Gestalt test. It is in a sense more open than the *Opens*, conveying the strong impression of a liquid expanse.

The Generosity of Prepositions

As I indicated in the previous chapter, in remarking on the power of ellipsis, there is something particularly rejoicing to the spirit in even the title of Motherwell's color collages: for example, *In White and Ochre,* or what we could think of as the series: *In . . . with . . . ,* of 1968 (*In Beige with White, In Ochre with Cobalt,* or *In Ochre with Gauloises*), or again the series called *Scarlet with Gauloises Blue* or *Grey with Gauloises Blue.* The beauty of these colors set against each other, the blue of the Gauloises packet against the stunning ochre, or the cobalt/ochre, where the simplicity of the rectangular forms is only interrupted by the two small patches of corresponding color, like those clouds floating to the upper left of *The Easel,* or in the epic *Voyage* canvasses and *The Voyage: Ten Years After.*

What matters in these works is not *only* the way in which the colors are set so simply against each other, with the stark rectangular forms never standing in the way of the initial color impression. It is also, and in my eyes just as importantly, the very verbalization of the spirit identical in its generosity with what I have called the giving and sending collages. Motherwell's precise use of the words *with* and *in* are significant as a choice. *With.* . . . We notice that the titles do not use *against* or *in contrast to* but always *with,* always the addition of an element, always a joining together. This is the bounteous spirit characteristic of Motherwell in his most joyous hours, the diametrical opposite of such negative statements as *The Tearingness of Collaging.*

The title *Tree of My Window (Robert Frost)* (1969) makes a decided move of prepositional peculiarity. Since it is a question of a window, and a tree seen from it, it would be "normal" to have entitled the collage *Tree Beyond My Window.* The very fact of putting the tree in a genitive connection with the window and, by extension, with the *my* of it brings the tree into the space of ownership and of perception, putting it on the same plane as the window and having it generate the window, as the window does the tree. This is an important picture for Motherwell, as I have said, one of the very few nature works and his first work in Greenwich. It manifests, like the poetry of Frost, a certain Americanness.

An exemplary use of the generous preposition *with* is the *Art Bulletin Collage, with Cross* (1968), its dark green set against a differently green rectangle; above it is a page of the *Art Bulletin,* with a brown cross marked across its print, itself carrying the trace of a torn red paper. So it combines the feeling of a gift tied with a red

Gauloises with Scarlet, 1972.
Acrylic and collage on canvasboard, 14 in. × 10 in. (36 cm × 25 cm).

Private collection. Photo credit: Zindman/Fremont. © 1994 Dedalus Foundation, Inc.
{see color plate}

ribbon, the red and green colors of Christmas, a reference to the red of the crucifixion and the Passion, all this reminiscent of the anguish marked in the single *Elegy* that is "Tinged with Blood." The ability to present ambivalence, combining in the same moment suffering and giving, is part of Motherwell's open spirit.

The very lines that speak of the connection between painter and audience, painter and material, and painter and emotion reflect the way in which certain collages are linked to their shapes and their sides. I am thinking of such works as *La Crémaillère* of 1972, with its strong inner framing, outside of which the painter's signature rests, to mark it *as* a frame, with its thin lines inset into the thick edging, enclosing another rectangle slightly separated by a patch of white background showing through. All this layering stresses the label "La Crémaillère" itself. I am thinking of the thin vertical lines reaching from top to bottom of the series of *Gauloises* collages, tying the centralized packet of blue to the background, anchoring it ever so lightly.

I am thinking also of the *Manchester Guardian* of 1977, where the patch of this newspaper takes the form of a left-hand glove, with its very beautiful trinity of thin black lines with hooks at the top, traversing the horizontal print lines of the paper. These are echoed outside by three uninterrupted lines. The fact that two of these interior black lines are edged with the ochre color of the background, as the paper is pasted onto another ochre, less intense, acting as a bridge, makes the entire collage coherent and, from my point of view, a triumph of simplicity, as moving as it is simple. I am thinking too of a work dated 1972, the beautiful *Matte Medium,* where three vertical black strips divide the central rectangle of brownish-ochre, itself set against the rectangle of white, signed with its title to the bottom right. This small double rectangle is then set on an opposing deep blue stripe running horizontally below the rectangles. This stripe, once upon a time black, has now taken on its true color, underlined by a stripe of white, as if to say: *This is right now, look.* Everything is perfect here and perfectly balanced, the tiny splotch of black at the left upper corner and the tiny splotch of lighter blue to the upper right.

Another work of 1972, *L'Art vivant,* or Living Art, calls attention to the words *Art vivant* included therein. Like Matisse's *Le Bonheur de vivre* and Motherwell's own *La Joie de vivre,* this art of living corresponds to what Motherwell says of his collages:

> The papers in my collages are usually things that are familiar to me, part of my life. . . . Collages are a modern substitute for still life. . . . I do feel more joyful with collage, less austere. A form of play . . . An artist is someone who has an abnormal sensitivity to a medium. The main thing is not to

Manchester Guardian, 1977.
Acrylic, charcoal, and collage on canvasboard, 36 in. × 24 in.

Photo credit: Ken Cohen. © 1994 Dedalus Foundation, Inc. {see color plate}

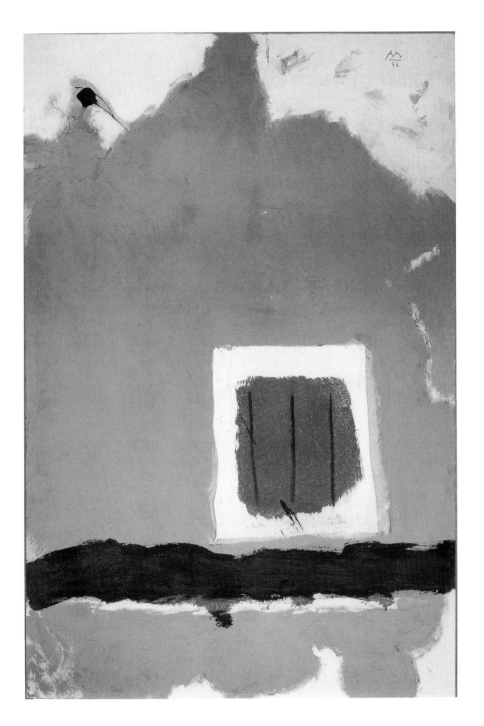

Matte Medium, 1972.
Acrylic and canvas collage on canvasboard, 37 in. × 24 in.
(94 cm × 61 cm).

Private collection. Photo credit: Zindman/ Fremont. © 1994 Dedalus Foundation, Inc.

be dead. And nearly everyone is dead, painter or not. Only an alive person can make an alive expression. The problem of inspiration is simply to be fully alive at a given moment when working.[7]

The French words are set diagonally within a roughly marked pattern of vertical lines, wittily matched to exactly the direction taken by the other printed words: the instruction *not to be folded* ("ne pas plier"), themselves diagonally set to the *Art vivant.* "Ne pas plier" also carries the connotation: don't give in, don't conform to what others would ask of you. This tremendously articulate artist is here using the simplest means at hand to make one of his major moral statements of these years. This art is living, this art will not conform, do not try to bend it. These are works of a balance so delicate you can only say, quite quietly: *See. Look.*

Probably the most effective holding device that Motherwell was ever to find, the system of vertical lines in such collages as these holds good. There are other demonstrations of the *holding power* of this vertical field, for example, the stunning series of lithographs called *Soot-Black Stone* of 1973. Here again thin vertical stripes anchor the central form, which in turn refers out to the black, the white, and the entire conception. Like the works entitled *Redness of Red, The Stoneness of the Stone,* and all the essentially self-intensifying expressions of density in the title, these workings out of *the thing in itself* show Motherwell at his most philosophically acute, with his eye knowing how he can have us hold on to something that matters, to the essence of the thing. He expresses not just the object but the idea of holding and holding on.

And Motherwell will keep these lines. One of their most successful uses dates from 1980–1981. Called *Greek Door,* it shows a lightish, brightish blue door to the right with two vertical black lines running up. The color was originally navy blue, but that killed the yellow color, Motherwell told me one day, so he changed it to this blue, nearly the color of the Gauloises cigarette packs so frequently a part of his collages. These vertical black lines are rhymed to the left by a light beige strip, running a bit tangential to the sure straightness of the door lines, and a surrounding three-sided white strip, acting almost as a handle to the door. Like an afterthought blowing by in the wind, a piece of a symphony score adds its joyous tatter with a twist, just touching the beige strip and the blue door, itself echoed by a smaller tattered stripe on the door above, of the same triangular shape as the right side of the music. It trails a bit of paint below, down the door, in a readymade and rapid remembrance of the two vertical strips in the door frame. The balance of colors, of lines, even of tatters, marks, or *flags,* in its yellow, white, and blue, a moment in the *living art* Motherwell knows how to capture.

It is not easy to say about these works what gives them their breath-taking *certainty.* I can only suggest that it is the meaning given, implicitly, to these holding lines themselves, and the way they speak for this art.

The greater the precision of feeling, the more personal the work will be.

Robert Motherwell, *letter to Frank O'Hara*

You can recognize from a great distance Motherwell's writings just as well as his art. It has his touch. This is one of the rare cases in which much of a great artist's writing is itself of lasting value. Since my main concern in these pages is Motherwell's relation to the literary, his own verbal fluency and intense relation to the moral import of writing are matters of singular importance to me, and matters of delight.

Venturesomeness. I want to begin by celebrating this term, which Robert Motherwell applies to Guillaume Apollinaire and his writing. And, thinking of Motherwell's own writing and conceptions, to set it over against the dire boredom he evokes with one terse cry:

O sameness![8]

Motherwell himself, as I said at the beginning of this book, was never afflicted with that dread disease of sameness. This is not to say that he was not, when it mattered, consistent, in his work and his affections; it is rather to insist on how venturesome his writings really are, no less so than his visual creations.

Every artist's task, he would say frequently—meaning it, doing it—is to invent himself. To invent is, of course, to come across (Latin *in-venire*), and he came across. Found himself. And in inventing, finding himself, he helped us invent and find ourselves. What more could we have asked of him?

He believed in working relations: work, he would say, with Matisse, is about interior relations, as surely as it is about the relations of the artist and the medium. He believed in other relations too: just witness the warmth of the people he gathered around himself and his work, inseparable from each other. His works and his friends all have the art of relation.

"The Place of the Spiritual in a World of Property"—so Robert Motherwell had first called the publication that was to become "The Modern Painter's World." In those pages he retains one of those presumably polar opposites, "the spiritual," claiming that "the modern artist tends to become the last active spiritual being in the great world," inhabits a "spiritual underground." He lets go the other, at least in its literal appearance. For property, once freed from its too specific sense of ownership and objects that have accrued over the years, is now able to take on once more its real inner meaning, to become what the German philosophers would call

eigentlich—the quality of what is *one's own being*. What you hold on to, in spite of everything. What marks you as yourself. In brief, what endures, as Motherwell recalls the word Mark Rothko so often used and as I am using the verb "to hold."

Motherwell will endure, of course, through his great visual works alone but also through his writing. We have his mind in his words as well as in his art. Of course, his living, working, and often speaking were inclined toward sight. Yet it was frequently in relation to his *thinking* that he would use the word so important to him, *open,* the key to so much. We have already seen this in his comparison of his mind to a glass-bottomed boat, open to "what is swimming below." DON'T LOOK BACK! EVERYTHING IS OPEN, he cries, with Charles Olson, associating himself with the open field poetics that initiated this book.

When Motherwell imagines openness, he thinks of the brushes and the blank paper, invoking again and again Mallarmé's memory, about the anguish of the white virginal page and its affecting glory. This is the backdrop of the epic gesture he believed in making. It is, as I have emphasized, a typically American gesture. Motherwell was not just part of the New York School, whose tenets he helped to define and for which he was perhaps the leading and certainly the most articulate spokesman. He was also a spiritual kinsman of the open field school, a visual spokesman for what has turned out to be one of the most important representations of American poetics. Motherwell, in spite of his obvious connections with France, was always—to use William Carlos Williams's term—*In the American Grain.*

Setting Sail from Provincetown

> O Mort, vieux capitaine, il est temps! levons l'ancre!
> Ce pays nous ennuie, ô Mort! Appareillons!
> Si le ciel et la mer sont noirs comme de l'encre,
> Nos coeurs que tu connais sont remplis de rayons!
> [O Death, old captain, it's time! let's lift anchor!
> O Death, this country bores us! Let's set sail!
> If the sky and sea are black as ink, still
> Our hearts you know are filled with light!]
> Charles Baudelaire, *"Le Voyage"*

By the sea in Providence, at five on one summer afternoon—those two words that Henry James always declared to be the two most beautiful words in the English language, *summer afternoon*—at five in the afternoon, just as in Lorca's elegy he loved so, Motherwell was dying. When he was taken out on the stretcher, Lise Motherwell remembers his lifting his arm, as if to gesture to the studio and to the sea.[9]

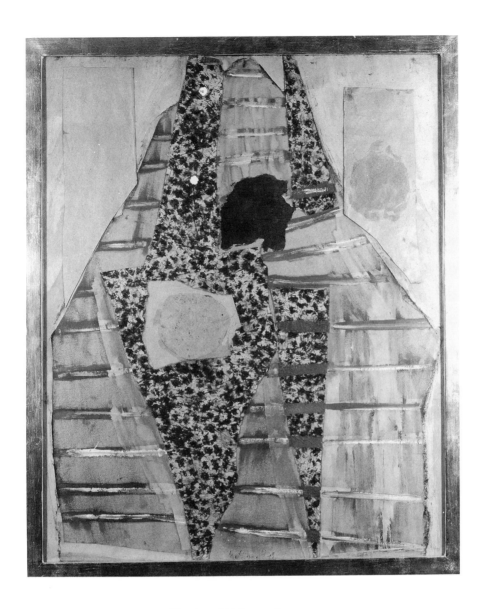

The Joy of Living, 1948.
Paper collage and oil on board, 29.5 in. × 23.5 in. (74.93 cm × 59.69 cm).

Collection Robert Elkon, New York. Photo credit: Peter A. Juley. © 1994 Dedalus
Foundation, Inc.

Empty chair in studio, with *Elegy* on wall.
Photograph courtesy of Renate Ponsold Motherwell

Motherwell's repeated rendering of the French artists and writers like Baudelaire and Matisse—with their strong acknowledgement of sensuality, *Le Bonheur de vivre*, echoed in his *Joy of Living* and his *Joie de vivre*—had made the same point over and over, implicitly and explicitly. What is worth loving and living for hold and is worth holding onto. His art holds, even beyond him. One critic and friend has described it as the act of "*absenting* the subject matter,"[10] a central concern of the modernist gesture. That gesture begins, as so much does, with Mallarmé, who defined a flower as "what is absent from all bouquets." Robert Mother-

well knew how to show us about presence and absence, about what holds. And why.

In response to Motherwell's large gestures, I want to end with something small. For me, one of his most moving works is a little painting called *Open with Elegy,* which finally joins these two terms. The elegiac itself is held within a form at once open and contained, the four elements of the elegy just reaching the top edge of the open window form that holds it. There is room around. This is the way I read Motherwell back from here: holding, mourning, stretching upward and out beyond the actual bounds of the work, pushing the thick black forms up with a sensual pagan reach, against the void he recognizes and salutes.

Another great American painter, his friend Mark Rothko, asked him once, "How does one live a life?" Motherwell mused, quietly and aside, "as if I knew." In his best moments, I think he knew. It was a knowledge in his spirit, in his conscience and his consciousness of his passion for a work that was always setting out.

CHAPTER SIX

Five Interviews with Robert Motherwell

AUTHOR'S NOTE: Ellipses mark pauses in the conversation, while line breaks indicate changes in the subjects of our talks, from which I have simply omitted the parts I consider irrelevant to this study, without signaling them.

Interview About Joseph Cornell

1989 (GREENWICH, CONNECTICUT)

MARY ANN CAWS: I'd love to hear anything you had to say about Joseph Cornell.

ROBERT MOTHERWELL: First of all, I would say he was closer to French romanticism, whereas I am closer to French symbolism.

He pursued images of beauty. Once he presented a glass box backstage to a ballerina he found lovely. She asked me if he was crazy, and I said, "No, he's just like that." He looked like Captain Ahab. I mean he was burning.

MAC: Did he ever smile?

RM: Not often. I remember an incident Matta told me of, in the very early days, in 1942–1943, when the movie houses had a glass cage to take the money through. There was a very pretty girl behind the cage, and Cornell went out into the field to gather a bouquet, then stood in line with all the people waiting to pay and shoved the bouquet through the glass hole. The girl was so terrified that she called the police, and he actually was charged with harassment. Matta once said to me: the only trouble with him is he only knows about masturbation.

His mind was very convoluted. He earned his living at that time by designing fabrics. What he did, which I also did, but not as obsessively, was this: he used to ransack Fourth Avenue between Fourteenth Street and Eighth Street, which was lined on both sides with secondhand bookstores, for postcards and every sort of thing, to build a kind of private museum, a collection.

Robert Motherwell.
Photograph courtesy of Renate Ponsold Motherwell

About that time, in 1944, I edited Apollinaire's *The Cubist Painters*. There was some talk of Loie Fuller and the butterfly dance, and Cornell was desperate to see it. Finally he located a film of her. He was particularly interested in ballet dancers. He built a world unto himself, and that is why I say he was essentially involved with French romanticism, with what happened in Paris in the first half of the nineteenth century.

He was really a mental traveler, living in book shops, and from that point of view, there would have been no point in his going to Paris, except for the book shops along the quai.

Later on, he wanted to establish a course. . . .

MAC: He did? In what?

RM: In this kind of thing. He wanted to know how you did that, setting up teaching. He was also tough—he insisted you have sour balls, that kind of candy, and when there weren't any, he expressed real anger.

MAC: This was in his house?

RM: No, in mine. I used to have a Welsh terrier. Once we were sitting on the sofa talking, and when the terrier sprang up beside us, Cornell shrieked in horror. . . .

MAC: Would you say he had a feminine sensitivity?

RM: I don't know. I would certainly say he was not a homosexual.

MAC: The chase after the beauty you are not going to use, . . . all that heavy framing, that keeps a distance. You don't have to do anything.

RM: The attraction of flamboyant beauty . . . It turns it almost into an object, the Chinese vase. . . . But I remember the terrible little house where he worked in a corner . . . with his brother in a crib at the age of thirty. . . . he didn't have a car, I would imagine him, with his craftsmanship, working in his corner. When I was in the third grade, in California, where the schools are much less traditional than they are in the East, we had to make boxes, with amateur carpentry, just this big.

MAC: All very tiny.

RM: Yes. In a funny way, he was totally obsessional. How much he actually knew about French literature, how involved he actually was, I don't know. I do remember us talking about Nerval he had come across in translation. And you see from that standpoint Cornell and I had the same mental image of France. For him, it was much more literal than for me, and it had much more to do with female fetishes.

He must have understood my interest in his craft. "It's as though you ransacked your grandmother's attic, or her den," I said to him once. And then to my astonishment, he would say, "Tell me that again about the attic." As if it were a sort of credit to himself. And of course what I was referring to was that it sometimes gets very sentimental. . . .

MAC: Did he have a sense of humor?

RM: I never thought of it, but no. I also think he had no sense of irony. He was absolutely straight. I guess my mental image of him as Captain Ahab comes also from that. There was a very strong American Protestant strain in him. For example, when it was a question of the WPA, Joseph went into a tirade about how obscene it was to be taking money from the government.

MAC: On what grounds?

RM: I think it was too frivolous, or whatever. I mean it was a shock to him. Someone who needed money should be doing something practical, like designing fabrics.

MAC: Did he do that for long?

RM: I don't know, I basically knew him during the forties.

MAC: Did he have any close friends?

RM: I don't think so, but he was like Gorky. He always had a few admirers, usually women, who thought he was a real genius. Usually somebody moderately well to do . . .

MAC: Is that what he lived on?

RM: I guess so. His mother was in that house, and there was no sign of their starving. I don't know if she had a pension, but she kept very much out of the way. I never thought of it, but in a funny sense, the whole lifestyle would have been much less unexpected in France.

MAC: Why is that?

RM: Well, there are French petits-bourgeois who have some kind of obsession, and without a thought of the big world, just pursue it determinedly.

MAC: Did he interact with other painters? You wouldn't see him in groups, right?

RM: No. Matta paid him a visit once a year. He would come like a prince, for two or three hours out of respect, out of generosity. And also like a magnífico. He came to see Joseph, but certainly there was no real personal friendship; I don't know that there was with anyone.

MAC: He certainly strikes you as a loner. I was amazed in his journals by the ups and downs and didn't know if that was related to Christian Science. Something so bizarrely solitary . . .

RM: To be with him was an endurance contest. He would sit staring at the floor, never looking at you, and speak in monologue after monologue. Maybe after fifteen minutes you would begin to see the gist of it, and then it would float away again. In that sense he was very rude, very selfish, but in another sense that was the obsession. Occasionally it would be about a thought. It wasn't so much a subject in that sense as a free association. He would get on a railroad track, and whatever the scenery was it would appear, but you had no idea where the train was going. Almost no conversation back and forth. It was tiring and very boring, and also exhausting, and I would think, "For God's sake let's have some ex-

change, or what is all this conversation leading to?" I think it would have been impossible, for example, for him to have any job where he had to work with other people.

MAC: I find Cornell very moving.

RM: Absolutely. He was the sort of person who could not get out of his own skin for three minutes.

In a way he was straight out of Kafka, almost grotesque in the sense that a Kafka character in the real world would be grotesque, and totally internalized. I used to wonder whether he suffered . . . and in the sense of a Kafka character, it was also almost as if he had a secret temperature. I mean he never complained about it or talked about it very much, in any way that you could relate to. You were an imprisoned audience. And at a certain moment, after three or four hours, he'd abruptly get up to signal it was over.

MAC: Do you think he would have gone through exactly the same ramblings with another person?

RM: I think so. Except that I was always sympathetic, and somewhat knowledgeable about the things he was talking about.

MAC: That must matter a good deal: if you are going to ramble, you'd like the other person to know where you are, and might be going.

RM: What I'm trying to say is that it was all unfocused, or a lot unfocused, so that he didn't know what the points were either. Or maybe I was insensitive, I don't know.

MAC: It's interesting you should say that about France, because he seemed to me so typically American . . . something peculiarly American about that kind of genius or eccentricity.

RM: I agree with that, but nevertheless, the lifestyle really fit in with my conception of France, you know, the self-containment, the obsession. The obsession was stronger than other people's reactions. Americans are more confused, or want more.

Interview About Motherwell

1989 (PROVINCETOWN, RHODE ISLAND)

MARY ANN CAWS: Do you think of yourself as typically American?

ROBERT MOTHERWELL: Oh sure. But very attracted to France. There's something about Europeans that's more focused on what really counts, and sometimes I think it's because apart from the Civil War and the Great Depression, Americans have not had a collective tragic experience. Europe has been so involved, and European schooling is so much more narrow and so much more thorough. Whereas American schooling is practical. . . .

MAC: And not all those layers.

RM: And European literature is so incomparably brilliant. . . .

MAC: I've been fascinated by the permeation of French symbolism into what you are doing, as you contrast it with Cornell's closeness to French romanticism. . . . Can you tell me how you began your connection to European art?

RM: You know, I went to a prep school in California, because I lived in San Francisco and as a teenager developed horrible asthma. San Francisco is foggy and damp, and they didn't know much about allergies. A specialist at Berkeley advised my father that the San Francisco climate was murder, so I got sent to this

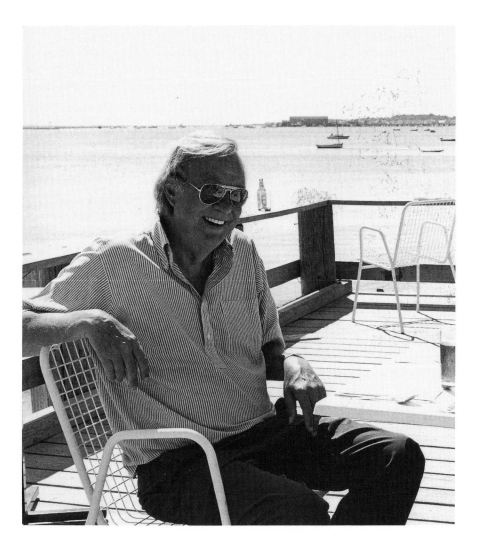

Robert Motherwell outside on deck at Provincetown.

Photograph courtesy of Renate Ponsold Motherwell

new little prep school halfway between San Francisco and Los Angeles, where the location was deliberately chosen so they could draw on both northern California and Southern California, in San Luis Obispo. The air is very dry, twelve miles from the ocean, with oak trees and no underbrush, very dry soil, marvelous climate. Very much like Catalonia. And in California, unlike the East, you didn't go to prep school as the way to go to Harvard or Yale. I'm talking about sixty years ago, when all the students there were emotionally disturbed; the parents were getting divorced or whatever, and essentially it was a school to park battered children. It had a huge study hall but no books except the *Encyclopedia Britannica.*

This was in September 1929, when it had only been open one year; in October the stock market crashed. We were forced to study two hours a day in the study hall, and I could do the work in five minutes but wasn't allowed to leave, so the boredom was incredible. In those days there were little pocket books from Alinari, and I would take one out, and copy it from beginning to end. Then I would run out of my Alinaris, or money to buy them, so I would pick up the *Encyclopedia Britannica* and copy all the plates in it, in the article on art. Then at the end, it said, "*See* modern art, modernism." I looked up modern art, which I had never heard of; I was maybe fourteen. There was a Cézanne, a late watercolor, and I copied it in chalks: of course it wasn't very permanent.

In California there were also no art collections. I went out to Stanford and was there about a year; I played tennis a good deal. One day after a set, a friend said he was going to a cocktail party and would I like to go. I said "No, I don't like social situations," and he said, "I heard you were interested in pictures, and this will be in a place with a lot of real painting." "In that case," I said, "I will change and go." It was Michael Stein's and I saw some Matisses, and they went through me like an arrow. No one could have told me that Cézanne and Matisse were not the greatest, and my mistake, my innocent mistake, was to suppose that modern art was all French. But I realized that this couldn't just have been personal achievement, that there had to have been some extensive intellectual background. I wanted to find out what modernism was, since my interests were in these artists.

My introduction to the French symbolists came about because the French poets wrote about modernism in a way that I could connect with the painting, and there was nothing in English that I could connect with those paintings. I just knew that, and then, of course, I started reading some of the poems. My main interest was, through Valéry and Baudelaire—whom I still read—to find out what modernism was, and what modern art is.

In 1935 my father took me to Europe and the first stop was Paris. The bookstalls were still open, and I got this marvelous paperback of Joyce's *Ulysses:* I began to see what modernism was. The edition is now very rare, but some babysitter stole mine.

Open, with Robert Motherwell.
Photograph courtesy of Renate Ponsold Motherwell

MAC: What about the titles in your paintings: do they precede the paintings? What importance should we give them?

RM: The point I would like to make is that all my titles that are taken from poetry come after the fact.

MAC: How do the collages fit in with your work? Did you start them early?

RM: Why essentially I take to collage is because you can draw anything out of the

Provincetown: light on water, easel.
Photograph courtesy of Renate Ponsold Motherwell

real world and just stick it in. I started painting seriously in '41, and the collages are from '43.

MAC: Is the *Open* series still going on?

RM: Once in a while. I don't work in a straight line, I work in a circle, and I think various things correspond to something in my psyche, or really various aspects in my psyche. I lose interest for five years, and then something is activated again.

MAC: What about that journal of yours called *possibilities*?

RM: In those days the great art bookstore was called Wittenborn. George Wittenborn and Schultz really wanted to do some good, and so we did the journal *possibilities*. But I didn't want to have all the responsibility, or to have all my time devoured, so I asked Rosenberg for literature and Cage for music and a French architect I knew very well for architecture.

Wittenborn and Schultz imported lots of European art, and Schultz had

gone over to Europe. He arrived in the Shannon airport, his plane disappeared from the radar, and two or three hours later they found it in the Shannon River. I saw it in a newsreel, with a few people falling slowly off into the river. Consequently, Wittenborn had to buy out Schultz's share of the thing. They were both married to wealthy women. Wittenborn's wife was very tough and regarded all these things as useless enterprises. She cut them all out.

MAC: Did you choose the title?

RM: Yes, as a result of a discussion with Rosenberg. I know there were half a dozen *possibilities*.

MAC: It seems to me that the idea of *possibilities* and the *Open* series imply the same sort of spirit.

RM: Exactly. But the Wittenborn story has a sad ending. In 1974 I had two operations—which turned into five operations—in four weeks. And about two days before I was to go into the hospital I had a call from George, saying he wasn't a rich man, but he wanted desperately to acquire one of my collages, with a German name to it, and so I wrote back that I was going to the hospital but when I got out of the hospital I would get in touch and I was sure we would settle it one way or other.

And I also couldn't understand where he could have seen it. I had taken some of it from a nineteenth-century book of German love songs; although I couldn't understand a word of German, I would tear out a page here and there. The collage he was referring to was on the cover of *Art International,* which George had gotten by airmail, in order to figure out how many copies he wanted to order, whereas I got it by regular mail, so I had never seen it pictured. The title of this collage was *Happy, oh Unhappy Love.*

After my hospital stay, I was waiting for Renate, and had gotten hold of the *New York Times.* I had to be picked up at the hospital's time, early in the morning, and since I usually get up at ten-thirty, for me it was the middle of the night. There, in my groggy state, I read the obituary: George Wittenborn had hanged himself.

MAC: You never did another magazine?

RM: No. But the Documents of Modern Art is still going on. And Harvard has just reprinted the Dada book. Jack Flam did the preface to it and acts as managing editor for the Documents. The basic idea was always to have things from the horse's mouth instead of all this journalism around it.

MAC: I wanted to ask you something about the light here in Provincetown: do you paint differently in Greenwich from here?

RM: Not really. And yet all my life I have lived in a seaport, and my main influences have been Matisse and Picasso and Miró and so on. There is a thing called Motherwell blue. . . . Normally, this water in front of us is really like the Côte d'Azur. You see it is very narrow, it is only five miles straight across there, from

Robert Motherwell painting in studio, with *Elegy*.
Photograph courtesy of Renate Ponsold Motherwell

here to the ocean, a very narrow peninsula. And it is like the Greek islands; in the light of the Greek islands, the sea is reflected all the time. That has to do with the direct sun and all the reflections. So the difference is between the reflected and the simple.

MAC: That peculiar fascination about the *Open* paintings, and the term you use of *ascensional:* the blue and the light can't *not* influence you. . . .

RM: Sure. The French made a film about me last year that won the Grand Prix, and in it we talk about that some. Pictorially it is either very poorly done, or European TV has a different tone. All the colors are off.

MAC: The film is of you painting or of your paintings?

RM: I am in the studio, and occasionally you see a painting. At my request, the talk is only about painting. On the other hand, my mind goes blank in front of the camera, and I am dyslexic.

MAC: You write backwards, or you read backwards?

RM: No, I can't say long words, so that my speech is basically made of great circumlocutions, whereas in writing it is no problem.

MAC: Is there any kind of angle you wish someone would bring out? So many intelligent things have been done already.

RM: I think only that Italian book has come close. I suppose at this moment what I would most like to see is a critique from my point of view of the books that have been written about me. There is a certain mythology about me. . . .

MAC: The superintellectual one?

RM: Yes, and the super-Wasp. I went to Harvard, and my father was a banker. . . . People jump to such clichés: banker-father, oh, rich. Offhand, I can think of let's say, ten or twelve false assumptions. I would give each a comment very briefly, a page each, two pages each.

MAC: Have they been benevolent misconstructions? Worse than that would be malevolent ones . . .

RM: And there are a lot of malevolent.

MAC: Because of too much fame?

RM: Yes. For example, in the *Washington Post,* at the time of a major exhibit. One day, I guess it was right before a show and I was painting. My secretary came in and said, "It is the art critic of the *Post,* will you talk to him?" I said, "Not at this moment, maybe later."—This happened also with a couple of local newspapers.—The *Post* critic took two whole pages to tear the show apart, with the most vicious things: for example, he crosses his 7's. Very un-American. And that was reprinted all over America, because it is the *Washington Post* chain. That was one of the many examples. Also, my position is threatening to 100-percent Americans.

MAC: How so?

RM: In that it's international.

MAC: Ah, so that *Elegy* might be for anyone's Republic, and anything entitled *Open* is already suspect?

RM: Exactly. It has partly to do with my personality, and partly to do with the work itself. Like the point that the titles of the pictures always come after the fact. Or, for example, at Harvard they are going to exhibit my *Joyce's Ulysses,* and my *Octavio Paz,* and one huge painting, one of the best paintings I ever did, called *The Hollow Men,* and now who knows, maybe I'll be associated with Eliot, who went to Harvard, and maybe I'm ultimately going to be thought of as an anti-Semite. There's always this implication of the aesthetic snob gentleman.

Yet my first contract was for five years, for $200 a month, and that was what I had to live on, in New York City, married. Back in 1945–1949, every year I had to produce seventy-five works, that is one reason I am such a compulsive worker. In those days I painted for exhibition, under contractual terms, and I would paint the year's work with just one piece over and over: it takes quite a piece. I remember a stunning recording with William Primrose, of Berlioz's *Harold in Italy.* I never had even liked Berlioz, but this particular piece . . . I really had to do too many works. You see, I've paid my dues, and in a way I resent those implications. At the same time I'm a fortunate man. The whole art world in the last four years has gone crazy: see the auction houses.

Also I'm very shy, diffident, in big social situations, and very absentminded and often don't remember people, so that there is this feeling that I'm a terrible snob, whereas it is the exact opposite. Did you read about Francis Bacon in last Sunday's *Times?* In some ways, I'm much more like him: chaos, and I basically prefer to drink than to do anything else. Fortunately my wife, who is very like me in many ways, has a sense of celebration, and has nothing vicious or weak, and really is more naturally creative than I am. At many dinner parties, museum dinner parties, who ever is seated next to her will come over to me afterwards—the last time it was some writer who said, "What a pleasure it was to sit with your wife." She divides the world into two slots: creative and diplomats. Any creative person she can listen to by the hour. . . .

MAC: And the others?

RM: She is totally indifferent to them. But I ask her: All these different people that you charm, how does it work? And she says, "It's easy really. All these people that you are indifferent to, you ask them about themselves and they will talk indefinitely and have a ball." . . . She's a marvelously complex person.

And she has that European gift, for example, she knows how to put you immediately at ease. Her warmth, even on the phone . . . Oh, and so sometimes I answer the phone, and I immediately see the difference. They put on a special voice: a telephone voice, and when they are hanging up, the pitch goes up, whereas my flat monotone comes across the phone, or my anguish at being interrupted.

MAC: You paint late at night, right?

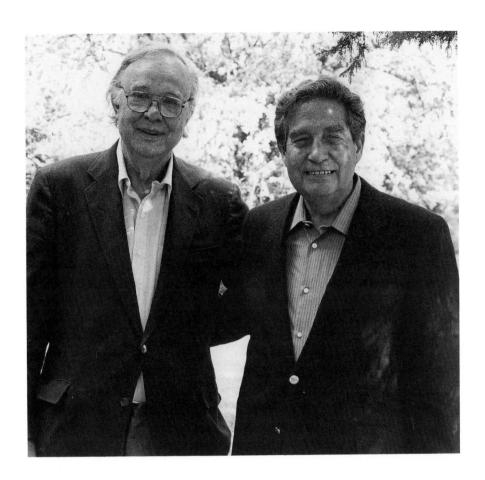

Robert Motherwell with Octavio Paz.
Photograph courtesy of Renate Ponsold Motherwell

RM: Yes. One thing, as you get older, a certain set of habits become increasingly important. Not only do I not get up until ten o'clock in the morning, but my wife has always left a tray with coffee and a flower on the tray and the *New York Times* and I spend the first hour in bed having my breakfast and reading the *New York Times*, and I could kill anyone who wants to talk to me between ten and eleven. Then I have a shower and shave, and by eleven-thirty I am ready to confront the world.

MAC: How about your teaching at Hunter College?

RM: I taught at Hunter in the evenings, in the graduate school, and my students would come in exhausted. The college was basically empty, and we just had a ball together.

MAC: You enjoyed that teaching?

RM: Yes. But I also did it during the most horrible times. . . .

MAC: Are your writings that are now being edited mostly about your art?

RM: All kinds of things. Prefaces I have never written except on request, so that there is one I gave to the American society of psychotherapists.

MAC: When the French refer to that, they have been calling it "The Creature's Use of Psychotherapy," so in my translation of Marcelin Pleynet's book on you, I put "the creative use," assuming it wasn't some other creature. Were there other talks like that?

RM: Yes, and basically, the center is either modern art or the creative process. . . . You see, when abstract expressionism wasn't understood at all, I had two insights. One was that the art journals were hopeless, which they were at the time. They were filled with social realism and all that kind of thing. And the other was that maybe universities could be the neutral meeting ground. There was great curiosity: what was this all about? So I was invited by all kinds of persons to be on symposia, and so on. That is how it started.

The thing I loved in universities was graduate seminars, and how it could be a place for fair hearing. I remember one of my philosophy seminars at Harvard, in epistemology, in which the teacher had each of us become Russell or Bergson and defend our position. So when we had this school called the Subject of the Arts on Friday nights I thought I would get some artist to talk, and with a iron hand I would keep the conversation kosher, and not let one person say, "You are full of shit." My wife says, "I am married to a judge."

MAC: What was the Motherwell school?

RM: Oh, the first part of it was this seminar, called the Subject of the Arts—for it turns out abstract art does have a subject. It consisted of the sculptor named David Hare, Mark Rothko, George Baziotes, and myself. There was supposed to be also Clyfford Still. We met in a loft on Eighth Street. The idea was that the students, instead of being taught in a doctrinaire way, would listen to five different points of view each week. Rothko and Still had a falling out, and although Rothko was one of my closest friends I could never could get out of him what the row was about.

That left five weeks open, and then I had an idea. This was in the forties, when the avant-garde was very split between geometric abstractionists and surrealists and God knows what, and there was a terrible kind of hostility between them. I thought we should let everybody have their say. And so we did, on Friday nights. Joseph Cornell was one of the guests, de Kooning was another. . . . They were all terrified. . . . Their pay was a bottle of liquor, whatever they chose, and I would take them to dinner first and reassure them, or try to.

I found that sort of exhausting in a way. Barnett Newman was basically a sort of uncle to the artists and could charm them and so I asked him to join the dinner. . . . It went on for a year, and it didn't begin to coalesce the avant-

garde. It then became the club which very quickly became a Tammany Hall. But some of the students said, "Please won't you see us at least one day a week?," and so I got a dozen students for that year.

Then a marvelous woman took over the art department at Hunter College. When she became chairwoman, she called up the Museum of Modern Art and said, "I want an artist who can talk," and they recommended me, and she gave me a job. Then she advanced me as quickly as she could to assistant professor and associate professor, and one time I said, "How do you have such confidence

Renate Ponsold Motherwell.

Photo credit: Stanley Moss. Photograph courtesy of Renate Ponsold Motherwell

Robert Motherwell in Provincetown, house in background, looking over fence at grandchild.

Photograph courtesy of Renate Ponsold Motherwell

in me?" "I will show you," she said. "You are the kind of person to whom it would never occur to look at someone's mail, in that office shared by six people. Number two: I have tremendous feedback from your students." And then, to my surprise (number three, I forget) she said "and, four, you speak standard English. It is very important." Never a committee, it was really marvelous. [. . .]

1990 (PROVINCETOWN, RHODE ISLAND)

MARY ANN CAWS: Let's talk more about you and the surrealists.

ROBERT MOTHERWELL: It was an extraordinary experience, but it was not a big help for me in some ways, because I had negative feelings about a lot of it. I guess I thought they weren't painterly enough. The painters were definitely secondary to the writers. The unexpressed opinion was the writers were good, and the painters existed primarily to illustrate the writers' ideas. Of course that was partly the problem with surrealism in America, because surrealism was identified partly with Dali and several others, and because all the writing was in French. . . .

I remember one of the crises. They were worried about being exiles, and all the rest of it. Breton was offered a position, to be regularly on the Voice of America, to broadcast to Europe in French, and was this giving in to capitalism and imperialism, and so on. That kind of issue, and there were a couple of months of—I am sure on his part—tormented decisions, and so on. Whereas painters are much more peasants, one thing at a time. You know, and what is the practical solution.

Another thing that struck me was they would get into violent arguments, and there were once in particular Max Ernst and Breton having a furious argument and standing face to face shouting in each other's face, and it had something to do with their wives, and Breton was saying at a certain moment, "If it weren't for me, your painting wouldn't exist." What struck me was the Frenchness of it. At that point of emotion, Americans would have hit each other, but there was never any question of that. I remember once Breton had a meeting—there were occasional meetings—and it was to choose new saints for the calendar, the Bloody Nun, and so on. So everybody had to write fifteen mythological personages that interested them. To Breton's rage, the three or four Americans present all put down the unicorn, whereas he preferred the Bloody Nun or the Black Mass and so on. Finally he wanted it to be part of the surrealist document, this thing on the saints, and there was no consensus at all.

Which also reminds me: I remember, I think, they wanted a new letter, a triple VVV, and I kept explaining that in French it makes perfect sense: "double-V, triple-V," but in English, you can say "double u," you can't say "triple u." I remember another time he wanted a column in a magazine, called "The Conscience of Surrealism," and I asked if he meant "consciousness" or "conscience," and he couldn't get the distinction with "conscience." He made it all quite ambiguous.

But basically I stayed on the sidelines, because what did interest me was the fraternity. All the American painters were basically essentially rivals, and the collaborativeness of the surrealists was something really amazing. Also I was

particularly friends with Matta, who was brilliant in his way, and generous, and my age. The surrealists in general were a generation older.

MAC: What did you find most important about the group?

RM: Well, just the idea of poets sticking together. There was a real fraternity, with very high stakes, in the sense that if somebody was thrown out, it was almost like a family disinheriting a cousin or a son. And Matta was always a little sensitive to that, because he came from a wealthy background with which he had broken, and was Spanish-speaking and a young genius. The last young genius they had had who was Spanish-speaking was Dali, who was absolutely a traitor, and Matta instigated a palace revolt. He wanted to do abstract expression by creating a palace and getting Baziotes to go around and explain automatism to some other American artists, like Gorky, Hans Hofmann, De Kooning, and a more minor artist called Peter Busa. And the Americans were all not very interested, maybe because I was just a beginning painter and didn't have any prestige, but mostly essentially every man was on his own and out for himself.

But Peggy Guggenheim, who was then married to Max Ernst, was interested in the project, and said if we did come up with a new visual idea of some sort, that she would give us an exhibition in her gallery, and that did interest especially De Kooning and Pollock. Then, a couple of months later, Matta fell in love with some very rich American girl and divorced his wife and twins and moved out of his poverty into some more well-to-do circumstances, and into a crowd of more well-to-do people. He sort of abandoned us all, and so nothing came of it.

MAC: Did you gather over long dinners, or in cafés? How did that work?

RM: There used to be a restaurant in the mid fifties, called Larre's, where Renate quite independently used to go. I remember lunch was prix-fixe. For I think eighty-five cents, you had a three-course meal, and wine was fifteen cents a glass, and dinner was about a dollar and ten cents. I wasn't that intimate with them, but I certainly had many lunches there with them. Maybe I was there twice a week. And quite often in the evenings, sometimes at Breton's place, sometimes at Peggy Guggenheim's place, when she was married to Max Ernst.

MAC: Did you play surrealist games?

RM: Yes, one game was penalty—it was truth and consequences and you had to tell the truth or pay some devastating penalty. It was some question like "When did you first start masturbating?," and in front of fifteen people, it was awful. We played the Exquisite Corpse a lot, and in one sense there was a lot of childishness, from an American standpoint, I mean. Americans in an equivalent mood would be much more apt to horseplay, but the solemnity of these childish games was funny. And the other thing was that none of the Americans was Catholic-reared, and all of the surrealists except Kurt Seligmann were Catholic, so that one of the chief enemies was the Church and all the anti-Catholics which go with it, which left all of us unmoved, because all the Americans were either Jews or Protestants, and there was none of the whole store of us who were Catholic. I

always thought it extraordinary that one of the extraordinary things about that moment in painting is that there were no Roman Catholics, and I would have assumed that French, Italians, Greek, and Spaniards would have been the ones to take most naturally to painting.

I think it had a lot to do with American painting being much more abstract, because Catholics grow up, after all, being surrounded by imagery. And I think it is why the French have always had great difficulty with abstract art, and why on the other hand, it blossoms in Holland. And the Italians have had difficulty with it. . . .

MAC: So if Mondrian had not been Dutch, the whole course of modern painting would have been different?

RM: He's a perfect Protestant painter, and his whole rationale for his painting—that the source of human anguish is conflict—is to make an art of harmony. The source of wars is every kind of conflict, what he calls the particular, that we would call the personal, you know, a husband and wife fighting, or Germany and France fighting. He would like to have made an art like Spinoza, *sub specie eternitatis*. It is ironic in some ways that his painting is the most dated of the period.

In short, I was very close to the surrealists, but I had one tremendous advantage over them, since I was philosophically trained and had that kind of critical mind, and am not the kind of person who could be doctrinaire. For me, to put it in more vulgar terms, everybody has his own insanity. The best part of human reality and the part that is really crucial, you ignore, you and the rest, unless it comes to crucial issues. Also I liked abstract art, and in the nineteen-thirties, to really love the Cubists, which I did, or Cézanne or Mondrian, was really very rare. And when I found them, I knew nobody who knew them or liked them. . . .

MAC: So you couldn't discuss them with anybody.

RM: No, they were my own private domain. One of the first great pictures I ever made was in '43, all yellow and purple stripe. And I remember when Matta saw it, he said, "I don't know whether Breton would go for a painting of the flag." I knew it was a marvelous painting, that part of its impulse was the unconscious influence of Mondrian. He was the only one, and I fought against it, so I made the lines more hand-made, more sensitive, more I don't know what. In another sense it wasn't abstract at all, in the Mondrian way of being an assertion of universal principles and so on. It was done when I was in Mexico, or right after I got back, I don't remember. So in that particular sense, there was always a great gulf between me and the surrealists. What attracted me was their Europeanness, their camaraderie, whatever I thought of their paintings, which I admired very much, but I remember the surrealists asking me if I thought Miró was any good. He was too abstract for them, but I said, "Absolutely." Miró was also suspect in leading a perfectly ordinary orderly bourgeois life. In fact, Matta told me that once, in a drunken studio party in Paris, somebody had seen Miró with his wife

come out of church—it must have been a Sunday night—and somebody sober came in, maybe Giacometti, they had put a rope over the rafters, and they were about to hang Miró, and they cut the rope.

MAC: Was there anyone else they disliked as much as that?

RM: Their bête noire was Dali, whom they nicknamed Avida Dollars.

MAC: Did they talk about Tzara at all?

RM: No. But the meetings I attended were always about some project, the next issue of *VVV,* the first papers of Surrealism, that huge show at the Whitelaw-Reid Mansion. There was always something specific. I think they tolerated me because one of their admirable qualities was to believe in young talent. Because after all their heroes were Rimbaud and Lautréamont, Seurat, all of the great young people. For example, in the Whitelaw-Reid Mansion show, there must have been a hundred pictures, including a Picasso, and the four youngest artists—I was one of them—were given the place of honor, and Picasso was given the worst place, as a beau geste. There were lots of marvelous things. I would say in a way they were aware, and I guess in a way this is what attracted me to them. I never thought of it until this moment. The culture demanded responsibilities, and obligations, the way a citizen does, a citizen of a country, not somehow everybody for himself, who is going to be the first one to show a picture at the Museum of Modern Art, or get Knopf as a publisher, or whatever.

At the same time there was a real sense that culture entails responsibilities, because they were Marxists and anti-Stalinists. They were very free of the Stalinist cant which was all over the place in the thirties and the nineteen-forties. The *Partisan Review* in a way took the same position. . . . I think the strength of Marxism in the artistic and literary communities in the thirties and forties is very underestimated. It was a very difficult problem for intellectuals.

MAC: Was there lots of talk about politics at those dinners and lunches?

RM: No, because I think they had already agreed in principle before they came to America, and most of their conversation was about more immediate problems. The fear that in America, if we entered the war, the mails would be censored, that this might become a totalitarian country. I spent a lot of my time reassuring them about that. In fact, in those days I had a Mexican wife, and one day in Provincetown there was a knock on the door and it was two FBI agents with those anonymous pants and very serious, and finally they tore out a letter that my wife María—she was a very childlike actress—had written to her family in Mexico that a German submarine had been sunk off Provincetown, which was true, but rather childish gossip. As if a Ferris wheel had been turned over. The FBI guys were all upset about it and cut it all to pieces, so there was just "I love you," and a couple of other things left in it. And another time they came in and asked me about Max Ernst, who was technically a German citizen, though he had left Germany. In 1938 he had been in a huge show called "Masterpieces of French Art." They made him and Peggy Guggenheim leave the Cape, because it

was against the law for an American citizen to live with an enemy alien within ten miles of the seacoast.

When I was living in East Hampton, they visited me and wanted to know who were all these naked swimmers. There were quite a few surrealists out there who often went nude bathing on a secluded beach, so they were obviously in a deep political plot. The war was on everybody's mind. In the beginning, the *New York Times,* every day they would have the map of Europe, and every day it was blacker and blacker, and by the third year it seemed as though Germany was actually going to conquer all of Europe. . . . Everyone had relatives. I remember the French department at a woman's college, Holyoke, arranged a conference like Pontigny.[1]

MAC: You went and spoke, I believe.

RM: Yes. André Masson was also there, and we went swimming, I think in the river, and when we were in our bathing shorts, I noticed he had a gaping hole in his chest, and I turned to his wife Rose, who is a lovely simple woman, and said, "My God, what's that cavity in André's chest?" and she said, "It's from a German machine gun in the First World War." And then she said, "André and Max Ernst both believed that they were in opposite trenches at the time it took place, and that Max may have actually shot him in the chest." Something that is not emphasized enough about the Dadaists is their involvement in World War I; I imagine if you have gone through something like that, then Dadaism and Surrealism would seem far more real, instead of parlor games and pure intellectualism.

And I had to do little things. . . . In those days, I was interested in cooking, and there were simple practical questions, for example, since you couldn't get olive oil. What was the cooking oil that most resembled olive oil? I happened to know it was peanut oil, which they didn't know about in those days.

You couldn't get French wine, and I knew which American ones were the closest. I mean pretty simple practical things. . . .

Interview About a Number of Things

1990 (GREENWICH, CONNECTICUT)

ROBERT MOTHERWELL: I am going to the warehouses tomorrow. My dealer is afraid to let me go there, because I will be tempted to destroy a great deal of my work.

MAC: Do you do that a lot? Do you think about it first? You don't just say, "Tomorrow I am going to go in and destroy the things I like the least"?

RM: No, but I should perhaps.

MAC: Because you don't think it is as good as the rest?

RM: Because I think some of it is immature. Or even a valiant effort that didn't come off. Also as the work gets more and more expensive, I would be ashamed

to have someone spend a great deal of money on something that wasn't of some enduring value, which is a problem poets don't have.

MAC: But what about conserving the stages on the way of something you really like? I am thinking of poets keeping the "fair copy" of their manuscript changes.

RM: You know, I have a storeroom back there that must have three hundred pictures in it and three storerooms in Long Island City that must have two thousand works. Sometimes I have this feeling I am running a hardware store. You know, you go into a hardware store to get several ounces of nails of a certain size, without thinking, "My God, what a nightmare it must be to have the inventory a hardware store has. Six different kinds of hammers and all the rest of it." I don't know whether I paint too much, but at times I feel I am drowning in my own work, and yet I also think of myself in many ways as a lazy man.

MAC: How did you arrive at that particular thought? It seems a little far out.

RM: It is actually that I mainly sit and read and listen to music, or watch the news, but I am always surrounded by my work, and from time to time I'll see something or occasionally in a frenzy I'll do a lot. If I were retired, I would think I would do about as much painting as a retired person might do whose hobby was gardening.

MAC: Like two hours a day.

RM: Yes. But on the other hand I hang around it six or eight hours a day. . . .

MAC: I keep wondering why certain people react to certain paintings. Your *Opens*—everyone must react to them?

RM: Well, they certainly didn't when I first did them. It was betraying abstract expressionism.

MAC: Not abstract enough?

RM: No, not expressionist enough, in the sense of German expressionism, which is what *expressionism* means.

RM: You know, if Renate is going to take pictures, she always does it in the first twenty minutes of a conversation. She will just know immediately what is going on, and it's her way of seeing and remembering. She grew up in an extraordinary German family. If something moves her, she takes a marvelous photo. She really loves creative people. She has half a dozen great women friends, all exceptional characters. I said to her, "You found the freedom here you wanted." She looked at me, and said "That's right."

With all the dreary things about this country, there is the kind of democracy that can be monstrous, but that is really ingrained. A hatred of pretense, of putting on airs, that everybody has a right, an obligation to say what he really thinks. And in a funny way when you think of how all political situations zigzag and so on, America has really held a very steady and on the whole rather generous course toward the rest of the world, considering it's a superpower. Much more so than any country I can think of.

But it was born at a magical moment, at the height of the Enlightenment and at the height of a rebellion against traditional authoritarianism, and the mentors were Voltaire and the French Encyclopedists and the English experience with the Stuarts and their parliamentary system.

RM: I have something I would like you to look over, the French translation of a talk I gave. I showed it to you in Provincetown, from the boy's school. It's only four or five pages, but I don't know why at St. Paul's Boy's School I should give the most technical, philosophical thing I ever wrote in my life, but it is very precise, much more precise than I normally write, and it needs to be very accurate, very literal. I love that little publisher, and it has been a year and a half and I haven't answered. I was going to send it to you in France, but then I remembered you were about to give a lecture you hadn't written yet, and I thought, "Oh My God." . . .

MAC: Sure, I'll do it immediately.

Interview About His Work

1991 (GREENWICH, CONNECTICUT)

MARY ANN CAWS: How did the *Dada Painters and Poets* come about?

ROBERT MOTHERWELL: Well, Breton and others were always mentioning Dada. I was not wild about Duchamp, but he was a fair judge of what was and was not surrealist.

I did the illustrations for Marianne Moore's *Fables of La Fontaine,* but either Reynal or Hitchcock then fell dead and it did not appear. There were animals, but abstract.

MAC: I am planning an overdue sequel to your *Dada Painters and Poets* about the surrealists. Would you write a preface?

RM: I trust implicitly your eye and your scholarship, and besides you are simpático. Of course I will do a preface if you do the *Surrealist Painters and Poets.* I always write when I am asked, and I prefer to be focused like that.

You know, Allen Ginsberg came up to me at an annual dinner of the Academy of Arts and Letters, laid his hand on my shoulder and said he just wanted me to know that *Howl* could not have been written without the *Dada Painters and Poets* that I did with Bernard Karpel. There is often a kind of negative facilitation that permits art to be made.

RM: Marcelin Pleynet doesn't articulate it perfectly, but I think he is really on the track of what his book was a preparation for. One's perception clarifies in stages. He has understood that there is something in it that there isn't in contemporary painting very much, I mean painting of the moment.

In this English publication, a certain number of painters were asked to write about a painter of their choice. He really hit what he has been trying to say in the previous two essays. There are some additions.

MAC: Is this going to be edited over here?

RM: No. The gallery is enormously wealthy—I imagine they will lose money on the show.

MAC: Will it travel?

RM: Perhaps to Stockholm. The gallery there that likes my work and can afford it. Owned by Lancôme cosmetics and enormous stockholders in Nestlé. And the gallery in Sweden . . . I don't understand the whole art business.

Apparently it is a beautiful seventeenth-century building, the whole show with very long corridors. They gave a big dinner party at the Bristol Hotel which Renate's travel agent decided she should stay at. The American ambassador was there, and he phoned and said the show was beautiful. "The other thing I want to tell you is that you and your wife have a permanent invitation to stay at the Embassy any time you are in Paris." He repeated his name four times, which is good, since I don't remember names unless they are repeated four times. They have a picture of mine hanging in the Embassy.

MAC: You are still doing *Opens?*

RM: Occasionally. Yes, see, this is one of the Matisses. See, this is how he ended. Look at this one. I was going through it the other day and thinking: "It needs some black."

MAC: It was just blue and red before?

RM: Yes. And it wasn't functioning. I mean it was all right, but it had no magic to it.

MAC: Are there others that you would go through and revive with black? Why do you think black makes such a difference?

RM: There might be. It deepens everything. See here, the black is what keeps this from being decorative. And I don't know anything about music, though I have a lot of likes and dislikes. But I happen to love Flamenco music, among many other things. And my helper, Mel, is a musician, and I asked him what is it I love in a certain passage, we were playing some day, and he said, "It is called a descending third." And as a metaphor I would say the black acts as a descending third and gives it a kind of weight and depth.

MAC: Yes, tragic, and yet not sentimental or sloppy.

The other day, I was trying to talk about Bach's descending third in relation to one of your works; it rips you up and doesn't say "take a handkerchief."

RM: Exactly, and before I put the black on it lacked a weight, a black weight. A lovely picture, but . . .

MAC: It wasn't anchored.

RM: Exactly.

MAC: That is why I like your cave paintings.

RM: That is the way I write too. One night, in a hotel, I wanted to write, and was thinking about the grain of the wall. Helen had tacked up some pieces of paper there, and the grain came out like dots.

MAC: It all reminds me of the way the Lascaux painters, and at Les Eyzies, used the irregularities of the cave wall for the animals' muscles.

RM: Yes. The French made a marvelous film about me, in which I talk about Lascaux and how much it has meant to me, and the material is taken from the floor of the cave. It is all forms of iron, black, red, etc. The Lascaux paintings are made from the guts of the cave itself, and that is the kind of color I love, as opposed to that in stores, where you can pick out any color you want.

MAC: That reminds me, to the side of this. Do you like Ryder? His using the dirt off his shoes . . .

RM: Absolutely. Very often, when I have done anything I think is too corny, I rub charcoal on it, and say to Mel, "This picture is not dirty enough."

MAC: I was thinking that there are so many ways to approach a work like yours, and that so far I have done mostly the kind of thing, relating to how you talk about the color "ochre . . . ," for example.

RM: Your judgments are impeccable.

Interview About His Work

1990 (GREENWICH, CONNECTICUT)

MARY ANN CAWS: I have a question about the violence in art, the brutality in American Art. How does it enter the canvas? To what extent is it American?

ROBERT MOTHERWELL: I think it is American, perhaps Irish-American. I remember once taking a train from Marseilles to Paris, a night train, very crowded. This must have been shortly after the way, and all the compartments were crowded. An American army sergeant and a soldier got out at a short stop near Marseilles, perhaps Arles, and they had had a bit to drink. They opened the door, and asked if anyone spoke English, and I didn't answer. All the other people were French and must have known that I did speak English, and I felt very ashamed of being so cowardly. But in another sense, what was there to do? The compartment was filled with elegant Frenchmen, and it flashed across me that American brutality is a peculiar kind of brutality that one doesn't find in older civilizations. Maybe South Africans have it, or Australians, even Germans. Or Swedes, or Northerners. The Mediterraneans can be cool, but not brutal. Maybe the Northerners drink hard liquor and the other cultures only drink wine. There is a difference between someone who has had four whiskies and someone who has had only wine.

I am often accused of being too elegant. The word *elegance* is again an Ameri-

can prejudice. I don't think this work would look elegant in Paris or Stockholm. It would simply look like work. Any more than Matisse would look elegant.

A sort of finesse, but that open as it has been changed is both elegant and brutal.

MAC: I see you have that wonderful ochre thing back up there . . .

RM: That probably was done in late May.

MAC: You said somewhere that 90 percent of your work was correction . . .

RM: This one, I decided to make the blue more dirty. . . . In that red open, the black shape was red, and some times there is too much red, it doesn't have a trace of the descending third, it is too playful and easy. And I made it black—I'm very glad I did. I like it much better.

MAC: That is a piece of music by a musical genius.

RM: I see it, I can't hear it. I can't read music. All the music I put in, it is because I like the looks of it. But it might as well be in Arabic, as far as I am concerned. I wouldn't put in a composer I didn't like.

MAC: I like this *Open* in green. Is it early?

RM: Yes. It was done thirty years ago at Tania Grossman's, and it was just lines. And then twenty years later, I made an addition, called it *The Green Studio.*

MAC: You change the things on your studio wall?

RM: Mel reframes them, and when he brings them out to me to look at the mats and all the rest of it. So this was really a feeble *Elegy,* and about a month ago, I repainted it, and now I like it so much we have ordered a gigantic canvas and are going to make it full scale.

MAC: Which paintings have the most universal appeal, do you think?

RM: Most often, somebody will say something about the dog by Goya, the most unexpected person will talk about it. I have a deep affection for it.[2] It comes up, where I would expect it to be Michelangelo's Adam or some other painting. Another that has the same following as *Goya's Dog* is Titian's *Flaying of Marsyas.* It has a following of its own. Both have something in common, tragic but in a way subtly tragic, they are way out and yet in a way they share some mysterious magic. Most people trying to talk about the same kind of thing would probably say a Rembrandt is what they remember. I feel it about practically all of Piero's work.

MAC: Do you remember the first Piero you ever saw?

RM: I think it was in the National Gallery in London.

MAC: The *Baptism of Christ?*

RM: Yes. To me, it works on a level with Bach, with Mozart, there is never a mistake. Just incomparable, and in a certain way divine. It is beyond what you think a human being would be capable of, in its implacable perfection. That is only in relation to a relatively modern period. Ancient art is all marvelous, prehistoric art, cave art. There is no ulterior motive, no egotistical motive.

MAC: The magic comes through unmediated by the self.

RM: Exactly. In fact, when I wrote that piece for St. Paul's school, I was very seriously considering, but am probably too lazy to do it, writing a second section, on the function of abstraction. It is so clear that the relation of the twentieth-century artist to prehistoric art has to do with abstraction, in the search of reducing everything to essences.

The function of abstraction is to select what you want to talk about. There are lots of books about the so-called appeal of primitive art, but I think they all miss the point, that it is not *like* modern art, but that it is incorruptible, because there is nothing to corrupt the makers. There is absolutely no reason for them to do anything except with reference to the subject matter. There was no art audience; the word *art* didn't even exist in primitive society. Anyway, the point about abstraction is in a sense that abstraction is an emphasis on what one wants to say, and an omission of everything that one doesn't want to say. All primitive art in the best sense of the word, in a T. S. Eliot sense, is abstract. Totally focused on what is to be said, and there is *no* diversion. And then naturally, modernists, without religion, ironically, without everyday affairs as their subject matter, begin to find an affinity in getting to the—as you say—quintessence. They work for an audience, an audience that would have the same interest and so respond in that way.

And the difficulty of most people having an eye is that they don't *see* that point, and therefore it's: "What is it?" or "What does it represent?" Representation presents much more detail than is needed. "The Doctor and the Child," or "The Execution of Marie-Antoinette" and so on. You know, this is okay the way a novel is okay, but what is missing is the connection with poetry: just essences.

MAC: That is why I think that training in sensitivity to art can develop a sensitivity to poetry.

RM: I do too. On the other hand, it can be rather shocking. I just got this catalogue from the same publisher who did my *Ulysses*. Here are Diebenkorn and Yeats. About Diebenkorn, who I think is a superb artist, I think what he did with Yeats was disgusting.

MAC: I can't quite see that combination . . .

Are there poets you feel especially close to, besides Mallarmé?

RM: T. S. Eliot, regretfully. Regretfully because of his conservatism, his Catholicism, his English accent more English than the English. He was a rather disgusting human being, but there is something about his poetry that is really gorgeous.

And then, who else do I like? I don't know really, I don't particularly like Yeats. Stevens . . . and in a certain way, I have a feeling for Edgar Allan Poe.

MAC: He keeps coming back, doesn't he? What do you care especially for: the tales, the poetry?

RM: Everything, really, the whole man. I think he was a one-man modernist, at a

Robert Motherwell in Greenwich by pond.

Photograph courtesy of Renate Ponsold Motherwell

moment when America was moving in the opposite direction. His English is so alive, sophisticated.

MAC: Whitman you don't have any particular affection for?

RM: No, I don't really. I don't know why—it may be that his subject matter, his camaraderie, his longing for sociability, is totally foreign to my character. Remember when we were talking about Thornton Wilder. It may be that his homosexuality, in the sense of his idea of America being masculine fantasy, in

some way doesn't ring true to me. If you want an American in that sense, I would take Mark Twain.

RM: I was thinking while I was waiting for you to come. . . . You write your best things when you are dealing with something visual, and I paint my best things when I am inspired by something I read.

RM: Here are some things I wanted to show you. Look at these yellow skulls from Mexico. I love to look at them. This yellow . . .

Preface

1. In *Partisan Review* (Winter 1944), reprinted in Frank O'Hara, ed., *Robert Motherwell* (Garden City, New York: Museum of Modern Art, 1965), p. 35.

2. To Jack Flam, in an interview, 1985; quoted in Dore Ashton and Jack Flam, *Robert Motherwell* (New York: Abbeville Press—Albright-Knox Art Gallery, 1983), p. 12.

Personal Criticism and the Essay Form

1. I shall simply quote two of these sendings, in addition to the interviews at the end of this volume, verbatim:

1 May 1990

DEAR MARY ANN CAWS,

It is shocking that I have not written you sooner!—It is partly because my health has not been very good and I have been seeing specialist after specialist. [. . .] But it is mainly because I am so stunned by what you have written about me that I have been waiting for an inspiration worthy of your text, and every time I wish to express something of what I feel I am struck dumb. In a way I could almost wish that your writing was about someone else, so that I could speak about it more detachedly. [. . .] All I can say is you have done something that is generally agreed that cannot be done, that is, to convey perfectly in words the content of certain paintings. I would do everything in my power to convince you to stay on the track of such writing, that is to convey the emotions in the observer which, after all, is the basic function of a work of art regardless of its cluster of origins & influences, society, history, autobiography, psychoanalytic and all the rest. [. . .] You are the *ideal* audience, and you convey it

with an eloquence of which I suspect no man is capable.—Anyhow, simply put, you make me feel as though what I have done *is* meaningful. Otherwise it could not evoke such a deep and impeccable response.

I hope to meet again with you when you come back from California before I go to Provincetown around the 7th of June.

Bless you.
Robert M.

P.S. The ravishing ochre shell you sent me (with the bluish grey eye at the tip) went through my heart like an arrow, and is further evidence of your keen and empathetic eye.

And a month later, in a telegram sent on June 6, 1990, he wired:

"Ravished as usual with your latest installments. Bless you. Will definitely hold open July 4th holiday time in Provincetown. [. . .]" One of the interviews printed in this volume dates from that time.

2. Among other places, in the preface for *Women of Bloomsbury: Vanessa, Virginia, and Carrington* (New York: Routledge, 1990); in my "How She Matters Now: Personal Criticism and Virginia Woolf," *Massachusetts Review* (Fall 1992); and in my forthcoming *Personal Criticism.*

3. See my discussion of conversational poetics in *The Art of Interference: Stressed Readings in Visual and Verbal Texts* (Princeton: Princeton University Press, 1986) and in *Personal Criticism.* It is based on the notions of conversation, say, in seventeenth-century France, as discussed by Elizabeth C. Goldsmith (*Exclusive Conversations* [Philadelphia: University of Pennsylvania Press, 1988]), and the much-discussed notion of conversation taken up by Richard Rorty in his *Philosophy and the Mirror of Nature* (Princeton: Princeton University Press, 1979).

Chronology: Living Art

1. See especially David Wright Prall, *Aesthetic Judgment* (New York: Thomas Y. Crowell, 1929), pp. 63–64. I am indebted to Murray Krieger's *Ekphrasis: The Illusion of the Natural Sign* (Baltimore: Johns Hopkins University Press, 1992), pp. 172–74, for this discussion.

The importance for Motherwell of Prall's teachings at Harvard, to which he referred so often in conversation and in his courses, can be summed up by two points. First, by the importance of the "aesthetic surface," where the word *aesthetic* has to do only with immediate sensation. This surface consists of "elements of sensuous content" as they are arranged. To be handled by the artist it must have "relations objectively clear in given orders and a defining structure of variation" (Prall, pp. 63–64). Motherwell's insistence on the surface and the *relations* the artist deals with and stresses has its origins in Prall's teaching, to which he always gave credit.

The second point concerns the distinction that Prall consistently maintained between nature and art, the latter being of necessity humanly constructed with the materials that "present objective structural orders intrinsic to their qualitative variation, through which we have controls over them to build them into the complex formal beauties of elements alone or of merely accidental natural combinations" (Prall, p. 68). Motherwell's repeated indications to me and others about his minimal interest in na-

ture should not be underestimated. They are also, at least in part, related to this aesthetic training. See his remarks about *Tree of My Window (Robert Frost)* for an example of this attitude.

2. Jack Flam has succeeded Motherwell as the literary editor of the series.

1. Thoughts and Themes

1. The garden scene in which the painter enunciates this call to "be yourself" is based, it seems, on one of James Abbott McNeill Whistler's Sunday breakfasts at 110, rue du Bac.

2. Marianne Moore, *The Complete Prose of Marianne Moore* (New York: Penguin, 1959), pp. 321–22.

3. Stanley Cavell, *This New Yet Unapproachable America: Lectures After Emerson After Wittgenstein* (Albuquerque, New Mexico: Living Batch Press, 1989), p. 11. The reference is to Emerson's "Experience": "To finish the moment, to find the journey's end in every step of the road, to live the greatest number of good hours, is wisdom" (ibid., p. 1).

4. "Self-Reliance": "This one fact the world hates; that the soul *becomes*" (New York: Library of America, 1983), p. 271.

5. *Selected Writings of Gertrude Stein*, ed. Carl Van Vechten (New York: Vintage Books, 1990), p. 258. Wendy Steiner's work on Gertrude Stein, especially in connection with repetition and narrativity, is invaluable in this regard (see pp. 176–78 in her *Pictures of Romance: Form Against Context in Painting and Literature* [Chicago: University of Chicago Press, 1988]). As she points out there, "the idea that repetition is artistically vital both for formal and expressive purposes is a far cry from the standard modernist attitudes towards it" (p. 176).

6. *The Humanism of Abstraction*, translated as *L'Humanisme de l'abstraction* by Joël Dupont (Caen: Editions de l'Echoppe, 1991), n.p.

7. Interview with David Sylvester, 1960; quoted in Clifford Ross, *Abstract Expressionism: Creators and Critics: An Anthology* (New York: Abrams, 1990).

8. Robert Motherwell and Jean Paulhan, *Peintre et public* (Caen: Editions de l'Echoppe, 1989), p. 21.

9. *L'Humanisme de l'abstraction*, n.p.

10. *Peintre et public*, n.p.

11. Robert Motherwell, "The Universal Language of Children's Art, and Modernism," *American Scholar*, vol. 40, no. 1 (Winter 1970): 24.

12. When Breton turned to Motherwell for a translation of one of his articles and the latter insisted on making the distinction, Breton did not grasp the importance of it, and there was a falling out. See later in this chapter for a fuller discussion.

13. From "The Painter and the Audience," 1954. Quoted in Ross, *Abstract Expressionism*, p. 106.

14. Stephanie Terenzio, *The Collected Writings of Robert Motherwell* (New York: Oxford University Press), p. 97.

15. Documented by Robert Saltonstall Mattison, *Robert Motherwell: The Formative Years* (Ann Arbor: UMI Research Press, 1987), p. 113.

16. See the catalogue of *Flying Tigers: Painting and Sculpture in New York, 1939–1946*

(Providence: Bell Gallery, Brown University, 1985), p. 75, where reference is made to Picasso and Mondrian, in connection with *The Little Spanish Prison.*

17. Dore Ashton and Jack Flam, *Robert Motherwell* (New York: Abbeville Press–Albright Knox Art Gallery, 1983), p. 19.

18. The reference is to Mallarmé's sonnet of the swan, where the swan is—like the poet—paralyzed in the frozen lake of the white page, uncertain as to the possibility of freeing himself.

19. Motherwell's commentary in Ashton and Flam, *Robert Motherwell,* p. 112. In my picking up of the term *misremembrance* I am remembering also Harold Bloom's famous misreadings (how not?), but intending it in a slightly different sense.

20. "Painters' Objects," *Partisan Review* (January 1944) (see also Terenzio, *Collected Writings,* p. 23).

21. Wallace Stevens, "The Snow Man," in *The Palm at the End of the Mind* (New York: Vintage, 1972), p. 54.

22. Stevens, *The Palm at the End of the Mind,* p. 158.

23. Terenzio, *Collected Writings,* p. 95.

24. Terenzio, *Collected Writings,* p. 77.

25. Terenzio, *Collected Writings,* p. 78.

26. Terenzio, *Collected Writings,* p. 53.

27. Terenzio, *Collected Writings,* p. 53.

28. Terenzio, *Collected Writings,* p. 110.

29. He and I often spoke of his doing a preface for my book—which is to be published by the M.I.T. Press—a sequel to his *Dada Painters and Poets* that is called *The Surrealist Painters and Poets.* "Oh," he would say, "what a great idea. I'd love to." I'd have loved that, too.

30. Arthur Danto recounted this in "Robert Motherwell: An Artist in Modern America," Motherwell symposium, CUNY Graduate Center, March 5, 1993. Danto posited a notion of the Apollonian paleface (like Motherwell, educated, patrician, and Eurocentric) who wanted to be a Dionysian redskin (like Pollock); the closest he got to being a redskin was the notion of spontaneity, with the doodle, like something out of a Frank Capra movie, says Danto, never being dignified. He was a paleface with a seething redskin stratum underneath, a being isolated in Greenwich, longing for intimacy. See also Dore Ashton's remarks on his fear of being a "tame goose" instead of a wild one.

31. Terenzio, *Collected Writings,* p. 111.

32. See Martica Sawin's *Surrealism in Exile and the Beginning of the New York School* (Cambridge, Mass.: M.I.T. Press, 1995) and Dickran Tashijan's *A Boatload of Madmen: Surrealism and the American Avant-Garde* (New York: Thames and Hudson, 1995).

33. My initial interviews with Robert Motherwell, in 1989, had to do with my edition of *Joseph Cornell's Theater of the Mind: Selected Diaries, Letters, and Files* (New York: Thames and Hudson, 1994). I have used Motherwell's essay on Cornell as one of the prefaces, the other being by John Ashbery.

34. It was no coincidence that Motherwell's Mexican wife, María, had an uncle who was a general in Pancho Villa's army.

35. Interview with David Sylvester, 1960; quoted in Ross, *Abstract Expressionism,* p. 111.

36. Discussed by Robert Mattison, at the Motherwell symposium, CUNY Graduate Center, March 5, 1993.

37. Dore Ashton, *The New York School: A Cultural Reckoning* (Berkeley: University of California Press, 1973), p. 155.

38. Terenzio, *Collected Writings*, p. 98.

39. Quoted by Robert Enright, Motherwell symposium, March 5, 1993.

40. These drawings are reproduced and commented on also in my *Surrealist Voice of Robert Desnos* (Amherst: University of Massachusetts Press, 1977) and then in Robert Desnos, *Le Bois d'amour*, ed. Marie-Claire Dumas (Paris: Editions des Andres, 1995).

41. Anton Ehrenzweig, *The Psycho-Analysis of Artistic Vision and Hearing: An Introduction to a Theory of Unconscious Perception* (New York: Routledge and Kegan Paul, 1953), a book Motherwell purchased in 1955. See page 3 for the ideas discussed here.

42. Ehrenzweig (p. 30) was particularly interested in Willard Stotts's study entitled *Shakespeare: A Study of His Marks of Expression to Be Found in the First Folio*, 1948. He points out how when the speaker starts a new speech, when he has just joined the conversation, he originally sets the entire text on a new line. But when the dialogue is printed as if one line followed on another, and the newcomer had understood what preceded, this satisfies the gestalt expectancy of the readers but takes away the dramatic impact the author had intended. Motherwell is of course in agreement with the surprise element, and against the smoothing out process.

43. Quoted in Irving Sandler, *The Triumph of American Painting: A History of Abstract Expressionism* (New York: Harper and Row, 1976), p. 202.

44. Terenzio, *Collected Writings*, p. 55.

45. "Art, N.Y." Robert Motherwell interviewed by Bryan Robertson, December 15, 1964; quoted in Frank O'Hara, ed., *Robert Motherwell* (Garden City, New York: Museum of Modern Art, 1965), p. 66.

46. Letter to William Carlos Williams, December 3, 1941, quoted pp. 16–18 in Terenzio, *Collected Writings*.

2. Dark Elegies

1. "Carrion Comfort," in *Gerard Manley Hopkins: Poems and Prose* (Harmondsworth: Penguin, 1953), pp. 60–61.

2. Quoted by David Rosand, "The Iconography of the Self," Motherwell symposium, CUNY Graduate Center, March 5, 1993.

3. Translation by Stephen Spender and J. L. Gili, in *The Selected Poems of Federico García Lorca* (New York: New Directions, 1955).

4. Translation by Jack Flam in *Robert Motherwell and Black* (New York: Petersburg Press, 1980), p. 7.

5. Translated by Mark Strand, in *Modern European Poetry*, ed. Willis Barnstone (New York: Bantam, 1966), pp. 355–56.

6. Dore Ashton, *The New York School: A Cultural Reckoning* (Berkeley: University of California Press, 1973), p. 163.

7. Arthur Danto, *Encounters and Reflections: Art in the Historical Present* (New York: Farrar Straus Giroux, 1986), p. 195.

8. Danto recounts how Motherwell tried a series of *Elegies*—*Irish Elegies*—in shamrock green and how, of course, they did not work (mentioned in "Robert Motherwell: An

Artist in Modern America," Motherwell symposium, CUNY Graduate Center, March 5, 1993).

9. See Stephanie Terenzio, *The Collected Writings of Robert Motherwell* (New York: Oxford University Press, 1992), p. 7.

10. Rafael Alberti, translation by Jack Flam.

11. Lorca's meditations on the *duende* are recorded by Dore Ashton in her essay "On Motherwell," in Dore Ashton and Jack Flam, eds., *Robert Motherwell* (New York: Abbeville Press–Albright-Knox Art Gallery, 1983), p. 29.

12. The story of the engagement is told in some detail in the intriguing document entitled *Robert Motherwell: The Reconciliation Elegy*, edited by E. A. Carmean Jr., with Robert Bigelow and John E. Scofield (New York: Skira/Rizzoli, 1980). He and Motherwell's assistants and Motherwell all speak of their collaborative work on the painting for the East Wing of the National Gallery.

13. In an essay written in 1953 as a preface to a proposed catalogue for the Joseph Cornell exhibition held that year at the Walker Art Center, Minneapolis.

14. See recent writing about the notion of *gift* by Jacques Derrida (*Given Time,* tr. Peggy Kamuf [Chicago: University of Chicago Press, 1994]).

15. Letter to Frank O'Hara, August 18, 1965; p. 67 in *Robert Motherwell* (New York: Museum of Modern Art, 1965). O'Hara's superbly crafted introduction itself opens with the idea of giving and gift, as I read it, and—consciously or not—marks the point repeatedly in its first few pages. It opens:

A symbolic tale of our times, comparable to the legend of Appelles' leaving his sign on the wall, is that of the modern artist who, *given* the wrappings from issues of a foreign review by a friend, transforms them into two collage masterpieces; and who, *given* a stack of Japan paper, makes six drawings and on seeing them the next day is so excited by the black ink having bled into orange at its edges that he decides to make six hundred more drawings. (p. 8)

and continues, about the abstract expressionists:

Their *gift* was for a somber and joyful art. . . . But the abstract expressionists were frequently the first violators of their own *gifts*. (p. 9)

16. Quoted by O'Hara, *Robert Motherwell*, p. 10, about Matisse.

17. For detailed information on the relation of walls to each other in Motherwell's early work, as on Motherwell's own relation to Mondrian, and for interesting discussions of the importance of such works as *The Little Spanish Prison* and *Mallarmé's Swan*, see Robert Saltonstall Mattison, *Robert Motherwell: The Formative Years* (Ann Arbor: UMI Research Press, 1987), pp. 41, 54–59, and 113.

18. Carmean, *Reconciliation Elegy*, pp. 68–70.

19. O'Hara, *Robert Motherwell*, p. 23. And also, he says, "some of the most coldly disdainful ones (emptying out of self)."

20. Federico García Lorca, "Theory and Divertissement," in Reginald Gibbons, ed., *The Poet's Work: Twenty-Nine Poets on the Origins and Practice of Their Art* (Chicago: University of Chicago Press, 1979), p. 34.

21. Gibbons, *Poet's Work*, p. 35.

22. Gibbons, *Poet's Work*, p. 39.

23. *Sewanee Review* 52 (Autumn 1944): 499–507; *Predilections* (1955), quoted in *The Complete Prose*, p. 401.

24. O'Hara, *Robert Motherwell*, p. 58.

25. Carmean, *Reconciliation Elegy*, p. 71.

26. Robert Motherwell and Jean Paulhan, *Peintre et public* (Paris: Editions de l'Echoppe, 1989), pp. 18, 20.

27. O'Hara, *Robert Motherwell*, p. 208.

28. Jack Flam, *Motherwell* (New York: Rizzoli, 1991), p. 10.

29. Wallace Stevens, "Domination of Black," in *The Palm at the End of the Mind*, ed. Holly Stevens (New York: Vintage, 1972), pp. 14–15.

30. Terenzio, *Collected Writings*, p. 105.

31. Terenzio, *Collected Writings*, p. 107.

32. Terenzio, *Collected Writings*, p. 108.

33. Terenzio, *Collected Writings*, p. 124.

34. Ashton, *New York School*. See especially pp. 178–84. Ashton quotes Sartre's ambiguously phrased introduction for David Hare's exhibition in 1948 at the Kootz Gallery:

 He offers us at the same time passion and its object, labor and its instrument, religion and the sacred object. . . . Graceful and comical, mobile and congealed, realist and magical, indivisible and contradictory, showing simultaneously the mind which has become an object and the perpetual bypassing of the object by the mind. (p. 178)

35. As noted in Terenzio, *Collected Writings*, p. 291.

36. Ashton, *New York School*, p. 187.

37. Dore Ashton and Jack Flam, *Robert Motherwell* (New York: Abbeville Press–Albright-Knox Art Gallery, 1983), p. 29.

38. "Correspondences," in Charles Baudelaire, *Les Fleurs du mal*, in *Oeuvres complètes*, ed. Claude Pichois (Paris: Gallimard, Bibliothèque de la Pléiade, 1975), p. 11. My translations.

39. According to Renate Motherwell, this wild duck, plunging to earth in his rendering, occurs exactly at the point in 1974 when the artist is about to enter a period of hospitalization, and so it is associated with apprehension.

40. This information comes from Dore Ashton, who invoked the goose tale twice, first at the Motherwell Memorial Service in the Metropolitan Museum of Art, and then at the Motherwell celebration at the CUNY Graduate Center on March 5, 1993.

41. This analysis was presented at the Motherwell symposium, CUNY Graduate Center, March 5, 1993, by James Breslin, who points out how Motherwell will become disinterested in formalism in general:

 Thus, painting the grid shapes in this work more and more faintly.

42. T. S. Eliot, "The Hollow Men," *The Complete Poems and Plays* (New York: Harcourt, Brace, 1952), pp. 56–58.

43. T. S. Eliot, "Ash Wednesday," *Complete Poems*, pp. 60–67.

3. Open Possibilities

1. Quoted by Robert Saltonstall Mattison, from an interview in 1979, in *Robert Mother-well: The Formative Years* (Ann Arbor: UMI Research Press, 1987), p. 7.

2. "What Abstract Art Means to Me": quoted in Stephanie Terenzio, ed., *The Collected Writings of Robert Motherwell* (New York: Oxford University Press, 1992), p. 86. This excerpt is included in Jack Flam, *Motherwell* (New York: Rizzoli, 1991), p. 27.

3. In *possibilities* I (Winter 1947–1948). The opening statement, signed by Motherwell and Rosenberg, is from September 1947. Stephanie Terenzio believes, given these drafts, that the first sentences may be ascribed to Motherwell, although the "thrust of the writing is Rosenberg's," with its more political persuasion (p. 45).

4. Information from Mattison, *Formative Years*, pp. 28, 36.

5. Quoted in Flam, *Motherwell*, p. 13.

6. Dore Ashton, *The New York School: A Cultural Reckoning* (Berkeley: University of California Press, 1972), p. 162.

7. Quoted in Diana Crane, *The Transformation of the Avant-Garde: The New York Art World, 1940–1985* (Chicago: University of Chicago Press, 1987), p. 47.

8. In this demand, he resembles Roger Fry, that other great interpreter of the "purity" of form and its independence from anything outside it.

9. For further commentary on Motherwell's relation to Jung's collective unconscious as opposed to the Freudian id, see the entry in the catalogue of the exhibit *Flying Tigers: Painting and Sculpture in New York, 1939–1946* (Providence: Bell Gallery, Brown University, 1985).

10. Wolfgang Paalen, *Form and Sense* (New York: Wittenborn, 1945). This discussion comes from Ashton, *New York School*, p. 125.

11. Ashton, *New York School*, p. 66.

12. Meyer Schapiro, *Theory and Philosophy of Art: Style, Artist, and Society.* Selected Papers, vol. 4 (New York: George Braziller, 1994), p. 31.

13. Interview with Irmeline Lebeer, 1973; quoted in Clifford Ross, *Abstract Expressionism: Creators and Critics: An Anthology* (New York: Abrams, 1990), p. 119.

14. Interview with Jack Flam, 1982; quoted in Flam, *Motherwell*, p. 119.

15. Martin Heidegger, *Poetry, Language, Thought,* tr. Albert Hofstadter (New York: Harper Colophon, 1975), p. 44.

16. Heidegger, *Poetry*, p. 45.

17. Heidegger, *Poetry*, p. 83.

18. "What Abstract Art Means to Me," *The Museum of Modern Art Bulletin* 19, no. 3 (Spring 1951): 12; Quoted in Flam, *Motherwell*, p. 14.

19. Jean de La Ceppède, "Théorème spirituel," *Penguin Book of French Verse* (Harmondsworth: Penguin, 1957), pp. 220–21. My translation.

20. Conversation with the author, 1990, in Greenwich, Connecticut. In his review of Motherwell's second one-man show in 1946 at the Kootz Gallery in New York, Clement Greenberg gives the artist as an instance in which the baroque spirit of the times and something very unbaroque clash. "In concept Motherwell is on the side of violence, disquiet—but his temperament seems to lack the force and sensuousness to carry the concept, while the means he takes from Picasso and Mondrian are treated too hygenically. The richness and complication of color are applied too deliberately and

do not accord with the arbitrary constricted design" (Clement Greenberg, *The Collected Essays and Criticism,* vol. 1: *Perceptions and Judgments, 1939–1944,* edited by John O'Brian [Chicago: University of Chicago Press, 1986], p. 54). In his later work, I think, the artist arrived at a far less stilted stance.

21. For a meditation on Motherwell's use of black, see Stephanie Terenzio, *Robert Motherwell and Black* (London and New York: Petersburg Press, 1980).

22. See my *Eye in the Text: Essays on Perception, Mannerist to Modern* (Princeton: Princeton University Press, 1981) for the inside-outside passion of surrealism, and *The Art of Interference: Stressed Readings in Verbal and Visual Texts* (Princeton: Princeton University Press, 1990), for a brief meditation on moral passion.

23. Conversation, Provincetown, August 1989, between Robert Motherwell and Mary Ann Caws.

24. *Robert Motherwell,* 2d edition (New York: Abrams, 1981), p. 171.

25. Quoted at the Motherwell symposium, CUNY Graduate Center, March 5, 1993.

26. David Smith, whose untimely death interrupted the *Lyric Suite*—those free sketches done on rice paper in a constant outpouring until this news—lived, like Motherwell, in a world of Joyce. This was yet another strengthening bond to their friendship.

27. In *Harper American Literature* (New York: HarperCollins), p. 1511.

28. Conversation, Greenwich, March 1990, between Robert Motherwell and Mary Ann Caws.

29. Charles Baudelaire, *Les Fleurs du mal,* in *Oeuvres complètes,* ed. Claude Pichois (Paris: Gallimard, Bibliothèque de la Pléiade, 1975),, p. 129. My translation.

30. Speaking of the juxtaposition on the same page in *Robert Motherwell,* 2d edition (New York: Abrams, 1981), of these two pictures (p. 144).

31. Delmore Schwartz, "The Vocation of the Poet in the Modern World," from Reginald Gibbons, ed. *The Poet's Work: Twenty-Nine Poets on the Origins and Practice of Their Art* (Chicago: University of Chicago Press, 1979), p. 83.

32. Gibbons, *Poet's Work,* p. 192.

33. Gibbons, *Poet's Work,* p. 193.

34. Gibbons, *Poet's Work,* p. 196.

35. Clement Greenberg, *The Collected Essays,* vol. 4: *Modernism with a Vengeance, 1957–1969* (1986), p. 157.

36. From Delmore Schwartz, *Summer Knowledge: New and Selected Poems, 1938–58* (Garden City, N.Y.: Doubleday, 1959), p. 25.

37. Virginia Woolf, *The Waves* (New York: Harcourt Brace, 1931), p. 109.

38. A jotting in the Joseph Cornell diary reads: "Listened to Mozart at Motherwell's."

39. André Malraux, *Les Voix du silence* (Paris: NRF, La Galerie de la Pléiade, 1951), p. 639.

4. Giving, Sending, and Looking

1. What Gerard Manley Hopkins called "selving," "that taste of me in me"—it is no wonder that he was Motherwell's favorite English poet.

2. Conversation with Jack Flam, 1982; quoted in Jack Flam, *Motherwell* (New York: Rizzoli, 1991), p. 18.

3. Quoted in Clifford Ross, *Abstract Expressionism: Creators and Critics: An Anthology* (New York: Abrams, 1990), p. 222.

4. Motherwell, "Beyond the Aesthetic," 1946; quoted in Ross, *Abstract Expressionism,* p. 104, and in Stephanie Terenzio, ed., *The Collected Writings of Robert Motherwell* (New York: Oxford University Press, 1992), p. 37

5. "Robert Motherwell: A Conversation at Lunch," *Smith* 1963, quoted in E. A. Carmean Jr., *The Collages of Robert Motherwell* (Houston: The Museum of Fine Arts, 1972), p. 66.

6. Carmean, *Collages.*

7. "Since the aesthetic is the main quality of the eternal in art, it may be that this is why Mondrian's work, along with certain aspects of automatism, was the first technical advance in twentieth-century painting since the greatest of our discoveries, the papier collé" ("The Modern Painter's World," *DYN* [1944], quoted in Carmean, *Collages,* p. 91, and in Terenzio, *Collected Writings,* p. 31.

8. William Seitz, *Abstract Expressionist Painting in America: An Interpretation Based on the Work and Thought of Six Key Figures,* Ph.D. dissertation, Princeton University, 1955, p. 61; quoted in Carmean, *Collages,* p. 41.

9. Carmean, *Collages,* p. 15.

10. Robert Motherwell, in "Beyond the Aesthetic," *Design* (1946), quoted in Carmean, *Collages,* p. 91, and in Terenzio, *Collected Writings,* p. 31.

11. Robert Mattison has commented on the pressure of the oval against the vertical in his work on the early Motherwell.

12. Quoted in Carmean, *Collages.*

13. Translated into French as "L'Humanisme de l'abstraction," by Joël Dupont (Caen: Editions de l'Echoppe, 1991).

14. Terenzio, *Collected Writings,* p. 178.

15. See his article in the *American Scholar* on "The Universal Language of Children's Art, and Modernism" (quoted in Terenzio, *Collected Writings,* pp. 187–92).

16. Quoted in Carmean, *Collages,* p. 64.

17. Quoted in Carmean, *Collages,* p. 63.

18. Robert Hass, "Meditations at Lagunitas," in *Praise,* p. 4.

19. Of course, Jacques Derrida's recent work on the idea of giving takes on Marcel Mauss and the other theoreticians of the anthropological, sociological, and philosophical issue of giving. I have wanted, quite simply, to react just to the work of art, without philosophical reference.

5. Holding and Setting Out

1. Gabriella Drudi, *Notes romaines* (Paris: Editions de la différence), p. 50.

2. Faulkner, *As I Lay Dying,* p. 34.

3. From "Beyond the Aesthetic," *Design* (April 1946) (quoted in Terenzio, *Collected Writings,* p. 37).

4. Quoted by Marianne Moore, in *The Complete Prose,* p. 98, in an essay on Frances Bacon.

5. Matthew Arnold, "Dover Beach," 1867.

6. Carmean, *Collages,* p. 66.

7. "Robert Motherwell: A Conversation at Lunch," *Smith* 1963, quoted in Carmean, *Collages,* p. 93, and in Terenzio, *Collected Writings,* pp. 135–36.

8. Terenzio, *Collected Writings*, p. 131.
9. Mentioned at the memorial service for Motherwell in Provincetown. Upon this scene, I have transposed another, of the poet René Char in Provence, who was taken from his house on the final trip in a standing position, held upright by a friend who refused to let the great poet leave his house lying down.
10. Jack Flam, *Motherwell* (New York: Rizzoli, 1991), p. 19.

6. Five Interviews with Robert Motherwell

1. Meeting place in Normandy, founded by Paul Desjardins, where intellectuals held *décades,* or ten-day meetings around a topic: they were mostly French, like André Gide and Jean Wahl, but with others often participating, Lytton Strachey and Roger Fry from England, for example. These meetings continue at Cerisy-la-Salle, near St.-Lô.
2. His affection is clear, in his own rendering of the *Disappearance of Goya's Dog,* reproduced here.

By Motherwell

Motherwell, Robert. *The Dada Painters and Poets: An Anthology.* 2d edition. Foreword by Jack Flam. Cambridge: Belknap Press of Harvard University Press, 1981.

Motherwell, Robert. *The Dedalus Sketchbooks.* Selected and edited by Constance and Jack Glenn. Introduction by Constance Glenn. (An Abrams' artist's sketchbook.) New York: Abrams, 1988.

Terenzio, Stephanie, ed. *The Collected Writings of Robert Motherwell.* New York: Oxford University Press, 1992.

On Motherwell

Arnason, H. H. *Robert Motherwell.* 2d edition. Introduction by Dore Ashton. Interview with Robert Motherwell by Barbaralee Diamonstein. New York: Abrams, 1992.

Carmean, E. A. Jr., with Robert Bigelow and John E. Scofield. *Robert Motherwell: The Reconciliation Elegy.* New York: Skira/Rizzoli, 1980.

Drudi, Gabriela. *Robert Motherwell: Notes romaines.* Translated from the Italian by Philippe de Montebello. Paris: Editions de la différence, 1980.

Flam, Jack. *Motherwell.* New York: Rizzoli, 1991.

Mattison, Robert Saltonstall. *Robert Motherwell: The Formative Years.* Ann Arbor: UMI Research Press, 1987.

Pleynet, Marcelin. *Robert Motherwell.* Translated by Mary Ann Caws. Paris: Editions Daniel Papierski, 1991.

Terenzio, Stephanie. *Robert Motherwell and Black.* London and New York: Petersburg Press, 1980.

General and on the New York School

Ashton, Dore. *The New York School: A Cultural Reckoning.* Berkeley: University of California Press, 1973.

Crane, Diana. *The Transformation of the Avant-Garde: The New York Art World, 1940–1985.* Chicago: University of Chicago Press, 1987.

Danto, Arthur C. *Encounters and Reflections: Art in the Historical Present.* New York: Farrar Straus Giroux, 1990.

O'Hara, Frank. *Art Chronicles, 1954–1966.* New York: George Braziller, 1975.

Ross, Clifford. *Abstract Expressionism: Creators and Critics: An Anthology.* New York: Abrams, 1990.

Sandler, Irving. *The Triumph of American Painting: A History of Abstract Expressionism.* New York: Harper and Row, 1976.

Catalogues:

The Collages of Robert Motherwell: A Retrospective Exhibition. Introduction by Philippe de Montebello. Text and catalogue by E. A. Carmean Jr. Houston: Museum of Fine Arts, 1972.

Robert Motherwell. Essays by Dore Ashton and Jack D. Flam, with an introduction by Robert T. Buck. New York: Abbeville Press–Albright-Knox Art Gallery, 1983.

Motherwell. Preface by Marcelin Pleynet. Paris: Artcurial, 1990.

Flying Tigers: Painting and Sculpture in New York, 1939–1946. Providence: Bell Gallery, Brown University, 1985.

Robert Motherwell. New York: Knoedler, 1989.

The Prints of Robert Motherwell: A Catalogue Raisonné, 1943–1990. Stephanie Terenzio. New York: Hudson Hills Press, 1990.

Robert Motherwell: The Open Door/La Puerta Abierta. Fort Worth: Modern Art Museum of Fort Worth. InterCultura, 1992.

▮LLUSTRATIONS

CHAPTER SIX *Five Interviews with Robert Motherwell*

COLOR PLATES *following page 58*

Greek Door, 1980–1981

Summer Seaside Doorway, 1971

Untitled (Blue Open), 1973

Gift, 1973

Je t'aime VIII (Mallarmé's Swan: Homage), 1957

La Joie de vivre, 1943

Manchester Guardian, 1977

Gauloises with Scarlet, 1972

N.R.F. Collage No. 2, 1960

ENDPIECE

Robert Motherwell painting "Robert Motherwell" 231

■ INDEX

Page numbers in italics indicate illustrations. The letters *cp* refer the reader to the color plates.

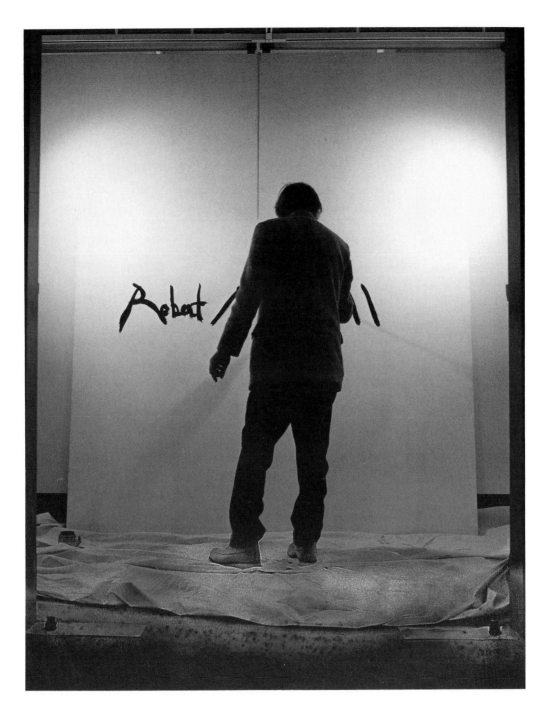

Robert Motherwell painting "Robert Motherwell."

Photograph courtesy of Renate Ponsold Motherwell

DATE DUE			

GHSMITH #45230

Printed
in USA